IN FARO'S GARDEN

A TOUR AND SOME DETOURS

R. E. FARO

Cover design by Marcia Gregory
Photography by John Mickelson

ISBN 0-9749502-7-0
Library of Congress Control Number: 2006929172

Ithuriel's Spear is a fiscally sponsored project of Intersection
for the Arts, San Francisco.

www.ithuriel.com

In Faro's Garden

A Tour and Some Detours

by R. E. Faro

Ithuriel's Spear
San Francisco

ACKNOWLEDGMENTS

With gratitude:

To my editors at *The East Bay Monthly*, Tim Devaney, Josh Sens, Tim Neagle, Kira Halpern and Kate Rix.

To Mary Segawa and Serena Billmayer, for corralling sundry miscues.

To Marcia Gregory, for her creative eye.

To Elizabeth Gillis, Sonja Rogneby and Frank Eddy, for love and support.

To Jim Mitchell, for patient and perceptive stewardship.

To Bob Glück and Phyllis Taper, for inspiration.

And to the three who gave generously and often, without whom the garden would not be: John Mickelson, Liz Peirano and Matthew Krieger.

R. E. Faro is the pen name of Richard Schwarzenberger, a gardener and writer at home in the San Francisco Bay Area. He writes regularly about gardens for *The East Bay Monthly* and the *San Francisco Chronicle*.

DEDICATION

To my parents

Contents

Spring

RULES OF THE ROSE

On the wall of my living room is a photograph of the East Bay taken before the human invasion. Live oaks nestle in folds of the hills, but the vegetation is mainly scrub and dry grasses. The photo was taken in summer; the grasses, even in the black-and-white picture, have a yellowish sheen.

Not far from my house is a stand of oaks surrounding a reservoir. They, perhaps, may be found in the photograph, but I doubt anything else is identifiable, other than the contours of the hills themselves against the sky. Gardens, as much as houses and streets, have changed the landscape.

Remnants of the native vegetation still crop up. A coyote bush (*Baccharis pilularis*) sprouted in the baked clay at the uppermost fence of the garden. It is neither well situated nor handsome. To be a great gardener you need to be ruthless, to banish the second-rate. While I can sometimes dispense with ruth, I still have my neighbor Rita.

"The coyote bush belongs," she said. As a transplant from Kansas, I wasn't going to argue about nativism.

What I've worked hardest, and done least, to change on the hillside is the soil, the clay that shows a hard face to the sun but gets soggy and clutching once wet, like a certain kind of drunk. My garden is large by local standards, often I think too large, about half an acre. I inherited the house and garden from my Aunt Dot 13 years ago. Everything her scuffed-up hands touched got saved, one way or another. I am still sifting out woody debris from the compost pile that should have been carted away, but she figured it would break down sooner or later. By now, it mostly has, and the compost pile works better each year. Still, it only produces a scant fraction of what the clay begs for, a lavish helping of the soil enhancer a local supply outfit sells in bulk, calling it "Walt Whitman."

"Walt Whitman" is a rich, semi-coarse blend of composted humus, poultry droppings and rice hulls, and it smells sweet and funky. Walt might be proud. The terraced lower garden has periodically enjoyed his company while the rest of the garden looks on wistfully. A walkway of 38 steps zigzags from the street to where the fenced upper garden starts. By the time Walt arrives there he is more nurse than poet. The only evidence of the two cubic yards I spread beneath my cherry trees four years ago is the relative ease of digging, but the clay, when wet, still gloms on to my shovel.

"Clays have a dramatic ability," writes the biologist Lyall Watson in *Lifetide*, "not only to grow, but to absorb other molecules...You have in a bed of clay everything necessary for the acquisition and inheritance of new characteristics." In other words, the gray matter is self-replicating, an organism. "We live on a parent, not a planet."

Dare I call our little branch of the family "dysfunctional?" Two winters ago the upper slope was so sodden that four lavenders, a lilac and a tibouchina expired. I'm the one who felt responsible, neglectful.

Do I claim my garden's successes? Up to a point. Something mysterious runs the works. In every place and climate, there is a genius loci, a spirit of place. It's best to ally with this power, or at least not get in the way.

Drench with your splendor me, or the men and women generations after me.
— Walt Whitman, *Crossing Brooklyn Ferry*

The only place in my garden where I feel that the soil is sufficiently drenched with splendor is the rose bed. When I inherited the garden about ten rosebushes lived there, some of them eyesores I discarded after undue deliberation, only to plant a few eyesores of my own.

Like diamonds, roses are romantic by consensus, but preciousness is created by collective self-delusion and marketing. (Ditto romance.) A rose isn't a rose isn't a rose. So much depends on the variety. Many roses flourish without much fuss. Choosing the right ones for your situation (like lovers) prevents hours of disappointment.

Not that you can take anything for granted. The 'Betty Prior' near my back door develops mildew twice a year whereas two other 'Betty Prior' bushes nearby stay resolutely healthy. The 'Sunset Celebration'

that last year was immaculate this year is afflicted with rust. If a rose is relentlessly disease-ridden, remember: ruthless.

Two things to consider at the nursery: glossy leaves are more disease resistant, and if you live in a cooler part of the Bay Area, look for a rose with relatively few petals. Without the thermal boost, many-petaled roses may turn to mush before they open completely.

Because I no longer spray toxic chemicals, any resistance I had to roses has evaporated. Every spring I'm in line at the nursery. I allow myself one acquisition a year. Two years ago I bought a 'Graham Thomas,' a rose the nursery said would grow to a mature height of four feet. Already it's eight-by-six, a gold eruption loosely tied to a fence, two wrongs equaling a right. I expected four feet and planted it in a spot that needed eight.

Half of what you learn gardening is gained by attentive muddling and the other half by picking someone's brains. I don't remember who told me about the everblooming 'Sally Holmes,' a climber whose apricot-tinged buds produce single white flowers about three inches wide. At first I wasn't taken with it because I grew it over a freestanding trellis. Without a backdrop it looked wan. Now, against the dark north fence, it glows, especially in late afternoon sunlight. Near it is a 'Double Delight,' a rose so faithful, so suited to our cool climate—not to mention intensely fragrant and perfect in form—that I feel unfaithful having become matter-of-fact about it. I seldom nosedive into it. What makes us continually seek new pleasures?

One thing I wouldn't recommend: having a rose bed as such, where roses reveal their pretensions and share their diseases. They display their true glory when integrated with other plants.

Always the procreant urge of the world.

— Walt Whitman, *Leaves of Grass*

I left my own bed eagerly this morning. A bouquet was in my mind's eye, an extravaganza of roses, purposefully excessive, two or three of everything. For my sweetheart. My would-be sweetheart. But someone (could it have been me?) left the gate open, and sometime in the night the deer came in. Came, saw, and ate. All the roses but the 'Joseph's Coat,' whose orange hues I was not planning to use in my

bouquet anyway. Where roses and rosebuds had been, upright twigs remained. Here and there a runt of a rugosa survived.

Three years ago there were no deer in the neighborhood. Now Mom and Pop and their baby hoovers are nightly visitors. My lower garden has been transformed willy-nilly. Even Rita has no patience for them.

So what is paradise anyway? An enclosed garden but there's an obvious contradiction in that concept, which another neighbor, Bertie, is happy to point out to me whenever I whine about deer. He doesn't have a fence around his house; he has a hectare of ivy and an acre of patio. He says, "Why can't you be friendly to the deer?" I am not unfriendly. They're welcome to graze the raphiolepis and the agapanthus and Texas privet which exhibit all the charisma of things plucked. They're welcome to the whole neighborhood, just not my back garden.

Despite the carnage (herbage?) much remains. The bouquet I put together contains 'Sunset' magenta rockroses, several stalks of a salmon-colored yarrow, a spray of leaves from the red Japanese maple, and some pale yellow spikes of *Kniphofia caulescens*, a cooled-down version of red-hot poker. I don't stop there. What pleasure in resistance? The sprays of 'Joseph's Coat,' which would have diminished the regal lavishness of 'Eden' and 'Lace Cascade' and 'Europeana' add richness here. All in all, the bouquet's a riot, colors God would not have put together. Add a dozen exclamation points of scarlet sage and there's no denying a statement is made. I wanted to say, "Here is my love, rich and luxuriant." Instead I declare, "I wanna kiss you till the cows come home, and don't you forget it." There are no accidents.

Summer

POISON IVY

There are times when I'm ready to bulldoze my garden. The urge often strikes after I've paged through a book like *Hidcote: The Making of a Garden*, by Ethne Clarke. I browse from perfection to perfection, my bloodstream toxic. Where are my alleys of pleached hornbeam, my arches of yew, my battalion of gardeners? A more painful question to consider: where is the genius who can create, as Vita Sackville-West called Hidcote, a "jungle of beauty?" Hidcote was begun in 1907, the creation of Lawrence Johnston. Not only did he possess genius, he was rich and modest. Inscribed on his tombstone are these words: "Deeply loved by his friends."

A similar sentiment might have been carved on Aunt Dot's tombstone. Instead there are praying hands. Knitting hands would have been more to the point. In many ways my garden will always be hers; like her afghans, comfortable and comforting, but evidence she may have been color-blind.

A garden needs a clear central concept, proclaimed Edwin Lutyens, the preeminent architect of Johnston's era. I look at my garden and it looks nothing like the Mughul garden for Viceroy's House in New Delhi (a Lutyens design). If Aunt Dot had a central concept I guess it was fruit. A list of her bequests: apples, pears, plums (six trees at last count), cherries, figs, grapes, raspberries, blueberries, blackberries, strawberries, pineapple guava, loquats, persimmon, and lemon. A native Kansan, to her "garden" meant edibles. Everything else was "yard." Her modus operandi was, "Here's a sunny spot, park it." Mine is similar, but my temperament is more critical. For example, it vexes me endlessly that a six-foot Meyer lemon tree grows next to a twenty-foot cherry tree. Besides the obvious problem of scale (not the pest), the tones of green clash. Bluish-green alongside chartreuse always elicits a wince.

I've improved plots and pockets of the garden and occasionally, at the right moment and in the right evening light, it all coheres and looks either ravishing or, better, harmonious and peaceful. But at noon hodgepodge persists. The lemon tree will always be a mutt next to the cherry tree, and I can't bring myself to get rid of either since both are bountiful, so I try to distract the eye. I let the lemon tree dictate the scheme because it's at eye level. I plant *Aloe saponaria*, scaevola and lime-green mounds of *Santolina virens*. The spotted aloes lounge in the dappled light like seven plump starfish, equable to drought but happier

with some water. In midspring the shrimp-orange pennants they raise wave for weeks unless Bambi conducts a taste test. A wave of blue scaevola laps at their haunches. I have no idea how the scaevola will do in the long run. In a pot last summer it was glorious, a necklace of lapis lazuli, and stalwart as well, impervious to the mini-snails thereabouts. My goal (is that the same thing as a clear central concept?) is to give the lemon tree some companionship that suggests the Mediterranean, but nothing so dominant as to make the cherry tree appear completely out of place. Is it a success? I wish I had considered a bit of reality called deciduousness and planted a rakeable groundcover instead of a bed of aloes. The cherry leaves are turning yellow and soon will fall. I foresee a month of gingerly collecting them from among the aloes' delicate, fleshy little arms. A good task for practicing mindfulness. I will take a deep breath and another. But there will be no becoming unmindful of the fact the lemon tree next to the cherry will always be an eyesore.

Then I think of Hidcote and bulldozers.

You should rather be grateful for the weeds you have in your mind because eventually they will enrich your practice.

 – Shunryu Suzuki, *Zen Mind, Beginner's Mind*

Simplify, simplify is my mantra these days, when patience is just a word for curdled indecision. It's what I tell my friend Vikki to do when she asks my opinion about her gardening efforts. Gently I float the idea that she might get rid of some of her statuary, perhaps the five-foot St. Francis, or the verdigris Pharaoh, or Mother Goose with her six goslings. My hints, unlike my garden, are fruitless.

I met Vikki in the early '70's during her Hindu phase, when her house was testimony to her devotion. I asked a mutual friend if Vikki had been to India. "No," he replied, "but she's been to Cost Plus." Over the years Vikki's enthusiasms waxed and re-waxed. Crystals? She had tables covered with amethyst. Macramé? A nirvana for spiders. The windows in her flat were fronted with potted jungles, many of the plants scattering leaflets advocating euthanasia. Now she's into cacti, which form a thicket around her hot tub, an odd place for them but the hot tub hasn't held water for several years. Vikki works out daily at the gym where's there's a jacuzzi and available men.

Until last spring her garden was as neglected as her hot tub, overrun by horsetail and blackberries. She had it cleared and has begun the task of stocking it. On her latest trip to the nursery she bagged one hollyhock, one delphinium, one aster, one thyme, one libertia, one small brugmansia dangling a yellow trumpet, and a six-pack of red salvia. She planted them in a way that shows no consideration of their eventual size. The meek inheriting the earth, alas, is still an unredeemed promise. "Beautiful," I tell her when she solicits my admiration.

Even in Vikki's garden, with its one-of-everything aesthetic, I think I could, by a process of elimination, elicit a central concept. If she keeps the Pharaoh she might plant palm and papyrus, lemon trees, hibiscus. St. Francis? An herbal knot and espaliered apple trees, like some monastic cloister. Mother Goose? A pond, ferns, a bed of lilies.

I never offer more than tepid remarks, lest Vikki actually take a stab at doing what I suggest and I end up fretting about her garden's failures in addition to my own. I do tell her about the lecture I heard by a masterful gardener who, upon moving to a new house in the mountains, did not plant anything for a year so that she could become attuned to the site and create the garden best suited to it.

"I've been doing that for eight years," Vikki replied.

Some speak of a return to Nature. I wonder where they could have been.
— Jonathan Williams

I know where. Perhaps in these pleasant hills on a Sunday morning when my neighbor Bertie is doing his gardening. He has what he calls a "low maintenance" garden, which I suppose counts as a clear central concept. The principal chore, aside from trimming the ivy, is to rid his driveway and patio of fallen leaves. For this Bertie fires up his leaf blower. Between ten and eleven, every blessed Sunday, except in football season. Each year he seems to get a noisier, more powerful blower. The sense of fulfillment he feels in blasting the fugitive leaves from side to side and down his driveway is undoubtedly heroic. Our neighborhood Terminator.

Ivy, Scotch broom, bay laurels; that's about the extent of Bertie's low maintenance garden. The ivy does what you would expect: scurry over, under and through the fence into my garden where it finds sun and moisture. For the fifth time this year I've had to attack it.

In the heyday of the Cold War, when clever minds conceived of mutually assured destruction, one of my happier thoughts was that at least it would finish off Bertie's ivy. Now I would not bet on it. His type is *Hedera canariensis*, the broad-leafed Algerian ivy. (Algeria should sue.) It is one of the idiots of the plant world, good only as a skirt for a freeway. I can't believe nurseries still stock it. Detesting this rat trapeze as I do, my animosity extends to most other forms of ivy, with somewhat less justification. *H. helix*, equally common, is also tiresome though its vices don't rank anywhere near *H. canariensis*. Relatively mannerly, it has some good-looking cousins. I planted 'Gold Heart' against a concrete retaining wall and find myself wishing it would grow faster. This is year number three, so I expect it to begin motoring. Ivy, it is said, is like a child: crawling the first year, walking the second, running the third. Already the gold in the fold of each leaf enriches the shade beneath a Japanese maple, and provides a nice foil for the orange flowers and dark green leaves of nearby clivias.

I feel self-satisfied in this part of the garden though it came into being haphazardly. The fuchsia draping above the ivy is from a cutting pilfered on one of my walks. The euonymous at the base of the maple were birthday gifts. I couldn't think of anywhere else to put them. I ignored my mantra, simplify, simplify. In truth, there's not much in my garden to indicate a dedication to it, except for a bank of agapanthus that I would gladly get rid of with no torture to conscience, only to lower back.

Nor does it foster discipline when Rita, my downhill neighbor, treats my garden as an orphanage. This morning she appeared, pulling her little red wagon while I was abusing the ivy. Rita is over six feet tall, fifty-ish, hair flaming auburn. The wagon is half-size, designed for a toddler.

"I'm giving you this plant," she said. "I'm cross with it. It grows too big and too fast for me to keep up with it. You've got room for it there." She pointed to the spot where the fuchsias are just getting established.

Her plant was on its head. The leaves on its underside were dried up, gray as nickels. I felt a little less averse to it when Rita grabbed its neck and turned it right side up, revealing a shawl of wooly, greenish-white leaves. *Helichrysum petiolatum*, probably 'Limelight,' a fine plant if kept in check. For a moment I could see it in place of the fuchsias, how it would set off the gold of the ivy and the euonymous, offering enough contrast to brighten up the slope like a patch of reflected sunlight. But then I remembered deciduousness. What happens in six

weeks when the fallen maple leaves cover the helichrysum like a feather bed? I'd need a vacuum, or Bertie's blower, to remove them. I pointed to a spot near where she stood. "Leave it right there." "You don't need to snap," she said. "What's the matter, your love life fall apart?"

At another moment I might have told her about the way my sweetheart accepted my bouquet of flowers and stuck them in a vase with no more attention than someone putting socks in a laundry basket. Instead I said, "It's this damn ivy."

Rita made a palms-up gesture that read, "So don't blame me," and circled her wagon and beat a retreat back to her garden, leaving the dumped plant aslant on a stepping stone, a metaphor of thwarted desire.

As it was, I spilled the beans later in the day when she invited me over for scones and tea. "I'm probably being too sensitive," I said.

"Too sentimental. Get real," she said, pouring steaming mint tea into my cup. "Sentiment is fine, but when did it ever make honey? I don't think you know what you want. You need to find out. You need a strategy."

Is that the same as a clear central concept?

Fall

THE WORM RETURNS

Hallelluja. Most, I say most, of the leaves of the deciduous trees have fallen. The trouble with this annual defoliation is that it goes on so long, starting in late August with the plums and continuing in some cases until March (the liquidambar). I've raked bushels of leaves out of the various beds, often with my hands, and, except for the liquidambar, limbs are bare. Gardening is in a rare hiatus. The garden and winter rains are in a dialogue to which the house and I are mere eavesdroppers. These weeks indoors are a mixed blessing. Here is an opportunity to rest my limbs and, like the garden, soak up some energy. I could be making grand schemes for the future, bedazzlements for muddy bare spots, but I brood. My mind drifts not toward spring but toward the past, and what's been lost.

I've been thinking a lot about Aunt Dot. In comparing this garden to her afghans, I put too much emphasis on "colorblind." "Comfortable and comforting" is more to the point. "Gardens are places to be, not places to look at," I heard someone say recently. This garden will never be a model of surprise or stunning design. These are visual achievements, certainly, but creating a place where one can find peace, perhaps even a respite from being surprised or stunned, is a higher one. Aunt Dot mastered that, and as long I live to sit at this window and watch the rain drip off wet boughs she will be a breath away.

While it may not be advisable to follow her example and plant as many fruiting plants as space and climate allow (gardens are places to look at, too) a garden is poorer if there's nothing to eat, no ripe handfuls of blueberries, no golden plums. Aunt Dot was queen of the harvest. She picked, she pitted, she canned. Cobblers and tarts and pies rolled from her oven. My downstairs closet still smells of the apples she stored there.

When she was in her eighties she confided to me her concern about her failing memory. "I would hate to leave my house, she said, "but leaving my garden would break my heart."

I downplayed her worries. "I spend half my life," I said, "trying to remember something I've forgotten or looking for something I've lost."

That was true enough. What I did not admit to her, or much to myself, was that she was repeating herself with alarming frequency, that postcards from her that found their way to my mailbox often did so despite the fact she'd put down the wrong house number and zip code.

Comfort me with apples.
 — *Song of Solomon*

Aunt Dot finally did move from this house, on a drizzly day in January. In the car on the way to her new apartment she said, "It'll be a relief not to have that big garden to worry about." A relief it would be, certainly, and relief is better than nothing when you have a broken heart. Her brave face was doing little to mask it. But a broken heart had never eclipsed her before and it didn't then. Within weeks she had window boxes growing lettuce, rocket, rosemary and basil, and two four-foot Meyer lemon trees in blue ceramic urns. Italian dinners at her place were simpler but no less delicious than before. And she fell in love with a man she met at one of her Saturday afternoon pinochle parties. It was mutual. "He treats me grandly," she said. "I've never been happier."

She never lost her memory. It merely shifted location, a revolving beam that lit upon random incident with a precision matching the labels on the jars that still sit in the pantry downstairs. Marmalade. Eureka lemon. March 1982.

Of Aunt Dot's fruitful bequests, I most cherish the apples. Apples are the archangels of fruit, nourishing our myths. An apple a day. Apple of my eye. Mom and apple pie. "And pluck till time and times are done,/ The silver apples of the moon,/ The golden apples of the sun" (Yeats.) The Garden of Eden too, we'd all say, had an apple at its core, though nowhere is the forbidden fruit specified. Why not a pear or, given the climate, a pomegranate or a fig?

The three apple trees in my garden are a Newtown pippin, a 'Golden Delicious' and a third whose name I don't know, or much care to, since its pretty green apples are mush from the get-go, falling suicidally in July, splat on the patio. Aunt Dot made sauces out of them but I flip them into Siberia for the snails and sow bugs. No tragedy. The tree contributes a buff elegance to the garden and I get plenty of apples from the other two trees.

The pippins I use in pies (spectacular) and the 'Golden Delicious' I eat right from the tree since they don't store well. I give away the usual surplus. One incontrovertible fact: whatever the apple, it will taste better eaten right off the tree.

Over the years I've pruned the trees into roughly identical shapes, plump ovals. (A principal of good design: repeat shapes.) At this time of the year a few bedraggled leaves still hang onto their branches. I don't think anyone ever planted apple trees for their foliage, which in any season is coarse and humdrum as coveralls. In contrast, the grayish bark, glossy as a catfish, is a magnet for the eyes.

The worms play pinochle on your snout.

I have to face facts. Last fall many of my pippins were little more than bungalows for the larvae of codling moths. A year ago the problem was minor and easy to ignore as I did. I usually cut and peel the pippins for pies anyway, content to share as long as I get mine. I know what I'm supposed to do, spray some nasty chemical in spring when the buds swell and again before they fall off. I conveniently forget. I tried sticky-paper traps one year. If they helped significantly I couldn't tell.

There is no surer cure for the blues than accomplishing some unpleasant task. Here is my first New Year's resolution. No more coddling the moth.

I consult *Pests of the Garden and Small Farm: A Grower's Guide to Using Less Pesticide*, by Mary Louise Flint. This is a Division of Agriculture and Natural Resources Publication, and it is clear and impressive. Codling moth warrants over four full pages. Under possible treatment, these headings: Biological Control; Sanitation; Trunk Banding; Bagging; Mass Trapping; Codling Moth Granulosis Virus; Bacillus Thuringiensis; Botanical or Conventional Insecticides; Horticultural Oils.

Plenty to choose from, even after the immediate elimination of the granulosis virus. *Bacillus thuringiensis* seems a good bet. I read, "To obtain significant control, it must be applied with the same frequency recommended for the codling moth virus." I skip up to the virus section. "Nine to 15 applications very carefully timed to get the caterpillars just as they hatch out of the egg. Use of a degree-day model is required. Because of the difficulty, use will probably be confined to commercial orchards." Next.

Trunk banding. Let's see. Two-inch-wide bands of large-core corrugated cardboard stapled eighteen inches or more from the ground, choosing the smoothest part of the trunk. "Place bands on trunk after bloom just before the caterpillars begin to move down the tree," Flint writes. "If you keep degree-day records, this would be about 485 degree-days after the eggs were laid." (Ugh.) "Less precise timing can be achieved by putting the bands up in early May in the Central Valley and by the end of May along the coast." (Whew.) "Remove the cardboard bands the last week of June in the coastal areas and burn them. Put new trunk bands up in August and remove and burn them between November and January."

Because the trunk of my tree is fairly smooth I am not terribly discouraged when I read that "scaly varieties like Newtown pippin have

so many crevices that many caterpillars will pupate before they get to the banded area." What upsets my applecart is the next sentence: "Even in the best situations, banding will only control a small percentage of the codling moths because many pupate elsewhere in the tree or drop to the ground, bypassing the trunk." A small percentage?

I finally settle on a strategy that includes sanitation, cleaning up fruit and leaves at the base of the tree, removing loose bark that may harbor pupae and a summer spraying of horticultural oil, hoping that I get lucky, since "oils must be applied as eggs are laid." How will I know when that blessed event takes place? Also, I will scrupulously thin the fruit to single apples, since the worms use a second apple as a wedge to enter the first.

> *And thus the native hue of resolution is sicklied o'er with the pale cast of thought.*
> — Shakespeare, *Hamlet*

The nice thing about my resolution is that it requires no immediate action. I've already done a thorough clean-up. The slope where my apple trees grow is slippery mud, and despite past efforts at soil amendment, I fret a little each year that the lousy drainage will doom the trees. Whoever advised spending nine of every ten dollars on soil preparation when starting a garden gave good advice, but it's hard to follow if your garden is already established and it's a hefty walk up from the street.

Never again will I take for granted good soil, soil that makes no music against my shovel. When I visit cousins in Kansas I note their indifference to the natural friability of the soil that produces, or overproduces, their annual summer harvests of cucumbers and tomatoes. In spring they buy seedlings at Wal-Mart and plant them as if that's what they're supposed to do, generic varieties that are comparatively tasteless. Were the cucumbers of my childhood such pleasure-withholding Calvinists? Blandness is scripture. If I'm lucky enough to find a head of garlic in Kansas not sweating in a little cardboard-and-cellophane casket, I rejoice.

Here in the Bay Area, miles from rich loam, we feel reliably superior. We talk about food as much as we eat it. We know a peach does not have to be as red and tasteless as a typical tomato (nor does a tomato) and that lettuce can be more than batting for stainless-steel bowls. Why should we see our own blindspots? Vikki has an ancient Comice pear tree in her back garden. Last August there were dozens of pears on

21

the ground, half of them on the far side of ripe. I collected the eatable ones, as well as those still on the tree, and brought them inside.

"No, you take them," Vikki insisted when I asked for a bowl, a look of alarm on her face. "I'll never eat them. I just bought these yesterday," she said, indicating four pears hard as bell clappers on the sideboard. Before I could say another word she had the Comice pears in a plastic bag ready by the door. I had made the mistake of telling her that some of the pears had fallen. Vikki talks about being "grounded" but she doesn't mean the ground. Pears with scuffs and pockmarks are not to be trusted. Pears in formation at the market can be—at the organic market.

Six weeks later, on a Saturday in October, I was picking pippins from my tree with my niece Lily's help. Lily turned nine in November. We were going to make pies. I climbed the tree and tossed her apples, which she bucketed. When it came time to peel, I suspected that she, like Vikki, would quickly decide that here was a bit more of Nature than she wanted to handle. But Lily has a lot of Aunt Dot in her.

"Look, a really good one," she said, grabbing an apple that was particularly tunneled. "You can tell because the worms really like it."

The worm turns.

That's what Aunt Dot would say when the cards started coming her way. Her cardplaying was a carbonated mix of drift and focus, and she won her share. Her favorite game was cutthroat, a six-point variety of pitch that, despite its name, is mild in all aspects. The game rewards keenness and attention but occasionally dim bulbs string out some luck and win. She played with deliberation. You were never sure if she knew it was her turn, and her dawdling drove my Uncle Tom crazy. She knew it, too. The only time she worked to win was when she played against him. Their sparring was intense, a flipside to fulsome affection. Everyone, including me, matched themselves against him and found themselves coming up short, but not minding.

He built the walkway that leads throughout forget-me-nots to the top of my garden. It is unprepossessing, of irregular bricks and local sandstone. It curves pleasantly but does not meander. What it lacks in drama it makes up in subtlety. Minute inventions—on one landing bricks placed on their sides around a smooth central stone suggest a sunflower—set off a flutter of pleasure with each passage.

That's what this garden does, despite (and because of) its worms: it bears repeated attention and delivers joy. What better forget-me-not than that?

Winter

CALM AFTER THE STORM

"More rain," groaned the checker at my supermarket. Trees thrashed in the parking lot and drops speckled the windows. "My girlfriend wants to move to Seattle. She says it can't be any worse."

I kept quiet, aware how endearing I'd sound if I chimed in with how much I loved the storms, how I wished they would continue until next November, when the rainy season starts again.

My garden has been soggy for weeks. Each cloudburst activates minute waterfalls here and there. In January a night of torrents spread the rocks and gravel of my stepped walkway onto my patio. But nothing worse happened, only showers and a quiet commotion of green leaves.

"Such whining," Rita says when I tell her about the checker. "Do you pay attention to those TV weathermen? Only blonde is beautiful. It's shameful, after all those drought years."

Truth is, we'd be sick of the rain too if our houses were flooded or we were driving around in it. But Rita and I are sitting in my glassed-in porch, drinks in hand. No disaster in sight or hearing. Our current "weather disturbance" is from the south—spicy, with a tang. My windows are open to let the weather in. That damp rot might be undermining my pilings I am not aware. I am a sahib in his pavilion, relishing the breezes of the monsoon, connoisseur of cloudplay.

There's a simple explanation: I grew up in a parched climate and still feel the heat on my neck. All too soon the grasses will dry up as quickly as they turned lush and the fog will roll in.

"You have a visitor," Rita says, pointing to a tendril that has poked through a crack in the baseboard and wrapped itself around one leg of my magazine rack. Hello jasmine.

In *Green Thoughts*, Eleanor Perenyi writes about a plant-gathering expedition made by Lawrence Johnston. "The trip killed Forrest and almost killed Johnston, who was taken ill and had to come home before it was over. But he brought back valuable seeds and living specimens, among them two mahonias and *Jasminum polyanthum*, beloved of all gardeners in warm climates."

I wager the jasmine found its own way into Johnston's suitcase. Yes, it is beloved, fragrant, floriferous, pristine as a princess but it has a soul troubled by craving. Perhaps in my raspberries it will find fulfillment and end its non-stop wandering.

"It's a national epidemic," Rita continues.

"Jasmine?"

"Whining. I told Rick right off. In my house there's a law: whine during the whining hour, 4:30 to 5. After 5 it's over."

"What did he say?"

"That's only a half hour."

The sun flashes into the room, a blast, a fanfare. Rita and I stand simultaneously, as if summoned, and move toward the door.

"Jasmine is the smell I associate with spring," she says. "You probably think of lilac because you're from the Midwest."

"Right. I dated somebody once who said jasmine smelled like burning rubber."

"Not for long, I hope. What news of your latest?"

We step outside into a blazing brightness, each blade and leaf studded with light.

"Party's over."

Rita pulls sunglasses out of a shirt pocket and puts them on. "When Hank and I broke up my therapist told me what I was really feeling was humiliated."

"Yes?"

"The point was, don't feel sorry for yourself. But you don't seem to be."

No torrent there is like craving.

– Sign nailed to a tree at a Buddhist temple

Not at the moment.

"Have you ever seen anything more gorgeous?" Rita points to the water-beaded burgundy leaves of my purple smokebush. She doesn't remember dumping it at my door two falls ago, having never removed it from its five-gallon container. It was peaked, its foliage adrift with mealybugs. I accepted it with as much graciousness as apprehension, knowing what it might become.

Compost-enlivened soil, regular water, and occasional splashes of fertilizer did the trick. I washed off the mealybugs with an alcohol solution. They eventually disappeared as the plant got stronger. Last fall I pruned it nearly to the ground in hopes of forcing a surge of new growth. It worked. The leaves are heartier for it. Before long they'll be as wide as my wrist. The bush blooms better when the soil is on the meager side, but I'm more interested in the leaves, so I feed and water regularly. What I feel for this plant is more than a crush—it's an appetite.

I'm thinking about planting a row along the upper walkway. I hesitate only because I don't know how they'll withstand sogginess.

"*Cotinus coggygria,*" I inform Rita. "This variety is called 'Grace.'"

"After the princess, no doubt. I've got to have one."

There was a cotinus, a green-leafed variety at my uncle's farm in Kansas when I was a child. In late summer it manufactured clouds of dusky flowers that enveloped the foliage entirely. The plant lasted as long as my uncle, which is to say it did pretty well given a climate suspicious of anything taller than buffalo grass. He often had more urgent concerns and watered it irregularly but it survived. Most of it did, anyway. Sections would die back and he pruned these branches with a lack of deliberation that bordered on the peculiar.

Maybe he identified, oddly pruned himself. Each decade had brought its mechanical mishap. By the time he was in his 50s he was short a hand, two toes and an inch from his left leg. "Uncle Stub" we cousins called him, perhaps also because he chain-smoked Lucky Strikes until a lung was next to go. Though he was genial, I was a little afraid of him, as if bad luck might be contagious.

Now I wonder why he planted his cotinus, where he even got it. There were no nurseries within 100 miles. His attitude toward a tree was, yes, it's good for shade but other than that, what's the point? It only blocks the view.

At Strybing Arboretum in Golden Gate Park there is a red cotinus by itself on a grassy slope, a ruby in a simple setting. It's placed perfectly. I moved mine three times before finally settling it near the back door where it gets the attention it deserves. With royalty there's always a downside: the tendency to dominate. I haven't figured out what to plant around it that won't look abashed. It helps to have two or three other plants with a compatible redness within view, which I don't, so I've sent away for a catalog from a nursery that sells a red columnar barberry, as well as varieties of cotinus with which I'm unfamiliar.

In fall the leaves will be flecked with oranges and reds, cameos of sunset, before they turn ashen and droop. Not a pretty sight, so I spend five minutes every year relieving the twigs of this sackcloth. Would that life abide by that ratio: ten months of bliss, five minutes of penance, two months of hibernation.

"I'll pick one up for you at the nursery," I tell Rita, deciding to get a few more for myself.

Out of the fountain of delights rises a bitterness that chokes them in their very flowering.
— Lucretius

Rita's gone home. Through the latticework fence I can see her yellow gloves at work. I direct my own pruning shears toward the jasmine. The explosion of white flowers that began in February has faded, so it's a good time for a haircut. Beloved? It wears off. My jasmine is climbing three miles per hour up the telephone wire stapled to the side of my house. I use pole pruner to snip the stems off, resigned to the day when I once again sever the wire. I tore it once by yanking, though I learned something in the process. The elasticity and toughness of jasmine stems make them ideal for those small tie-up jobs in the garden. Cut eight inches or so of a semi-woody stem, tie a half hitch and snip off the excess. It'll last for months, about as long as a green plastic tie, and it's much better looking.

And for all this nature is never spent;
there lives the dearest freshness deep down things.

— Gerard Manley Hopkins, *God's Grandeur*

Many fresh blossoms remain on my jasmine vine and I stick my nose into each of them. Burning rubber? Not by a mile. The drops of water that slide down my cheekbones into my mouth are so sweet I lean into the vine and lick the water off the panicles one after another.
"Can I ask what you're doing?" Bertie is standing at my south fence, looking over. "No, don't tell me. Can I borrow your long extension cord?"
This can only mean one thing: some kind of racket.
"I lent it to Rita," I say. "You can get it from her."
"Hmm," Bertie grunts and disappears.
I know he doubts me but he won't ask Rita. He's terrified of her. Whatever works. The victory will be short-lived, though. I only hope it lasts the day. Bertie's red Mazda is already pulling out of his drive, bound for Home Depot.
My shears slip through the network of jasmine with a satisfying resistance. It's far too easy to cut back the vine too much, rationalizing that one will then need to do it less often, and end up with naked patches. Pruning regularly one can avoid this, as well as the development

of a heavy-headed thatch. But it's easy to get behind and then ruthlessness is necessary.

Clean-up is a breeze, almost a pleasure—nothing in the cuttings to poke or prick or jab. I press the tangle into the garbage can to carry to the street. My own compost bins are too full. The green recycling bin streetside is a boon, a great leap forward in civilization. The city empties it twice monthly, and I have it full each time. No longer do I fill plastic bags with organic matter that gets tossed into a dump.

Task complete, the jasmine trim, the garden itself seems a banquet. The cherry trees are in bloom. Above a pool of forget-me-nots, orange and pink Darwin tulips clash triumphantly, just the effect I hoped for. Must I sober up and reflect how far behind I am with weeding? I don't.

A garden inevitably becomes a calendar. The roses are in bud. My sweetheart is "my latest," but for now it's enough that my house is dry and my garden roars into spring. I don't say this lest the gods hear and make mischief.

Somehow I thought that a garden would be a prelude to happiness.

– Edna O'Brien, *Happiness*

Too late. Walking down the front steps I immediately sense something amiss. There's more sunlight across the steps, a gap in the arboreal canopy. A limb of the Monterey cypress has fallen like Zeus to bestow an inappropriate embrace upon my apricot tree. The apricot staggers under the weight. The middle of three camellias is crushed, possibly another as well—I can't tell because it's under the cypress foliage. Earlier this spring these camellias, hybrids called 'Baby Bear,' were covered in small, pink flowers, a sweet match for the blossoms of the apricot. Pink on pink in spring, bright yellow apricot contrasting with deep green camellia in fall—both good combinations. Obliterated.

Should I mention that there are a dozen hellebores mashed? That a lamp along the walk is hanging by its wires? That the fence is broken? Is it 4:30 yet?

Most annoying of all, there's a crack in the PVC pipe. These things are no fun to repair, requiring coupler, glue, hacksaw and particular patience. None in stock. Bertie has the stuff and it's the kind of job he loves. I'm halfway to Berties's door when it starts. The blower. Everything is sopping—what can he be blowing? He's doing it to let me know he can. Rick is right. A half-hour is not enough.

Spring

PUTTING MY FOOT DOWN

Finding a place for her wineglass amid the amethyst crystals on the table, Vikki takes me by the hand. "You have to see my garden now," she says, and leads me down the back steps. With a beatific look she awaits my approval—but everywhere I look I see bugs. Her garden has more plagues than plants. Naturally, the lemon tree has scale but it has mites too. There is a sort of cyst on the bark of the brugmansia that, when punctured, oozes albino worms. The iris has whitefly. Thrips darken the undersides and glaze the tops of the rhododendron leaves. Mildew withers the rose tips.

Against my better judgment I point out the problems. Vikki looks stricken. "Maybe you're not watering enough," I suggest. "We've had a lot of hot weather already this year."

"Luisa waters twice a week," Vikki says. "You told me that's how often you water."

I tell her that when I go to the hardware store later I'll check the "Problem Solver" about the weird white worms. It's the least I can do and the most I will. There's too much history of me coming to the rescue. This time the someone doing the something will be someone else.

If Vikki's garden were mine, after improving the watering practices (how could Luisa spend enough time, thumb over the hose nozzle, to give the plants an adequate soaking?) and beefing up the soil, I would start a regimen of sanitation spraying with soap and oil sprays. Three drops of liquid dishwashing detergent and three tablespoons of vegetable oil per gallon of water with a dash of baking soda might help with the mildew. Horticultural oil also discourages thrips and scale. As for mites, keeping leaves clean lowers the risk of infestation. A spritz of water on the lemon tree would help do this, as well as knock the resident mites off and raise the humidity. Mites don't like humidity. As for the worms, scraping them into a plastic bag and disposing of them seems the best, though distasteful, solution. If these mild remedies didn't work I'd think about euthanasia.

But I don't recommend these measures when I tell Vikki I've found no information at the hardware store. I recommend calling a professional.

"Aren't they expensive?" she asks.

Do I point out to her that at this moment there are $50 worth of dead and dying annuals on her patio, never having made it out of their

plastic six-packs, and that this is usually the case? I do not, bypassing a prolonged sigh, thus affecting by not affecting the arrival of the monsoon in southern India.

I come home to my garden with a feeling of relief and superiority. It's pest free. I never spray the roses with anything but water. None of my plants has scale, not even the lemon nor the abutilons. I think it is because of the compost I use.

There is a green gene, a magnetism to the chlorophyllic, which Vikki doesn't possess. She's got the shopping gene. I don't go shopping with her often but when I do I have a good time, and often a revelation or two. For instance: there are items at Target that I might want to buy.

For Vikki, spending money is a chore to brave like a trouper. By contrast, I really am cheap. To fill space, I've lifted and divided plants I don't even like—even agapanthus. Far too many populate my garden, awaiting roundup by the taste police. I'm as bad as Aunt Dot with her pelargonium cuttings. I still have a lot of those, too.

But I've gotten better. The three *Cotinus coggygrias* I bought in late winter along with an assortment of perennials make a broad, handsome swath of burgundy and violet across the slope near my apricot tree. It's a radical departure from my some-of-this, some-of-that aesthetic, and it is already a knockout. It will only get better as the plants grow and fill in. I am following the advice I gave to Vikki: plant three or five or more of one thing.

While I congratulate myself, I am reminded that self-satisfaction is not unfamiliar. Five years from now I may well be asking myself the same question I asked when I prepared this bed in spring, breaking a shovel in epic battle with an octopus of an agapanthus: how could I have been so dumb as to plant this?

May God defend me from my friends: I can defend myself from my enemies.

—Voltaire

My garden is not completely pest free: there are snails, naturally. Detested as it is, there's no denying that the snail, cartilage in a camper, is something fabulous. I'll never forget watching a documentary that showed snails mating. "Nymphs and satyrs copulating in the foam," to borrow a phrase from Yeats. Oozing, bubbling, frothing, slobbering, sudsing in liquid joy.

And (snails have all the luck) the nymphs are satyrs and the satyrs nymphs. They're hermaphroditic. "During the mild, moist spring nights when brown garden snail copulations occur, the partners first erect the anterior part of their bodies and slowly and firmly press their foot soles together. Then, after each injects a copulatory dart into the other, actual cross-fertilizations occur." PG-13 material, at the least, from *Rebugging Your Home and Garden*, by Ruth Troetschler, et al.

The products of this lubriciousness are multiple: about 60 to 80 junior gastropods per mating. I don't know how many matings occur each spring–certainly enough to keep snail-bait makers in gravy. I use bait occasionally. One recent night after work I sprinkled the sawdusty stuff around the lupines in the flowerbed near my back door. The metaldehyde in it paralyzes the snail and the snail dies from dehydration.

The next morning I heard a rapping on my porch door. "I thought you knew better," Rita said by way of greeting. On the flowerbed in the bright sun, near some ravished stalks, were four sputtering, sizzling snails.

I know this: I have tried other methods. I've roused snails from their bivouacs in the agapanthus, along the fences, in plastic containers. I have flung them, squished them, gotten them drunk, flattened them underfoot, tossed them next door into Bertie's ivy. Inevitably I relax my vigilance and this happens.

"Just once I want a lupine to flower," I explained to Rita. "That's all I ask."

"Then why throw that shit right on the lupines? Don't you get it? It attracts snails. Do you think they're going to avoid the lupines to get the bait?"

"I wouldn't have to use this stuff," I countered, "if my neighbors did something about the snails in their gardens."

"Meaning me, I suppose."

"Meaning Bertie and you. Him with his ivy and you with your holier-than-thou attitude. You don't expect me to open the gate and let the deer in so why should I let the snails wreck my garden? The snails aren't native. If God didn't want them here why should I?"

"Holier-than-thou. Holy cow. Look who's invoking God. God didn't exactly make you out of the local mud. What are you going to do, stand here and watch the agony? At least put them out of their misery."

Yes, it was stupid to put bait right on the lupines but I won't be browbeaten. Rita's stance of nonaggression is fine for her paltry garden under her redwood trees. Should Vikki embrace her albino worms?

While I use the "nonnative" argument against Rita, I don't really buy it. Gardens are not "natural" except in the sense that they exist.

They're like novels—the thrust of the endeavor isn't to countermand Nature but to do her one better: let's create Japan in Cleveland, Arcadia in Wales, Versailles in Versailles.

Periodically, Rita complains that such and such isn't doing well in her garden and the next day she is asking if I have a spot for it. I'm sure I would fare no better in the battle for sustenance under her redwoods. "They own the place," she likes to say. I know who owns the broom. "There," I said, grinding the snails under my sole. "Feel better?"

Summer

EXTRA SENSORY

Rita and Rick have been back less than an hour, but the enthusiasm with which I attend to her rhapsodies on gardens in the Cotswolds has already evaporated. *Purveyors of Chocolate to the Queen* is emblazoned in gold on the box she brought me as a present. I break open the cellophane wrapping, ease off the lid and select a dark, chocolate-coated morsel embossed with a thumbnail crown. I pop it into my mouth.

"What is this?" I say, spitting the mess into a napkin. "It's terrible."

"Glad you appreciate it. There's a diagram on the lid," she says, snatching it. While she studies, I sample another piece. Just as bad.

"The first had a lavender filling," she says.

"What about this?"

"Violets."

I like flowers. I love chocolate. But I don't like flowers in chocolate.

"My mother had lavender tea whenever she had a headache," Rita says. "It calmed her down. You might want to try it."

I half-hoped that while Rita was away the ill feelings between us would fade and our friendship slip back into synch. But I should have known, I did know, that reconciliation takes effort. I could have been polite about the chocolates, but when has Rita made a standard of politeness?

I could try. I spy another morsel and nibble an edge, unrolling the bit on my tongue to see if it too will tasty soapy.

"Well," Rita says, "I'm not getting unpacked sitting here. Rick's probably wondering where I disappeared to. I don't suppose you'd want to come over later and look at pictures?"

"This one isn't so bad," I say, swallowing a thimble of rosewater.

"Enjoy," she sings breezily going out the door, and I soon hear the metallic coupling of the gate latch. A vigorous pull, almost a slam. The bad taste in my mouth is not just from the chocolates.

It is one of the superstitions of the human mind to have imagined
that virginity could be a virtue.

— Voltaire

I have a French lavender, *Lavandula dentata,* in my upper garden.
It was an infant when I inherited the house. Now it is wizened and
venerable. Thwarted by soil that is brick-hard in summer and gumbo in
winter, sections die regularly. Moving it would kill it. I fiddle around
pruning it and each year the plant looks weirder. As far as beauty goes,
we've passed the point of no return. One of these days I'm going to
muscle it out, but not yet.

There are around 30 species of lavenders, with numerous varieties
arising out of lavenders' inherent promiscuity. The broad categories,
Spanish, French and English, are poetic at best. *L. stoechas* is sometimes
called Spanish, sometimes French. English lavender, the best for oils, is
called English because it was imported there. To contribute to the
confusion, the root of lavandula comes either from the Latin *lavare,* to
wash, or *livere,* to make blue.

Lavender has been used on sores and snakebites, for rheumatism,
nausea and hysteria. Herbalists claim it combats melancholy, restores
sight and sharpens memory. I can't remember where I read that. In
simpler times the pious sprinkled lavender on their heads to encourage
chastity. Claims were likewise made for its aphrodisiacal powers. And
no wonder. Imagine, sprinkling it on your head, and thinking all day
about resisting impurities, and then at sunset, in the fields by the
haystack, meeting some gorgeous muffin who smells just as delicious.
Nothing like resistance to add traction.

Lust-preventative or aphrodisiac? I'm not sure which is my goal as
I dig a hole for the 'Provence' I bought this afternoon at the nursery.
Both would have their advantages, or so it appears from the status quo.
Despite its French name, 'Provence' is kin to English lavender. The
spiky flowers of the plant protrude inches above the leaves, and smell
heavenly when crushed. If all goes well, by next summer I'll have a
three-foot violet hemisphere.

I vow to give 'Provence' a decent home with a gritty, well-draining
soil, unlike the *dentata* in the upper garden, in full sun. The more heat,
the less dampness, the better. I make no effort to amend the acidic
clay. Instead I bucket it to a back corner of the garden to dump there.
The planting medium I concoct is part commercial mix, part grit from
a delta of sand and gravel deposited in the gutter last winter, with a
sprinkling of lime, since most lavenders prefer a sweet soil. I'm guessing

how much to use, trusting the information on the container saying that 'Provence' is not fussy about pH.

The single specimen, I quickly see once it is in the ground, is not nearly enough. For 13 years there was not one, and now I am devoured by impatience to see lavender blanket the slope. I get into my pickup and head back to the nursery, lust triumphant....

There is something curiously boring about somebody else's happiness

— Aldous Huxley

By sunset, I have my field of lavender. Well, seven anyway. Planting took the entire afternoon, in the course of which I came to a realization that my estrangement from Rita did not spring from our argument about snails. I'm unhappy because she's happy. The apparent bliss with which she began her affair with Rick six months ago persists. Their trip to the Cotswolds seems to have been a great success, though Rick doesn't know a peony from a peon.

"He's really precious," Rita said and I coughed up a chocolate.

Calling it quits with my ex has not provoked serious regrets, nor do I feel particularly lonely. Why do I begrudge Rita, my best friend, happiness? What does it say that I connect more with her sarcasm and irony than with her newfound sweetness? She's being such a *schmoop*!

Thus my brain rattles as I drift through the garden, pulling weeds, snipping the tips of the teucrium, resettling an unbalanced stepping-stone. As the light fades I find myself at the blueberry patch, picking and eating one berry after another.

Blueberries were Aunt Dot's favorite fruit, which is saying a lot. When she dandled a blueberry on her tongue her face lit up with the rapture of a spelunker emerging from Plato's cave into the realm of ideal sensation. She had her share of tragedies and screw-ups but begrudge was not a word you would connect with her.

From the kitchen I take a blue bowl and half fill it with ripe blueberries. Bowl in one hand, vanilla ice cream in the other, I ring Rita's bell.

"I want to see the pictures," I say. It's a small lie. The Queen would approve.

Fall

PUDDING

There is a large tree, a liquidambar, that occupies a sizeable share of my mind these days. Its trunk is rooted on Bertie's property, its branches draped above mine. To a detached observer it may be beautiful. It might be the only thing in Bertie's garden that isn't a regular victim of some kind of electrified makeover, and I should be grateful. This fall, like previous falls, it has turned a blotchy yellow that Rita professes to admire.

"Your attitude is the problem," she says. "That's a beautiful yellow."

The color is not what I object to, nor do I mind the fact that many leaves fall into my garden. It's the way the leaves fall, detaching themselves in such measured numbers week to week that in February hundreds are still hanging onto the branches, guests that don't have a clue the party's over. By then the sylvan association is no longer maples and oaks; it is eucalyptus, avocado, Southern magnolia: the Big Messes. I tiptoe through my tulips week after week collecting leaves as three or four dozen more float to the ground behind my back.

Yes, it is a handsome tree, pyramidal, with a silver sheen to its bark. Liquidambars by the hundreds (also called sweet gums) line our streets, popular because they provide Fall Color, from banana yellow through orange and red to grapeskin purple, the intensity varying with degrees of heat and cold. I used to think that color was primarily determined by environment but there are varieties, such as 'Palo Alto,' 'Festival,' and 'Lane Roberts' that allow you to choose your disappointment. Even in Napa, where the temperature varies more than here, the sweet gum will not be a sugar maple. They are Southern natives doing a Northern job, and look homesick.

Twice recently I asked Bertie to prune his liquidambar, offering to pay half the cost to be sure he would not take on the task himself. Yesterday I called him and asked him not to prune it.

"Nature Boy got you worried?" Bertie laughed.

I told him that I had been thinking that pruning the tree might allow too much sunlight onto the azaleas below. Also, I liked the mass of color at the side of my garden, a chunk of "borrowed scenery."

Bertie responded with a snort. "Sure," he said, "not to mention that little death threat."

There was a note put in a mailbox. Was it a death threat? The slow simmer of neighborhood rumor has thickened it into one.

A few weeks ago I was working in my front garden when Carla, from the street above, came by walking her wolfhound Stella. I barely know Carla, but we found ground for conversation, commiserating about our mutual proximity to Bertie's ivied acres. I mentioned the vexing liquidambar. She lamented a redwood that had punctured the balloon of her Bay View. Property value and all. Just a neighborly, mildly malicious chat.

Not long after that conversation Bertie fired up his chainsaw. I heard from Rita later who heard from Francine up the hill that since he knew he'd have to top the tree periodically, Bertie decided to cut it down entirely.

Several doors north of Carla's house is a cottage in a copse of live oaks. The young man who lives there heard the chainsaw and rushed to save the tree. Too late. It was half dismantled. Somehow Bertie managed to deflect the young man's anger toward Carla, who the next day found a note in her mailbox. It read, "If it's OK to kill trees, then it's OK to kill people."

This little syllogism has stirred the local stew. A lot of weight hangs from the flimsy gibbet of "If." Even Rita doesn't know what to think. Do we have a Unabomber in the making or a welcome idealist? Is idealism welcome? What does it mean? Save the rain forest? Not right now, I'm busy urging my neighbor to dispatch his liquidambar. It is dropping leaves on my tulips.

Our little neighborhood skirmish is typical, says my friend Caleb who works in the mayor's office. Trees are the number one source of conflict in Berkeley. I don't know what this says about us except we treat trees like family members.

"They are family members," Nature Boy would no doubt say.

A fool sees not the same tree that a wise man sees.

– William Blake

Preoccupied, I have been lax in tending my garden. Each year I think that late fall will bring a lull, an inlet of reflection in the flow of work to be done. In fact, there is an upsurge of tasks. (We won't mention leaves.) All of the less-than-glorious nooks of the garden which lush foliage made atmospheric now show their morning-after face. Time for clipping and shaping and thinning and weeding and planting and deadheading.

Before I do anything, I take another long look at the liquidambar. The leaves, I had not noticed, have daubs of orange and red. Innumerable seed balls dangle from twigs. The older bark of the trunk is fissured, scaly. The newer bark is gray and semi-glossy. Woodworkers call the wood "satin walnut." Dyed black it resembles ebony. Along the trunk in several places sap has congealed into the substance that gives the tree its scientific and its common names, liquidambar, and sweet gum. This resin has been used in medicines, as perfume and incense.

I begin to see a tree that is "beautifying by its growth the landscape of which it is a part" (Julia E. Rogers on liquidambars, in *The Tree Book*.) An estimable tree. But I still wish it were 30 feet farther north.

Getting to work at last, I go like a dervish. The evening light, its honeyed luxury, is intoxicating one hour, but in the next reveals a hidden message, a memento mori. A little death threat. Time is running out.

A good scare, someone said, is worth more than good advice. I am reminded. Notice. Be grateful. If you have any doubts, look at the 'Hachiya' persimmon near the fence. Here is a tree I can't imagine stirring contention. Well-mannered in all aspects, in the fall it becomes a flash of glory, the orangeness of the leaves competing with the orangeness of the fruit to be the perfect orange. It is like having a stained glass window installed in your living room. Once the leaves have dropped, the fruit hanging on bare branches is a spectacle of oriental delicacy to which you succumb at some risk. Just when the persimmons are finally ripe raccoons strip the tree, not necessarily just of fruit. One year the marauders left substantial branches littering the ground. So now I pick all the fruit before any hint of softness, while they are still full of the tannin which traumatizes the taste buds of humans and raccoons both.

Why not pick the fruit today? I count 24 before I begin. Some I may let ripen and then freeze, to eat like sherbet. Others, I'm afraid, may ripen beyond soft and luscious into inedible goop unless I make persimmon pudding, which is a double delight: easy and delicious. I must ask my friend John what kind of whiskey his grandmother uses in her recipe.

Picking fruit is calming. There is nothing to be ambivalent about, except that I am finished so soon. As heavy as three apples, the persimmon is satin in the palm.

Soon on the wide windowsill is a large platter with a choir of twenty-four, their song of simple gifts, their destiny pudding.

Spring

99 STEPS TO EASY PRUNING

The flowering plum in the curb strip near my garage is remarkably unremarkable, like the dozen or so that line the street as it curves up the hill. Except when it is in bloom, I have paid it little attention for the last 10 years. Until a few years ago, it had a mate 5 yards to the south, evidence of which can be seen in its northward lean. One morning I found the mate ass-over-elbow, a victim of a hit-and-run. It was not a stripling, and I only hope it gave as good as it got, but I can't say that I went into mourning upon its demise.

Now whenever I am walking down the steps toward the garage, my eye is drawn to where it never bothered to go before. The remaining tree is so out of balance. There my gaze went this morning, with an unexpected result. The venerable tangle of plum branches, thanks to a couple of sun-splashed days, is once again decked out in debutante pink, trumpeting spring. Aroused, I decided to cut a few branches to bring indoors but instead I was struck by a vision: a plum tree so brilliantly pruned it would usher the curb strip into the embrace of the garden. Welcome Cinderella.

I might have had this vision years ago. At the least I should have had it last month, since it is better to prune when the tree is dormant, but you can't schedule visions. Nor can you schedule a flawless day like today when the sun tickles a whole keyboard of urges.

I'm not a master pruner, but I have learned enough to avoid major embarrassments. Here then are some tips.

(1) Have the vision. This means you probably have the energy to pursue it. My vision, thus far, is long on atmosphere, short on details. "I learn by going where I need to go," a line of Theodore Roethke's, is a good description of my method.

(2) If you don't have good tools, buy some. Really good tools. Without them there is no chance of doing a first-rate job, or of enjoying the process. You need only a few. I will mainly use clippers, loppers, and a curved, foot-long pruning saw.

(3) "If you need to climb a ladder, hire a professional" is sensible advice I don't follow. I should not have to climb higher than the third rung, in any case. If your ladder is on its last legs, use common sense.

(4) Study the tree from all possible vantages. Is the desired form weeping or vase-like, open or dense, wind-swept or tight as the bun on

my Aunt Ida's head? With my tree, any of these seem to be possibilities, and so I begin confused. What is clear is that I must simplify the dense, irregular tangle of branches and twigs that shoot off in every direction.

(5) The beginning position for the ladder is at the center of the tree. (6) While standing on the first step, test its stability. Don't wait until you are on the top step to discover one leg is in a mole hole. From the center of the tree (7) prune outward, beginning with the small branches that grow inward.

(8) Step away from the tree and circle it slowly, on the lookout for larger branches that can be removed, i.e., ones that overlap each other or that disrupt the graceful flow of lines. Typically I am pruning toward a look that is open, "natural," the kind of pruning that doesn't draw attention to itself. Half-dome this will not become.

(9) Before cutting visualize as well as possible the selected branches gone.

Rethink. Are you sure? (10) Remember this rule. When in doubt, don't. Of course if I take that literally I'll get nothing done, so, still in doubt I (11) remove some of the smaller branches from the larger, targeted ones, which gives me the courage to (12) begin removing the larger branches. I do this by first sawing through each branch six inches outward from where the final cut will be, thereby removing most of the weight. This makes the final cut a lot easier.

(13) Notice how your saw cuts. The Japanese pruning saw I use, and perhaps the one you will use, gets its bite from the pulling stroke. Don't force the stroke or you'll break the blade. Let the saw do the work. You'll go only marginally faster if you press, and wear out your arm in the process. When the saw binds, use your free hand to bend the branch and shift weight away from the cut.

(14) Make the final cut almost flush to the larger branch. Leave a nub, a small collar that contains healing chemicals. (15) As the saw glides near the breakthrough stroke, ease up so that the saw doesn't lurch and gouge your other hand. (16) Make sure there is an intervening branch between your sawing hand and your supporting hand and wrist to deflect the saw as it cuts through. (17) Removing the cut branches, you will be tempted to yank. Yanking is a good way to get a poke in the eye or snap other branches that later on you may wish were still in place. Instead follow the branch outward and cut it into smaller pieces that can be withdrawn with less resistance. Once that's done, (18) step back, observe. Take note of branches that overlap, are redundant, and (19) remove them. (20) Step back again, observe from all angles. Perhaps the view from the second floor of the house would be helpful.

As the tangle of branches becomes simplified, look for infelicities: watersprouts (new growth that shoots skyward), bristly wens, dead stubs. In a young plum watersprouts can grow two inches thick and twelve feet long in one season. (22) Get rid of them, (23) paying attention to each cut. (There are so many you will want to hurry.)

By now you've been working on this for over an hour, and your vision is still unachieved. (24) Don't hurry.

(25) A good way to slow down is to get off of the ladder and collect the cuttings. You'll also be removing a potential hazard. You might have done this sooner. (26) One more thing to resist, the illusion that you are nearly finished. The tree is looking much better but there are at least a hundred more cuts to make. The outer branches are still far too dense and too long, the inner ones a thicket. (27) Move the ladder and begin thinning them. This is tedious. When impatience nags again, (28) put your tools down. Enjoy for the first time the candy-sweet smell of the flowers. (29) Step back and observe, again and again, every time you make a half dozen cuts. What was that vision you had? (30) Reposition the ladder as often as necessary to make the cuts. No acrobatics.

(30) Review number 16. (31) Put on gloves. This should have been step number two. (32) Have Band-Aids available.

We learn from experience that men never learn from experience.

– G. B. Shaw

I know that my wound is minor, a slit on the fleshy pad of my thumb, but it is bleeding with a disproportionate eagerness. It can't be ignored, nor can my neighbor Bertie's red convertible nosing out of his garage. I put my bleeding hand behind my thigh as the Mazda comes to an idle along the curb.

"What are you doing?" he asks.

"Ikebana."

"Go a lot faster with a chainsaw," he offers. "Mine's in the garage. Door's open."

The shredder scene from Fargo, which I rented a few nights ago, pops into my mind.

"I'm almost finished," I say to cut this short. The trickle of blood running from my hand is making scarlet explosions on the mud.

"Don't let Nature Boy catch you," Bertie says.

"I'm not cutting it down."

"Better if you did, if you ask me. And you can get rid of mine while you're at it."

When he drives off, I gather my tools, and climb the stairs to the house. The bleeding has stopped already, so I pause for a moment. Two hours ago the morning felt generous with expectancy, an invitation to a ball. Now what's so irritating? Bertie, of course, a master at irritating. And gashing myself, the way I so often lose my patience and go dim. Third, maybe worst, not achieving anything near my vision. Look at the tree. Cinderella? More like Phyllis Diller. I console myself that the tree in its eager pinkness is pretty enough, and that even a master pruner couldn't have achieved perfection in one season after so many years of neglect. Mastery takes time.

And in this, my consolation, lies the problem. My perceived lack of mastery kicks off a telethon of self-criticism. Soon my whole garden seems rank with disappointment, failures. Oxalis, this year as always, has outlasted my will to yank at it, and is celebrating its victory with yellow banners. The rose bed at the base of a low rock barrier seems swampy out of sheer intent to hold water. I can practically hear the plants begging for air, the humus of the soil sucked into the omnivorous clay, much like my sense of well-being. Spring returns like a lover gone too long. The exhilaration of reunion evaporates, and the hard questions surface. Where were you when the roof was leaking?

...proud pied April, dress'd in all his trim,
Hath put a spirit of youth in everything.

— Shakespeare, *Sonnet 98*

One pint of Rocky Road later, my cut clean and dressed, the fit of self-criticism has run its course. The day's beauty, just past noon, is not merely restored, it's heightened, the sky a blue to dip the soul in.

I inspect the plum tree to see where things really stand. The finer branches at the top are still too long and need to be snipped. Here a pole pruner is necessary since many of these branches are inaccessible otherwise. (34) If you don't have patience to do all of them, do the

ones that are really out of scale, jutting up much higher that the main scaffolding. You'll find that this task goes a long way toward satisfying you enough so you can stop for the time being. And stopping is the right thing to do, because it is better to prune a neglected tree over a three-year span so the tree can gradually adjust to its new leaf mass (steps 35-99.)

And so the next two winters I will prune again, but I will also prune lightly in summer. This won't stimulate growth the way winter pruning does, thereby lessening the number of watersprouts.

As I circle for one last look, at certain angles certain angels appear, and behold, a vision. When I move to a different vantage I see cavities, confusion, stepsisters in nightgowns.

Does it matter? Of course it does. The idea of a garden is to create, if not paradise, a work of art. I have done a serviceable job. I'm not sure about much else except I'm neither satisfied nor finished.

Next year, perhaps.

Summer

SHOCK ABSORBED

Normally I would have said no when Phil asked me to a meeting of the Orchid Society. Orchids have never made a deep impression on me. Though their attractions are manifold, my heart stays put. But I accepted, needing a change.

Tables festooned with orchids lined a wall. The atmosphere was genial, epiphytes and neophytes equally welcome. In the first hour of the meeting the chairman moved from plant to plant, lavishing praise. From the size of a dime to a keepable crab, from creamy translucence to near black, by any standards each was exquisite. My heart began to melt a drop or two. All were lauded but only a few managed to set the room crackling with wonder and envy, and it was soon clear what was lacking in the others: novelty.

"I've got to see the one from the Andes," Phil said slaloming through the folding chairs after the meeting adjourned. I tagged along thinking I might learn something. The "one from the Andes," the smallest on the table and certainly the most homely, was already the center of a buzz. Magnifying glasses emerged. Questions arose as to how the plant was lassoed, through what intrepid expedition. No expedition, the Internet. Enthusiasm hit a downdraft.

"I'm pretty sure that's the same orchid that grows all over Costa Rica," Phil said as we left the meeting. "It's not a bit rare."

Once upon a time I may have said that neither novelty nor rarity is the point, that a plant's intrinsic merit should speak for itself. Now I ask myself, what is intrinsic merit? Behold the calla lilies of the field, scorned hereabouts as too easy, too common, yet selling by the stem for a bundle in New York. Behold agapanthus, trailer trash of our freeways; how the English extol it. And somebody somewhere is in raptures over Algerian ivy, to whom it's virginal as a nymphet, unsullied by prior association.

"As we age...we become less open to someone else's novelty," wrote Robert M. Sapolsky in a *New Yorker* essay. No wonder. The cultivation of novelty takes energy. Novelty is eye-candy, a sugar rush more cotton candy than all-day sucker. It evaporates as it is experienced. When novelty fades, rarity buffs the thrill, especially if mulish difficulty is involved.

Take Phil. For me getting my hillside clay amended to the point that I don't have to engage in a muddy tugfest for the shovel is difficulty

enough. Phil had a situation like mine, hard clay and numerous steps from where deliveries arrive to where they are destined. He didn't amend the soil of his garden at all. He removed it barrow by barrow and replaced it with an acidic, finely draining medium of bark, peat, perlite and "fairy dust" to grow Vireyan rhododendrons and a host of other tropicals whose names I've forgotten repeatedly. The effect is voluptuous, especially on warm evenings. The rhododendrons are his great passion. Cupping a particularly vivid blossom, orange as a clivia, he'll say, "This one is extremely rare. Very tender. It's from a mountain in Borneo."

In truth, all of them, the yellow ones, the red ones, the pure white ones, are rare hereabouts, and all of them tender. Every dozen years or so an Arctic blast turns them to gray mush. This has happened to Phil's collection twice, but undaunted he continues to put them into the ground, to exchange cuttings and seeds and pollen with fellow enthusiasts. They remind me of the bibliophiles in *Fahrenheit 451*, committing imperiled books to memory, because invariably these days the word "rare" is followed by "and endangered." As habitats are destroyed collectors become curators of plants and plant knowledge, islands of refuge.

But I don't activate the appreciative aspects of my attitude toward plant collectors when Phil visits my garden, when he floats along the paths, his eyes vacant. I anticipate approval ("What a gorgeous combination of begonias and browallia!") but it is neither withheld nor forthcoming. I'd settle for attention ("Look at all the lemons!") but I have no rare rhododendrons, no rare anything. Through his eyes I see leggy pelargoniums, ordinary pippins, the (can you believe it) agapanthus. I could do some subtle begging but I'm too proud. Do I secretly, ever so slightly, wish for a good hard freeze? No, I remember what happened to my lemon tree...was it 1991?

"Aren't there things that just have to be thrown away?" I ask.
"There's no such place as 'away,'" he replies.

— William Bryant Logan, *Dirt, the Ecstatic Skin of the Earth*

At a party recently, a stranger said, "My garden teaches me generosity."

I asked what he meant.

"The flowers make so many seeds, more than they need to, more than my garden could accommodate."

I said you could call that ruthlessness, an attempt by one plant to smother its neighbors. Peace and harmony are the byproduct of a universally shared will-to-survive. I said these things for argument's sake but there was no argument. The stranger just looked at me with a hint of condescension and drifted away.

I got that look again last night. Phil and I were having dessert, talking about compost piles. He said, "I don't have room for a compost pile. My garden doesn't have unused space like yours." Aesthetically-challenged, the implication.

"You could find a place for it."

"All my organic stuff goes in the green bin the city picks up. It gets composted." He put down his fork and gave me the look.

"But if you composted," I persisted, "you wouldn't have to bring compost in." A clear loser, this tactic. Most of what Phil grows needs a specialized medium, not homemade compost.

"I'm not trying to insult you," Phil said. "I'm just more interested in collecting. You're interested in having things to eat. It's your peasant genes. Mucking the manure makes you happy."

"Mucking the manure? You talk about planet awareness but you can't be bothered with doing the simple things under your nose. Yes, I get satisfaction from making compost. I have a garden, not an outdoor boutique."

Actually the above is a revised version of the actual conversation I had with Phil last night over dessert. We did talk about compost, and I was testy. "Outdoor boutique" came to mind this afternoon. Crankiness is not useless if your garden needs epic weeding but it doesn't help friendships. Phil, who knows tender, had hit a soft spot. The blank look on his face when he visits my garden is just tact. He's been seeing my agapanthus all along.

If we do not find anything pleasant, at least we shall find something new.

— Voltaire, *Candide*

It's true, I have not won the big battles in the design wars. Islands here and there sustain a level of satisfaction but there is no unity, no clear central concept. I got rid of four offending, huge clumps of agapanthus, but two remain, formidable. Unless I get a permit to use a wee bit of dynamite, their lease on life holds.

Elsewhere infelicities abound. As you come up the front steps, there are the mismatched lemon and cherry trees. Which can I possibly get rid of, the lemon that supplies buckets of lemons (generous!) or the cherry tree whose cherries the birds and I vie for? I remember helping Aunt Dot plant the lemon tree when I was fifteen or so. I don't know if the cherry tree was there already, or added later. One day the agapanthus will be banished, but neither of these trees will. The year the lemon tree got blitzed by the freeze I halfway hoped it was a goner but it has come back to full glory. Look at all the lemons.

I haven't given up. I enrolled in a twelve-week garden design class where I learned that what a landscape architect calls a garden is different from what a gardener calls a garden. The architect thinks design first, the gardener thinks plants. You need both, of course.

I asked the author of a prize-winning book on modern gardens why there was such emphasis, perhaps I said overemphasis, on sight, and such a dearth of touch and smell and sound and especially taste. He replied the gardens in his book were selected for their "capacity to shock." Shock apparently is the designer's version of novelty, and it too has a short lifespan. He admitted that several of the gardens featured in his book had already been demolished. I had my candidates.

I go to my garden for safety. "Endangered" is not an adjective I want to entertain there in any of its applications. A great garden looks like nature's fondest wish. In it there will always be a delectable, fluid tension between what is ancient and what is inevitably changing. In that reflective pool we see ourselves and connect.

Connection, in any case, is what I want and there's nothing like a handful of just-picked (fill in the blank) to do the trick. Strawberries, earlier this afternoon. 'Sequoia' variety. I planted them last December. Peasant genes, yessir. If Aunt Dot was a product of them, why should I be insulted?

To add the dot to the curve of the question mark, a large, lime-green apple falls upon the small of my back as I finish the last of the weeding. For about a week now apples have been falling from this tree, a 'Lodi' (I recently learned.) They fall so early in the year that you can't believe they're ripe. When you taste them you still can't believe it, so tart despite their softness. There are hundreds remaining, generous. Last year, for the first time since Aunt Dot days, they did not fall to the ground and rot. One of my sisters came to visit and left me with a freezer full of mango-applesauce, peach-applesauce, blueberry-applesauce. What was a nuisance became a bounty; what was humdrum, delicious novelty. All it took was imagination and energy.

Summer

THE GRASS IS GREENER

Up goes the nose of the plane, banking into the cottony fog and I feel a surge of exhilaration so intense you'd think I was zooming toward Kathmandu instead of Kansas for a celebration of my uncle and aunt's golden wedding anniversary. The summer I was fourteen my parents, exasperated, sent me off to their farm. "Your great-grandfather homesteaded that land," my father told me at the bus station, as if that might add some thrill to the prospect of a summer's banishment from friends.

My uncle met me at the bus station in his pickup, and his three dogs slobbered all over me as I stepped out of the truck at the farm. It was a ferociously hot day in late June, the air dense, the din of the cicadas so jangling I assumed it was part of the reformation package. My cousin Jimmy, a year younger than I but six inches taller, explained. "The seventeen-year ones, the eleven-year ones and the annual ones, all here this year."

It took a week before the sound dispersed into the daily hum. The buzz gradually went out of my delinquency as well. The simple pleasures I discovered, poking about the creek with my cousins below towering cottonwoods, or skulking around the pastures at the far reaches of the yardlight under a sky milky with stars, connected me to the place in ways that went deep.

Goodbye, fog, I say as the plane breaks into sunlight. A rainy winter, a coldest-on-record June, a foggy July....but am I really ready for the convection oven of the heartland? No expectations, I say, leaning my forehead on the cool plastic of the window.

The Kansas City airport does nothing to scuff up my good mood; from gate to baggage to exit is not much farther than from home plate to second base. Soon I am aswim in the summertime air of the Midwest. My body remembers how to sweat. "Lucky you didn't come yesterday," Jimmy says as he puts my suitcase in the back of his van. "Hot enough to gag a maggot."

Paula, his wife, settles the argument between her daughters about who gets to sit next to her on the front seat, and we set off. For my benefit, I suppose, though she hardly knows me, she switches the radio from a country to a classical station. I'm about to tell her I'm learning Western swing dancing, but a Bach piece, the *Goldberg Variations*, is playing. Who am I to complain? Some hazy clouds soften the light.

Lush, tall grass and trees thick with greenery are visible here and there, evidence of a wet summer, as we pass through suburban sprawl. Pastures and farmhouses float at a distance from condo complexes, looking quaint and doomed. I press the electric tab and open the window an inch and inhale a suggestion of cut grass, visceral despite being a mere hint. Darcy, the winner of the seating battle, zips my window shut from the front control panel. "The air-conditioning is on," she explains. Bach also appears to have been cut short, but no, the *Variations* have ended and the radio announcer breaks a thin crust of silence. "Grubs," he asks, "are they turning your prize lawn into a neighborhood eyesore?"

Not as far as I can see. Lawns dazzle, green as can be, around liquor stores, dental clinics, parking lots, under helixes and ellipses and grand jets of pearly water flung prodigally skyward. However wet the summer, it has not been wet enough to maintain lawns green as these. I start to tally the energy and the billions spent, the tons of pesticides and herbicides and fertilizers, and the armada of riding mowers ferrying posteriors that might get some benefit from a vigorous walk, and wonder why there seems to be no alternative but to produce and reproduce this banal landscape east and west, north and south.

At sunset we turn onto a straight road that has sprouted mushrooms of development. "Changed some," Jimmy says, though I'm not sure exactly what he's referring to.

"These houses look like they're on steroids," I remark, and regret it seconds later when we turn into a cul-de-sac and into my cousins' driveway. Their house has five bedrooms, four baths, three living rooms, two dining rooms and a kitchen big enough to muster grub for a regiment. "Why don't you sit on the patio?" Paula says. "Jim is getting drinks."

Given the size of the houses, the backyards are small; fenced rectangles spotted with clusters of crabapples and maples and beds of coxcomb and marigolds. For visual relief, I suppose, the lawns undulate yard to yard. Privacy and the mysteries of seclusion, the whole concept of a *hortus conclusus*, have no influence here unless you count the way the boy in an adjacent yard ignores me though we are less than thirty feet apart. He is leading his dog by the leash around the yard, trying to teach it something. Jimmy—Jim—comes out carrying two gin-and-tonics. "That's a new thing," he says following the line of my sight. "A buried line shocks the dog through a device on his collar. Keeps him from going under the fences."

"No cicadas," I say.

"Trees are too small, except for those cottonwoods," meaning some at a distance. "Tallest one on the right is where we had the swing. Most

of the neighbors wanted to cut them down because of the cotton. The field on the north sold not long ago so they're probably goners."
Now I get it, like a punch. This is where the farm was. I knew it had been sold, but obliterated? Where is the old house? Where is the creek?

Gatsby believed in the green light, the orgiastic future that year by year recedes before us.

– F. Scott Fitzgerald, *The Great Gatsby*

There is something about grass. Leaves of grass. Flesh as grass. It seems we became human at the edge of the African savannahs. The word "savannah" is easeful, but a lawn is a different thing.

Lawns are the wet dream America has about the English gentry. Featureless as amnesia, they are such a part of the domestic landscape that it is surprising that they only became popular in the 18th century, in England and France. In 1818, on a visit to America the Englishman William Cobbett lamented, "...the example of neatness was wanting. There were no gentleman's gardens, kept as clean as drawing rooms, with grass as even as a carpet."

That soon changed. Modeled after English estates, upper class suburbs in Eastern cities grew and became the template for suburban development whatever the economic level, wherever the location. Crisp as new money lawns spread westward. The house set back from the street with a lawn to show it off became the rule-of-thumb, and an industry followed expectantly. The first mower was patented in this country in 1868, the first sprinkler in 1871. From being an icon of prestige the lawn evolved into a badge of respectability. "There is nothing which more strongly bespeaks the character of the owner than the treatment and adornment of the lawns upon his place," wrote F. Lawson-Scribner, agrostologist for the U.S.D.A., in 1897.

Shame on shagginess. Could he time-travel, Mr. Lawson-Scribner would have to conclude that Jim and Paula are specimens of a very high order of humanity indeed. And so are their neighbors, and the liquor store owners and the custodians of the outlet mall. An ecologist in Denver recently recommended to his fellow Coloradans that they value dandelions as any other edible vegetable. I doubt the lawn cop on his ten-horsepower engine with his *Round-Up* will hear the call. He believes in the green lawn, the orgiastic future that year by year reseeds before him.

Most of the dandelions had changed from suns to moons.

— Vladimir Nabokov, *Lolita*

I didn't get over the shock that the farm was gone. Throughout the anniversary festivities a little ticker ran in my head, what a shame, what a shame. When I got home, I called Rita. "I told myself, no expectations. I guess I had some."

"Expectations are best seen in the light of disappointment," she said.

"I didn't notice anyone else missing the old days. Maybe my uncle, but he's always been melancholy. I wonder why there's such sameness."

"Conformity. Everyone with their patch of grass is saying look, no need to be afraid, I'm a sheep just like you."

I proposed that humans also hanker for tranquility, for a place where things are under control and expectations are satisfied; the green green grass of home. Naturally the byproduct of that desire is artificial. We might acknowledge that our own gardens have next to nothing that is not an imposition on the landscape, and little that is native.

"Right," Rita said, "your lawn for starters."

Sheepishly I acknowledge that I too have one. Lawn is too genteel a word for the would-be oval, my ragtag mix of grasses, some volunteer (Bermuda, St. Augustine), and weeds. Since much of my upper garden is developed around it, including the watering system, I've kept it. Through the summer I mow it regularly, edge it occasionally, water it guiltily, and would ignore it more than I do if the Bermuda grass would stop colonizing. How did these varmint grasses get in?

Suns become red giants as I range the limits of my imagination to see if there isn't something better to be done with my garden's sole patch of Kansas. I have one idea. A weed with velvety, triangular leaves, a creeping veronica, I think, has colonized a patch to a radius of three feet. When I first paid it attention three months ago, it had already spread to this extent, and I spent the better part of a lousy afternoon trying to tease its roots out from the grass it was overwhelming. Since then I've had a conversion. The weed is actually prettier, greener and by the looks of things tougher than the grass I was trying to foster. It even has minuscule, royal purple flowers. The mower clips it readily and neatly, and from the looks of things, it won't annex the world. Fescue rescue no more. I am making a place for my weed, cautiously, vigilantly.

How is this so different from my cousins' labors? This morning an emerald-throated hummingbird alit on a fuchsia twig an arm's length away from me and eyed me with a cool degree of curiosity. The saving difference, I like to think, between my artificial landscape and Jim and Paula's is that, even if it were hardy, this ancient, leggy and mite-bothered fuchsia wouldn't have a chance in their suburban "example of neatness," nor, consequently, would the hummingbird.

I moved closer; it flew off. What did I expect?

Winter

HEDGING

If love is giving attention to something, as Simone Weil proposed, then my neighbor Douglas loves boxwood, or geometry, or both. The six-foot high, four-foot wide hedge that shields his front garden from the street has always been so exact, so perpendicularly precise all thirty feet of it that I often found myself wondering how his kids turned out.

Two months ago one of them knocked on my door to tell me Douglas was going to Arizona for a few weeks for the birth of his first grandchild. I was puzzled by Matt's visit. While Douglas and I have been neighbors for a dozen years, our exchanges curbside sandwich low-calorie fare. He will remark about cars on the street that don't belong, streetlights that burn out. I will vainly scour my brain for an offering other than the weather, then give up. "Cold enough for you?" I must have asked three times already this rainy season, a simpleton to myself. Both of us are sickened by recent politics. What remains? Religion? Can you love thy neighbor when you don't have two cents' worth to say to him? Matt apparently thought so, and I crossed the street to bid farewell.

It was the first time I'd been in Douglas' kitchen. Perhaps it was the domestic intimacy—Matt and his very pregnant wife Jane at the table surrounded by the breakfast dishes and Douglas, head wreathed in steam washing some cups at the sink—that prompted me to say, "I'll keep an eye on the house."

"Good," he said. "Make it look like somebody's around."

A week later at dusk, uncertain of what I volunteered to do, I pushed open Douglas' garden gate. Bells tinkled overhead. Triplets stood at attention, three boxwood globes on either side of the front door; three yews on the south flank; three junipers flattened against the north garage wall thrusting pompons forward, cheering this lost cause. Except for citrus in pots on the patio, two lemons and a kumquat (a gift, no doubt,) the clipped symmetry was inviolate.

My spirits drooped. Perhaps because it was nearly dark (was there a streetlight out?) I felt like a prowler. The cumbrous yews reminded me of the gumdrop junipers of the prairie cemeteries where my grandparents are buried, row upon row baleful as the tombstones themselves. I returned hastily to my garden, thankful for its delinquency.

Two months have passed with no word from Douglas. Blatant as a marine in drag, the hedge sports a chartreuse shawl. It's an improvement. Spangled with raindrops after a nighttime rain, the green ruff verges, trembles on the edge of being truly beautiful. Douglas will hate it.

I consider doing some neighborly trimming but I know this feeling for what it is: madness. Patience in that volume is not in my catalogue of virtues. When in my garden I do the semi-annual shearing of the four half moons flanking my stairs (overdue), I always begin flush with attention—put to immediate use untangling the cord for the hedge trimmers. Why bother? Its teeth long ago lost their bite. Oh well, shears will do but they too need sharpening, which I can do. When I at last get to the job I'm already bored, and by the halfway point —two down, two to go— I am elsewhere, any elsewhere. At the Chateau of Villandry there are 17 miles of boxwood. Surely, I tell myself, I can manage another 15 minutes of attention.

One can always be kind to people about whom one cares nothing.

– Oscar Wilde

I settle for giving Douglas' patio a careful sweeping. Just as I am finishing I hear bells. Douglas! I am delighted at the timing, caught in an act of virtue, but the warmth with which he greets me astonishes me. He clasps my hands in his as the bells tinkle an encore. "Meet my wife Elaine," Douglas says, beaming at a tall redhead whose face is a study in *savoir-faire*. "Isn't she gorgeous?"

"We eloped," she reveals. "We were very naughty. We tied the knot onboard ship near Bali. You're the neighbor with the fabulous garden. I can't wait to see it."

I think I mask my surprise. Elope? Douglas? Does he really think I have a fabulous garden? Has he ever seen it?

Not having had a lick of luck in romance in moons, I have no affinity for schmoopiness, and when two days later I notice the hedge is restored to trim, I feel oddly content. I read it as a sign that I can once more slip into the background. Then the phone rings. It's Elaine, asking if I am busy. Caught offguard I say no, and she asks, can we come over and see your garden?

53

They arrive bearing two bottles of champagne, and before the first is empty I have agreed to visit them next week and offer suggestions about their garden. When Douglas steps inside to get the second bottle, Elaine sidles up and in a throaty whisper says, "Suggest we get rid of the boxwood. It's oh so boring. Have you ever noticed on warm days how boxwood smells like dog piss?"

I hadn't.

"It does," she insists, "dogs think so too. That's why they're always lifting a leg in its direction."

...Box, with its low-key, year-round greenery and unobtrusive flowers, requires a calmer, more discerning eye.

— Katherine Bradley-Hole

"I think it's boring, too," I assure Elaine.

"What's boring?" Douglas calls from the back door, his hearing as sharp as his hedge trimmers.

"Weeding oxalis," I say.

"What's that beautiful clover everywhere?" Elaine exclaims, thinking she's furthering the change in subject. I don't respond. Her attention has already veered off. "Look, a hawk. Isn't it majestic!"

"A red-tail," Douglas says and they chuckle at some private joke.

The giddy mists of champagne evaporate seconds after they leave. Queasiness condenses into discomfort. One small lie and I feel like a co-conspirator. Can I advise Douglas to scrap the hedge?

On my next walk in the neighborhood I notice boxwood everywhere, lumps, clumps, edges and hedges hidden in the open. Maybe that's why you have 17 miles of it, just so you notice it. Though I pay it more attention, I am still not loving any of it. The knee-high hedge up the street has defoliated sections. Dogs? A boxwood globe at a nearby house is mangy, the leaves bronzed by cold. Why is boxwood everywhere? Obviously, it has architectural properties but in our climate numerous other shapeable plants could substitute. It seems like nothing more than a leftover from a horticultural tradition (European) lingering like the tired habits of a once lively marriage.

Can boxwood ignite passion? The question leads me to the library at Strybing Arboretum and the discovery of the *Boxwood Bulletin*,

dedicated to "Man's Oldest Garden Ornamental" (in man's dullest format). The publication features a list of boxwood's attractions, compiled by a past president of the Boxwood Society. Except for one or two, the qualifications are more suited to a husband than a lover. In paraphrase: 1) Has many shapes, sizes. 2) Is vigorous, long-lived. 3) Has few problems. 4) Tolerates a wide-range of soils (pH 6-8). 5) Not a heavy drinker. 6) Nor feeder. 7) Requires minimum pruning when you've chosen the right one. 8) Can compete with grass and weeds. 9) Has few pests. 10) And few diseases. 11) Examples thrive Zones 5-10. 12) Most types easily propagated asexually.

Nevertheless, I am intrigued by the *Boxwood Bulletin*. The black-and-white photographs are so indistinct I feel an urge to whoop happily knowing that the dumpling pictured could be the object of someone's ardor. Here the adage is reversed. A word is worth a thousand pictures. A description of 'Dee Runk,' a cultivar of *Buxus sempervirens*, gets my attention: "A tall, narrow columnar plant, but with soft, loose foliage."

I read that there are 75 species of boxwoods available from U.S. nurseries, of surprisingly wide range of habits. *Buxus microphylla* 'Compacta' grows slowly to reach only 10 inches in 25 years while *B. sempervirens* 'Arborescens' can grow to 20 feet in the same length of time. There are mounding, drooping, pendulous, procumbent, pyramidal, columnar, and conical boxwoods. Who knew? Then why do I see the same variety everywhere? Do I? Do I have a calm and discerning eye?

I picture three different places where a row of well-mannered 'Dee Runk' would lend my garden aplomb. And no clipping! In *Andersen Horticultural Library's Source List of Plants and Seeds* there is no 'Dee Runk' listed, but the similar 'Graham Blandy' is available from 6 nurseries. I write down two addresses and phone numbers.

I am hedging about Douglas' hedge, easing away from advocating its overthrow. I don't want to be involved in such a decision, in any preemptive strikes. I won't even rule out witnessing for its defense. A change of heart? Or merely a retreat to the safety of the *same old* squared?

Spring

TWISTY COMPENSATIONS

It's well after midnight and the phone bleats. "Hello," I bark, prepared to round off the edge if tragedy warrants.

"You're not going to believe this," Vikki says.

Unquestionably I'm going to believe it.

"I lost my keys. They must have fallen out of my purse. I really hate to ask, but could you bring over the ones I left at your house?"

"Now? What about the ones in the potted palm?"

"That's the set I've been using."

She's calling from an all-night drug store a mile from her house. I don't ask how she got there, I just say I'll be over. Being Vikki's friend is, in Orson Welles' phrase, like riding a tricycle in a vat of molasses. I'm not even sure what our friendship is based on anymore except for longevity and habit. The dearness that does exist between us is predicated on meager contact, the milk of human kindness skim. But her heedlessness is not what rankles me at the moment. My own is far more annoying. I could see this coming. Why didn't I give her back her keys?

I dress and step outside into a warm and still night. Heliotrope? Brugmansia? *Rhododendron fragrantissimum*? Something spices the air. In another mood I could be persuaded that this time of year, spring's high tide, is as close to paradise as we'll get, and it's close enough. Earlier today I nearly crashed my pickup driving up Colusa making this list of what's in bloom: crabapple, Carolina jessamine, hyacinths, aloes, azaleas, cherries, wisterias, roses, salvias, pansies, primroses, camellias, rhododendrons, forget-me-nots, lavender, and plenty I missed.

At the moment, however, the sweet air does not transport me. My attention latches instead onto a leafless Japanese maple in a bay of moonlight near the retaining wall. The name of this cultivar, coincidentally, is 'Moonfire.' Six years ago I planted it as a memorial to someone I loved. Sculpting it, nipping twigs, fastening down branches, I coaxed it into an Audrey Hepburn-esque elegance, and I anticipated a matching career: youthful charm, middle-aged depth, charitable works in old age, the chief of which would be to delight my own.

Each spring, when its palmate leaves unfold, red gets redefined. But this spring there are no leaves. Bitter spoonfuls of hope, self-administered, have not prevented me from seeing the pallor of the twigs. A bit of bark scraped away with my thumbnail revealed no trace of fresh green. Last fall when the tree was decked in mottled crimson

I suspected nothing. Could I have done something? Improved the drainage? More fertilizer? Less?

Of all the plants in my garden (I say this with a prayer I never have to test its validity) this is the one I most hate losing.

He knows how to find the twisty compensation in this business of losing, being a loser, drawing it out, expanding it, making it sickly sweet, being someone carefully chosen for the role.

— Don DeLillo, *Underworld*

Starting the pickup I make a vow: to uproot the maple and ditch it first thing in the morning. The keys in my hand remind me: my talent for drawing out loss is spent. I've had my own key troubles lately. One sunny, seemingly benign morning, my keys, harried perhaps by overcrowding on the key ring, vaulted from my hands, scuttled across eight feet of asphalt and dove through the sewer grate. I squealed in shock and disbelief.

Fishing expeditions with jimrigged tools raised crud and lowered morale. A trooper, I persisted. Before Key Day was over I had two different crews from Public Works on the scene, the last with their humongous Vac-Con sucking muck from the past into the here-and-now: butcher knives, Oly cans, shoes, hubcaps—it was a commotion the neighborhood had not seen for some time. The keys, of course, would not be found. I should have known. Their intent was unmistakable, to be lost, when they hurtled like metaphysical triathletes into another dimension. This kind of loss happens frequently but nobody explains how. Occasionally these émigrés return to earth, but I doubt my keys will.

Their disappearance finally didn't matter much. I had spares for the pickup and the house, plus most of the other important stuff. Why the outsized fuss? I made a resolution: if I can live without whatever is lost—pretty much everything—I'll search no more than a reasonable amount of time. This resolution vaporized at its first real test, when I lost my hori-hori. A wooden-handled blade serrated on one edge, the hori-hori is useful and indestructible. I already had two trowels when a friend gave me one, and I couldn't imagine why I needed another digging tool.

It quickly banished the trowels to a webbed corner of the shed. But it had one serious drawback: the earthen color of the handle. After mislaying it dozens of times, occasionally for days, I had an idea that I might have had months earlier. I bought some flame-red plastic tape and wrapped the handle so that I could see it blazing from across the garden. Red paint would probably have worked as well, but tape was faster, simpler.

Since the problem was officially solved, the latest loss was especially galling. I prowled the garden, fantasizing about buying a metal detector. Three overturned compost piles unearthed merely a realization that I probably dumped my hori-hori with other debris into the plants-only garbage can—emptied by the city the day before. It was gone, gone, gone for good. Immediately I went to Hida Tools and bought another. Wrapping its handles in tape, I reminded myself that if I had hearkened unto my resolution, I would have saved myself hours of time. Then again, it didn't hurt to turn the compost.

Given this history, I am not feeling satisfactorily self-righteous when I pull into the parking lot at Walgreen's. I see Vikki near the door and honk, and she comes briskly over. "They're having an unbelievable sale," she says climbing in. "My favorite moisturizer a third off. I got an extra jar, thinking you might want one. You're in the sun all the time."

A minnow of wonder flails upcurrent through my mood: how does she manage to turn her life into one aria of accumulation? *She doesn't dwell on loss.*

"Oh I know you," she continues, " moisturize? You don't want to hear about it but you check yourself out in every mirror you go by. I see you. Let me tell you, you look good for your age but a little skin care wouldn't hurt."

At her house I walk her up the stairs to the door. It might be two o'clock, it might be three. The moon is tilted on its side above Richardson Bay, a jar spilling moisturizing cream. Vikki inserts the key into the lock, but the key does not turn. Wiggle, jiggle, wriggle, will not turn. "These aren't my keys," Vikki says holding them up to the porchlight. "You didn't. I don't believe it. Doofus."

The art of losing isn't hard to master.

– Elizabeth Bishop, *One Art*

The sun is already intense in the garden when I come outdoors after breakfast. Sometime in the night it showered, and ghostly

handkerchiefs spiral up from the damp boards of the deck. Vikki is asleep in the guest bedroom and will stay that way, god willing, for hours. I have not located her keys though I have looked in the places they're supposed to be, or could plausibly be. Or not so plausibly. I've looked everywhere but now I am letting go.

I am trying to breathe in the moment, which is not without charms, foremost of which is a nearby trio of 'Sunset Celebration' rosebushes. Last fall I took out a crescent of lawn near the porch to make room for them. Touted by the eponymous magazine, this floribunda justifies the hype. Though its fragrance is mild, its flowers, abundant and luminous, make nectar out of the morning light. I brought in two canes yesterday and like that, a lavish bouquet. The peachy color is companionable with nearly every other color in the garden, except maybe pink, which is unfortunately what I've planted nearby, another rose, this one more fragrant and nearly as worthy (or would be if I weren't in an orange phase), 'Audrey Hepburn.'

Her again. I remember my resolution. The morning sun and the roses can't eliminate the grief. You can't have sun without shadows, right? Right. A refusal to accept *what is* only causes suffering. Right. Twisty compensations. Right. Taking the loppers and tree saw out of the tool shed I prepare to get on with it.

Out of habit and a guttering desire, the first branch I cut is a small lateral which I have fantasized removing for months, unable to decide if taking it out would leave a hole or else lead to new heights of beauty. Since my projections came up blurred, I thought better not risk it. Now, after gently extracting the branchlet, I have my answer. It is superb; it would have been superb.

But another question is coalescing as impressions become observations. The subtle slice of the loppers—dry wood should give a bit more resistance. Red bark. Twigs not brittle, some are bleached, but a minority. And then I see them, what William Carlos Williams called "pinched-out ifs of color." Leaves-to-be. I am as flabbergasted as I was when my keys went interdimensional. I would have bet the farm the maple was dead.

I am brimming with an urge to awaken Vikki and tell her the good news but the phone ringing has probably already done that. I manage to get it on the eighth ring. It's Dan, Vikki's boyfriend. He found her keys in his car; he'll bring them over. The gears of the universe, with a huge, undetectable lurch, slip back into alignment, humming sweetly. I might search a bit more for my hori-hori.

Summer

HOT TOMATOES

"How many did you take?" I ask.

"Two. Two lousy tomatoes. I thought he was away and they was gonna rot. Son-of-a-bee-hiven luck. Not since grade school have I stole something. And I got in trouble that time too. He knows. I know he knows. Let's go outside. I need a cigarette."

Under sway of a couple of gins Gussie once told me she used to be called "Red." Her hair is gleaming platinum now, in a stack atop her tiny head. She thinks it makes her look taller. It doesn't, but it suits her, coiled and aglow like an extra energy supply. Her kids and her grandkids have given up telling her she shouldn't smoke, and I grab a saucer for an ashtray and follow her out the back door. It's a hot day, the first we've had in memory, and we take seats in the shade on my patio.

"Felonious Red. Caught red-handed."

"Don't you start," she says, her cigarette erect between lacquered nails, a spiral of smoke curling away from it. "I wasn't caught. He asked if I seen anybody suspicious in the neighborhood. 'Suspicious,' I says, 'what does somebody suspicious look like? Maybe it was raccoons,' I says. 'They look suspicious.' Do raccoons eat tomatoes?"

"Have they ever eaten yours?"

"Never. What's the hell's the matter with my tomatoes? They won't grow for nothing. Every other year I can't pick them fast enough."

I can't help but glance at my three hearty tomato plants, just behind her in their 15-gallon containers, each laden with clusters of not-quite ripe tomatoes. The hot weather today will speed the ripening.

"Hey," she says, "why don't you come over and tell me. You're the expert."

The expert doesn't know beans about multi-syllable rots and wilts. He says, "You should have planted a disease-resistant variety."

"I planted the same thing I plant every year. 'Early Girl.'"

"Maybe there's something in the soil. Do you put them in the same spot every year?"

"What else can I do? It's the only spot I got that's not shaded by his damn tree."

High over the platinum silo a little cirrus cloud of smoke hangs flat, a thought not ready to take shape. "I should forget about this, right? Hell, it's only two tomatoes, three if you count the half-green one. You ever steal from anybody's garden?"

"Who hasn't?" Before I had a garden of my own, I'd walk streets and pluck whatever I fancied—nobody owns the sunshine, nobody the rain. Now I'd be outraged if anyone nipped a rose of mine.

"I'll tell you who. Me. Not till yesterday. I knew I shoulda stood at home. I'm gonna die of embarrassment."

I would feel equally mortified if I were the perpetrator because the wronged party, Bertie, is the world's foremost wronged party, our neighborhood's hairshirt.

Gussie's beef with him is prime. Carpenters remodeling her house in June set up a ladder in his ivy, and he called the police. Her watering system malfunctioned and dampened his patio and he phoned, drunk and nasty. She gave him what-for, but what for? He's a dunce. One could point out (one has) that his leaf blower is an affliction, that his ivy smothers fences, his overgrown elm sends suckers up everywhere.

"Let him stew," I say. "Forget about it."

"I can't forget about it. I went to confession and the priest says I have to give the tomatoes back. 'I ate them,' I says. He says you gotta ask for forgiveness. 'For two tomatoes,' I says. 'What do you think?' he says. Why is he asking me? Holy Christopher! I ain't no priest."

"Could be the difference between purgatory and hell."

"Are you kidding? I'm going to heaven. You might be worrying about where you're heading. Are you going to come over and look at my tomatoes or not?"

We hie ourselves to Gussie's back yard where the diagnostic determines one thing: she may be going to heaven but her tomato plants look like hell, hunched like damned souls lugging boulders in a Dürer etching. The leaves are blotchy and the few tomatoes that have formed are Bertie-like cases of arrested development. "It's some virus," the expert opines.

"What do I do?"

"Get rid of them."

"How do I know the same thing won't happen again?"

Good question. If the pathogen is in the soil, it will. "I'll see what I can find out," I say.

Sorbet de Citron, White Queen, Shenandoah, Feejee, Lutescent, Aunt Ruby's German Green, Eva Purple Ball, Yellow Gooseberry, Big Rainbow

Repulsed by the mucilaginous cartilage found in supermarkets, everyone I know with a sunny spot tries to grow tomatoes. Even Bertie. Growing them is a religion right up there with Congregationalism and, like Congregationalism, in decline. A couple of six-packs from Wal-Mart do the trick, a bag of potting soil while you're at it. The same varieties from Alaska to Arizona. 'Early Girl,' Gussie's preferred, is among them, exceptional in that it produces well in a wide range of climates. Most do not.

Does the Wal-Mart shopper know that at Heritage Farm in Iowa the seeds of 4,500 known varieties of tomatoes are kept for preservation? That in the *Seed Savers Yearbook* there are 140 densely printed pages of varieties offered for sale?

When faced with so many choices, where does the novice begin? "Selection is simplified by knowing what color or shape you wish to grow, the purpose for which the tomatoes are being grown, and where (in a geographical sense) the tomatoes are being grown," writes Carolyn J. Male in *100 Heirloom Tomatoes for the American Garden*.

Because we don't have much of a hot season, it's good to get a head start with tomatoes. There is nothing better to elevate one's sense of self than ordering seeds, planting them in a tray and watching them come to life on top of the refrigerator (the warmth from below is beneficial.) Mid-March is a good time in our climate. Put the tray in a plastic bag propped open at one end. The seedlings will stay moist without additional watering until the bag is removed after germination, usually not longer than a week.

Once the plants have sprouted, transplant them into individual sections of a large cell-pack. Bury them up to their first set of leaves. Situating them two inches under a fluorescent light fixture is ideal, but a sunny window will do.

When the seedlings are about nine inches high, harden them off by giving them increasing doses of outdoor life and stress them by keeping them on the dry side. When you plant them outdoors (two to three feet apart,) again bury the seedlings up to their first set of leaves after having removed all yellow leaves and blossoms, if any.

When I think of the heroism of the conservation effort of Heritage Farm (the *Yearbook* offers 21,500 kinds of rare fruits and vegetables) my admiration crosses over into awe. But I confess I buy seedlings.

In local nurseries there are quite a few choices, and I generally make safe ones, small fry I know will ripen no matter how cool the summer, golden plums and cherry reds. I grow tomatoes to eat off the vine and a good cherry is as good as a tomato needs to be. Rolling a sun-warmed beauty around in my mouth is homegrown ecstasy. I'm not the first to think so. The German word for tomato is *Liebesapfel*, love-apple.

From aphrodisiac to poison to Miss Popularity has been the tomato's historical arc since its arrival into Spain from the New World in the 16th century. Who knows why its reputation went south as its cultivation spread north? By George Washington's time the tomato was considered deadly; the ones in his garden were there strictly for ornamental reasons.

A century later, tomatoes were thoroughly rehabilitated, and now a vegetable garden is unthinkable without them. Good news, not least for Gussie and me: recent studies show that the nutrient which makes tomatoes red (lycopene) prevents or inhibits the growth of a variety of different kinds of cancer, especially prostate, stomach, and lung.

What of her tomatoes? After a few investigative discussions with other gardeners and a trip to the library, the "expert" makes a diagnosis: a virus it is, and while there is no cure, there is prevention. He can't wait to spill the beans.

Red Currant, Red Fig, Early Large Red, Large Smooth Red, Red Penna, Rasp Large Red, Reif Red Heart, Germaid Red

"You're kidding me."

"Nope."

"Say honest to God."

"Honest to God."

"Holy Christopher. How come it never happened before?"

"You were lucky, I guess."

The virus afflicting Gussie's tomatoes is the tobacco mosaic virus, spread from tobacco products. A hand that holds a cigarette can spread it, so can smoke.

That's what I told her in my most assured tone. I did not tell her I'm less than absolutely certain.

Gussie lifts a beaded green cigarette purse off her lap. She withdraws a pack of Salems and puts it on the coffee table between us. "You take these with you. I want them out of my house."

No drama? I'm a little disappointed in the moroseness dragging down her face. What was I expecting?

"Congratulations," I say.

"The doc said the smokes are killing me. And now my tomatoes." Her shoulders sag further. Now I get it. This is the drama.

It lasts thirty seconds. The shoulders roll back, the platinum majesty elevates skyward. "Wait till I tell my kids. Hey, I'm proud of myself. And I got it settled with what's-his-name. I gave him two bucks for the ripe ones and a buck for the green one. He wanted two for that one, I said no way."

"What did he say when you confessed?"

"Not much. He wasn't too terrible. I kept my mouth shut but I felt about this high. From now on I'm a saint. You're my witness."

Before I can respond she says, "Don't you start." She picks up the empty green cigarette purse. "What am I going to do with this? You want it for something?"

I laugh, and she rises on her high-heeled mules, walks to the sink and starts filling the dishwasher. "You want more coffee?" she asks.

I don't. Suddenly I remember the cloud of smoke hanging over my patio a few days ago. I want to go home and see about my tomatoes.

"Well, hand me your cup then. By the way," she says as I'm leaving, "he said he suspected it was you who stole his tomatoes. How do you like that?"

Fall

SHINING PLAIN

It was time to show off. What better occasion than a birthday ending in zero? I spent a week accessorizing the garden, a brooch of ruby snapdragons near the fountain grass, several bracelets of lobelia next to the colony of aloes, a buckle of bronze heuchera to accent a crimson shawl of penstemon. I invited everyone from my mechanic to the nun in my niece's school, and stocked enough champagne to prime all pumps. Almost everybody said yes and so did the sun, shining unbefogged on the chosen day and warming the calm air.

Gardens have moods, and mine was in a mood to glitter. Imperfections faded into inconsequence. For four hours friends of four decades intermingled on the garden paths.

(Overheard: "For fifty he looks remarkably lifelike.")

Could it be that after all these years of gardening I have a grip on what I'm doing? The garden seemed to say so, thanks to my growing inclination toward simplicity. Last July, for instance, in a disheveled peninsula at the junction of two paths framed by a low border of star jasmine, instead of a mix of different kinds of plants, I planted a dozen variegated andromedas. I filled bare earth between them with a blue bayou of *Campanula isophylla*. Nobody raved about this scheme—nobody said a word—but I have no doubt it works. Here is calm decorum where before was only rowdiness. My newfound aesthetic may be only another sign of middle age, but I accept the change. Those who feel deeply behave, Marianne Moore said, and I bet she was over forty when she said it.

(Overheard: "When I turned fifty I couldn't think of myself as a kid any more.")

I watched Maggie's two boys, Connor and Garrett, competing for ripe ollalieberries, their blonde hair shining in the summer light. It probably wasn't the same bush, but I ate ollalieberries in this garden when I was Connor's age while Aunt Dot in her blue hat tended her darlings. Will I ever stop thinking of myself as a kid? Does anyone?

Gussie arrived, gussied up, her beehive honey-yellow, two cakes in hand. Corks blasted off toward the raspberries. The yoga teacher, the nun and the leather daddy began a conversation that lasted an hour. The eighty-year old poet and my niece Lily were mutually enthralled while Don the painter was being swept away, as I hoped, by Marylee's easygoing laugh.

When Francine strapped on her accordion and began pumping out blustery jigs, my pitiful lawn finally found a suitable use: to be soundly stomped by dancing feet. Rick took off his shirt and twirled partners of both sexes until they were dizzy. Merle somehow landed in the aforementioned jasmine but pulled herself out without losing her grip on her cigarette.

Conversation pealed; even the perennial wallflowers blossomed. Then abruptly a lull began to spread. The cake. A bonfire. I didn't think to make a wish; the moment was the wish fulfilled: to be surrounded by those I love, in a place I love. I took a huge breath and blew the candles out.

And then, just at sunset, the party was over and summer was over and I was fifty. Rita, pal that she is, stayed and helped with clean-up, fishing napkins from flowerbeds, rounding up leftover food. I collected the colorful trash, plastic maroon knives and forks smeared with baba ganoosh, half-empty containers of salsa, pink cake boxes. I quickly made a gross stew of it, bundling it in a Hefty bag, and hustled it to the street before Rita noticed I wasn't recycling. She would have sorted the paper and washed the utensils for reuse.

As she gathered empty bottles, she rehashed her chat with Sandra, the website manager. "Then she said, 'I can't imagine life without my Beamer.' Where do you find people like that?"

"About three houses down," I said. "You gave her your lecture about wasteful consumption?"

"I always say, if the slipper fits. I read that we have twenty years to change our ways. When are we planning on starting?"

I thought, it's my birthday and I won't talk about Armageddon if I don't want to. Guilt over two bags of garbage was bad enough. And anyway, I'm not a total reprobate. I've forsaken the use of anything more toxic in the garden than light oil spray; no fungicides, no herbicides, no pesticides, no more snail bait. What sacrifices did that entail? I yanked a number of disease-prone roses—the result was sheer relief. I said good-bye to irresistible snail snacks like dahlias, no great sacrifice. But washing plastic forks and spoons....

In a little over an hour the house was tidier than it has been in months. It looked as if it were trying to remember something. I lit the lamps. Not quite ready to be alone, I walked Rita to the gate that separates our gardens. Through the picture window I saw Rick lying on the couch in her living room, washed in the glow from the TV. Overhead a few stars pierced the blackening blue. The voices that seemed to linger in the air began to go mute as we said our goodnights. The trees, the shrubs, and the grasses which all day had seemed so

sociable retreated into themselves, pulling their shadows around them, delving into some unshareable reverie.

> The world's
> A dream, Basho said,
> Not because that dream's
> A falsehood, but because it's
> Truer than it seems.

> — Richard Wilbur, *Thyme Flowering among Rocks*

On the highboy were a stack of cards and a few gifts. I was glad that almost everyone had complied with my request of "No Gifts" though Miss Manners contends it is rude to make the request. Some people have the gift of gifts. Aunt Dot was a genius. She could troll gift shops at tourist traps and find the very thing that added fizz to an occasion. She could receive a cheesy gift with the kind of delight that erased its giver's doubts. I'm not so cranky that I don't appreciate the gesture, but nine times out of ten I open a package and a voice in my head drones, "Where am I going to put this?" I know the answer. In the big drawer at the bottom of the wardrobe, the one labeled, "Things to Cause a Quandary Well into the Next Millennium."

I unwound the string from a tan, corrugated, fancy-paper packet. It was probably something to be framed and hung on my crowded walls. Before I opened the flap I read the attached card: "For years you've been wanting a heavenly body. You've earned it. Love, Rita."

Inside was a letter. "CONGRATULATIONS. A star in the heavens has been named for you. The certificate enclosed indicates the new name of the star and its telescopic coordinates. The booklet with constellation charts will help you in locating the area of your star and the large sky chart shows your special star encircled in red."

The florid certificate looked as if it were designed by a cosmetologist instead of a cosmologist. "Know ye herewith that the International Star Registry doth hereby redesignate star number Aquila RA 19h 38m 17s D 1" 18' to the name R. E. Faro. Know ye further that this star will henceforth be known by this name." I started laughing. I laughed my head off. This kind of language does not inspire the sobriety it aims for, know ye what I mean?

I bundled the star chart, the letter, the booklet (*Our Place in the Cosmos*) and the certificate into the cardboard packet, and tied it shut with the little string. It would have to wait till tomorrow. At the moment my place in the cosmos could only be horizontal.

I am the least difficult of men. All I want is boundless love.

— Frank O'Hara

For two weeks after the party I barely look at the garden. I think more about who my neighbors in the constellation Aquila might be. I hope not rich Republicans. And what am I, a red giant or a yellow dwarf? Why am I so tiny? Is it because I'm so distant? Where is everyone?

My spacewalk comes to a halt one late afternoon when I notice that all the potted plants, even the lavender, are haggard from thirst. I fill the watering can, aware of the resentment that is filling me. One glance around is enough to see four hours of work. Apples and pears are falling to the delight of earwigs and slugs. The first of five months' worth of liquidambar leaves have drifted into the azalea bed. Everywhere there is deadheading to do. Trees? Tired of them. Flowers? Over them. I want stardust, not dependency.

"This damn garden," I mutter.

Abruptly I am appalled at my fecklessness and ingratitude and quickly offer my apologies to the local spirits. I suspect I should do a thousand prostrations but decide instead to pick the pears before they all fall.

The first, with a rouged cheek surrenders sweetly to my palm, then to my teeth. They've never been juicier, sweeter.

Spring

SUCCULENT NIGHTMARES

There are mistakes you go ahead and make even though they could be whoppers.

On this glorious morning, the night's raindrops gemming the undersides of leaves, I'm up to my elbows in one. What was I thinking when I planted this assortment of succulents here last summer? That the dormant little bulblets of oxalis my spade overturned would never arise from slumber?

I was thinking that anything was better than this patch of sun-baked clay staring down reproachfully into my kitchen another summer. Why not succulents? A long-standing indifference to them, yea prejudice, had over time evolved into infatuation. Visiting the wonderland of succulents at Ruth Bancroft's garden in Walnut Creek fleshed out infatuation into pulsing lust.

The prejudice had something to do with jade plants. So many local gardens, mine included, contain at least one jade plant tucked away in a shady corner or bursting a redwood planter. They are the pajamas of the floral world, casual and comfy, but if you want a garden with elegance they have to go. Yet they seem so harmless, so defenseless, it feels like a shameful act of brutality when I finally condemn one to the compost. Those little fleshy arms! Every third year or so, Jack Frost, less sentimental than I, offs several.

At the Bancroft Garden I bought a variety of semi-hardy aloes and my fate was sealed. I could not wait to get started with my own succulent bed.

Most succulents require a light soil with good drainage, not exactly what this piece of earth offered, so I worked in eight bags of a soil amendment called "Clodbuster." It was then that all the bulblets of oxalis surfaced, and I pretended they were not there. I knew I was being delinquent in using only eight bags but they were heavy and the steps many. The bed was sloped; mercy would flow down.

I could have used thirty. The eight bags have done little more than given encouragement to the oxalis, inspiring it toward jungledom.

"Do you have another digger?" Rita asks. "I'll give you a hand."

This is a first. In the dozen years we've been neighbors Rita has helped me with many things, but weeding, never. It's clear this is a trade-off: she'll weed if I'll listen. Man invented language out of a deep need to complain, Lily Tomlin said, and Rita has a festering complaint. Perhaps hers will make me forget mine.

From the tool bucket I pull out a spare hori-hori. I explain that huddled like refugees under the blanket of oxalis are clusters of echeverias and sempervivums. What I can't tell her is how to eliminate the oxalis growing through every interstice of the tender leaves without breaking or crushing them. You need the delicate touch of a geisha. Rita stabs the hori-hori into mud. "Easy," I say, "save that for Rick." Rick is Rita's whopper. When she hinted recently that things were queasy between them I felt distress, some of it self-referential. Rita in love was Rita transformed. The undercurrent of sarcasm in her voice disappeared. Propelled by adrenaline, she billowed with wit and a range of generosity that took me by surprise. My doubts and my envy I kept to myself.

Tragedy has downgraded into burlesque. Rita, first officer of navigation, is in an Okefenokee of muddle. "He wants to be with me but he wants an open relationship," she says.

I can barely resist saying something sarcastic. Only a recollection of my own history of love swamps keeps me mute.

"I knew it was a risk. My therapist says that men in their thirties don't know how to love."

"Rick is thirty-eight," I say. But who could tell? Sprawled over the sofa, buttery-blond hairs on arms and legs melted by sunlight, he is the Corn God himself, eternal. It's a shame that sprawl over the sofa is what he does best.

"See these?" I point to a colony of sempervivums newly exposed. "There are bunches of these tucked here and there, some probably where you're kneeling. You might find using your fingers easier. Don't worry about getting the bulbs and roots out. That's hopeless."

"These purply things?"

"Those purply things."

"They're gorgeous."

So they are. While the gasterias and one or two of the aloes are up to their armpits in rot, the sempervivums uphold the promise of their name, having responded to the damp as to an incubator, busily reproducing their geometrical green and purple pups. Since last summer they've doubled in volume. There are other pleasant revelations—most of the echeverias survive, as do two of the three showstopping *Duddleya pulverulentas*, their leaves white as a milkmaid in a flourmill. They are growing with their heads on a pillow of gravel to minimize the chance of rot. Elsewhere a batch of ivory-striped crassulas stands chipper as stockbrokers, their heads just above the yellow pennants of oxalis.

Excesses of simile are inevitable with succulents. The variety of color and form is amazingly rich. Individually, they remind the observer

of something else. Grouped they become dramatic, the sum greater than the parts. Like jade plants, many are only marginally hardy so the discriminating shopper will question how low they can go with respect to cold. At the Bancroft Garden during the winter the marginal ones are housed in plastic hermitages, to return to the larger world when the frost danger is past.

Puyas, aloes, duddleyas, echeverias, sempervivums, agaves, crassulas, haworthias, aeoniums—the names are succulent in themselves. With this bounty even an amateur can achieve arresting effects, something that is becoming more and more evident in this bed as the weeding progresses. Despite the gaps in planting there is a glimmer of cohesion, of associations being made in ways that add up to magic: see how the demure powdery blue leaves of the *Cotyledon orbiculata* arouse the blue greens of *Senecio madraliscae*, how an almost invisible echeveria, its leaves a nutmeg brown, hangs out a crimson sign that says, Notice me.

The aloes and aeoniums get straight A's. Of the hundreds of species of aloes, ranging from 6 inches to 35 feet tall, I'm growing the menorah-esque, *Aloe picatilis*, the light-dappled starfish *A. saponaria*, and a yellow-flowering *A. arborescens*.

"This aeonium is called 'Schwarzkopf,'" I tell Rita, pointing to an ink-dark rosette above a crooked stalk.

"After the diva?" she asks.

"Because of its color, I imagine."

"What a voice. The purest soprano I ever heard. Hank used to call her Betty Blackhead to irritate me."

Hank was Rita's first husband. For years he had a seat in the opera house, "so close you could hear their thighs rubbing together when they walked."

"Why did you stop going to the opera?"

"Rick hates it."

I have the fleeting thought that I might go with Rita some time, but I don't care much for opera either. She may be reading my mind because she says, "My therapist says that trying to please makes for a shitty relationship."

"That sounds more like me than you."

"Who do you try to please?"

"Everybody. Last night I found myself being extra polite with the checker at Safeway because she seemed so harried."

"That's just civility. I'm talking about losing your soul."

"Isn't that the point, to give over your soul when you're in love?"

71

Rita stands up straight and looks at me. "Are you serious? Maybe that's why you've been having a rough go. One soul is as much as any one person wants, way more most of the time. Nobody wants the burden of two."

I get back to weeding. Here the prospects aren't as confusing. If the oxalis were a map of the U.S., what remains is California; the Pacific is in sight.

"He called me, by the way," Rita adds.

"Who?"

"Hank."

"I thought he was in Thailand?"

"He's back. He wants to go out."

"As in date? What did you say?"

"Yes. Why not?"

"You'll regret it."

"Do you think I regret the time I spent with him? Not one bit. Or with Rick for that matter. Besides, Rick needs to know there are other frogs in the pond."

...if she doesn't watch out her life is going to be left aching and starving on the side of the road and she's going to get to her grave without it.

— Jane Bowles, Plain Pleasures

Perhaps I was projecting. Rita's no more in a swamp than Mt. McKinley. It's I who fear getting to my grave without my life. Regret? Three hours ago when I started weeding I regretted the very fiber of my life, aching and starving. I should have prepared the succulent bed better. I should have done something (what?) about the oxalis. I should have a sweetheart to be miserable over. I should be a someone else, a better someone else.

The oxalis is routed for the time being. The bulblets are still in the soil; they will be back once, maybe twice more this spring, though not to the volume they were, and I'll have to weed again. That's the way it is. By summer they will have withered to the ground, hibernating until the alarm rings in the form of November raindrops. Wired to sprout, like regrets, judgments, expectations.

Rita says, "My therapist said...."

"Your therapist again?"

"My therapist said that whatever happens is what you need to happen at that moment. There are no mistakes, no accidents. What's to be afraid of?"

Rita gets cosmic, I get earthbound. I feel fear, plenty. Fear of what? Things falling apart? They always do. They never do.

I turn my attention back to my succulent bed, not such a big mistake after all.

Summer

ALIENS R US

I was trying not to stare. Being stared at was old hat; you could see that in the smug half-smile. Three other heads followed his progress down the aisle. I curbed my gaze, directing it to the window at my right where my perturbed self looked back, offering to be reflective. I rejected the offer, peering instead down to the shattered glass of the bus shelter.

There were plenty of empty seats but he took the one beside me. A spike of cologne electrified the air. I walked my gaze back to the surface of the window, and noticed he was looking at me. Was there egg in my moustache? I casually wiped my palm across my mouth. Nothing. I felt a slight nudge, looked down to see his index finger resting on the book in my lap. "What are you reading?" he asked.

I showed him the front cover, *Farmageddon, Food and the Culture of Biotechnology*, by Brewster Kneen.

"Farmageddon. I get it. You believe that crap, don't you?"

I couldn't say what beliefs had sifted out from the few chapters I had read but I didn't need to. "Sure you do," he said. "Only somebody who agrees with the author would read a book like that. Am I right?"

Maybe he was. So?

"Fogeys. Frankenfoods. Help! Help! There's a monster in my Frosted Flakes."

Forget comeback or even a decent filibuster–I was too fascinated by the fusillade of "F"s, ejected glistening from that cupid's-bow mouth.

"I know what you're going to say. 'What about the butterflies in Iowa?' It wasn't Iowa, it was at a research lab at Cornell. That corn was supposed to kill larvae and it did, no biggie."

He was referring to the famous experiment in which the pollen of Bt-laced corn halted the reproduction of the Monarch butterfly. I agreed, it shouldn't have been a surprise to anyone. But no biggie? There are millions of acres of transgenic corn grown in Iowa. But then, who needs butterflies when you have holograms of them beamed up on high-speed cable?

I checked his fingernails. Immaculate. He was probably a white coat of some kind, a lab technician or research scientist. "Science is what humans do best," he said reading my mind. "It's our only hope to feed billions of future mouths. Don't you think some risks are worthwhile? You don't seem to be a fraidy cat." He looked me in the eye, a too-frank size-up that gave his words a dosey-do.

Phony praise takes effort, and the tinny compliment softened my heart. The animosity that had been wriggling out of larval stage died down, like the Cornell butterflies. He felt me soften, and smiled, and the length of his thigh pressed against mine. It was not out of necessity. I was already against the side of the bus. A drop of sweat fell from my armpit and ran down my ribs.

"Future mouths," my present mouth spoke. "Last summer in Kansas there were hills of wheat on the ground because all the elevators were full. The concern about future mouths would sound more sincere if Archer Daniels Midland worried about people who need food now."

"Is that where you're from? Kansas?"

"Not anymore."

"Is it true they don't believe in evolution?"

"Not only that, they think the world is flat. It is, I've seen it."

He cocked his head and let his eyes roam the ceiling of the bus. I made a display of resuming my reading but I did so uneasily, as if I'd abdicated a responsibility, given away the argument. At least I might have jangled the smugness whose dampness I felt against my thigh.

"Listen," I said, rousing to read, "'Genetic engineering is an expression of ingratitude and disrespect, if not contempt. It is a vehicle, in practice, of an attitude of domination and ownership, as expressed in the assumption that it is possible, reasonable, and morally acceptable to claim ownership over life.'" The cologne was making me dizzy, and I twisted sideways and tried to open the window, but it wouldn't budge. "Ingratitude and disrespect," I repeated. "It's not about feeding the hungry. It's about power and profits."

My words rolled off his expression like drops of mercury. "It's about living forever," he said. "Immortality. We have this incredible power in our hands. The Holy Grail." He grasped an invisible chalice. "Do you think we're going to turn back?" Standing, he took a business card from his blue jacket and dropped it into my lap. "Life would be death if we never took risks." The back doors swung open, and with a few fluid steps he was gone.

A lanky teenager with bleached braids claimed the vacated seat. She turned to me and said, "Man, somebody really heated up this seat." I blushed and blushed again because I was blushing.

The bus lurched ahead. I turned over the card and under his name read, "Patent Attorney."

Holy Grail, indeed.

...the highest enjoyment of timelessness...is when I stand among rare butterflies and their food plants. This is ecstasy, and behind the ecstasy is something else...like a momentary vacuum into which rushes all I love. A sense of oneness with sun and stone. A thrill of gratitude to whom it may concern.

— Vladimir Nabokov, *Speak, Memory*

My sister is visiting from up North, taking a vacation from her family, on a quest for some sun. It's her lucky day. The sun is sprawled in the sky and she on the chaise, both too lazy to finish the last swallow of lemonade in her glass. A yellow butterfly does a rough sketch of her form in the air, then veers off into the princess flower.

I tell her about the conversation on the bus. She's the perfect antidote to the queasiness it left in me. She's kindred in ways genes can only partially account for. Last night we stayed up till three, watching *The Importance of Being Earnest* and *Moonstruck* and drinking one too many gin-and-tonics. This morning, pixilated but functional, I am binding bamboo stakes to make a tripod to support my tomato plants.

"Arise, Miss Worthing from your semi-recumbent position and hand me that twine."

"I can't. My shell will collapse.

"The twine."

"Young man, where are your priorities?" She moves her toes.

"I'm middle-aged. My priorities are behind me. Never mind," I let the tomato sprawl. "I'll get it."

With a length of twine I tie the second tripod together. "Hey," I say, "babies." There they are, the first tomatoes. This plant is a Red Brandywine, an heirloom about a hundred years old. Somebody told me it would thrive in our cool climate. I'll believe it when I taste it. Still, I'm completely the proud parent, having grown these plants from seed. Mary doesn't even open her eyes. She's been a proud parent for fifteen years and is officially catatonic.

"I loved it," she mumbles, "when Olympia Dukakis asked that dorky guy why her husband screwed around with younger women and he said, 'It's the fear of death,' and she said, 'I knew it.' That's what all this screwing around with Nature is, too. Cloning especially. You know if they do it to sheep, they'll try it with humans. Just think," she sighs, "as we get older we could have a younger model waiting to take over. Who'd be the new me's mother? Would I have a brother? It's too weird

to think about. Although a younger me having this hangover wouldn't be bad."

It is too weird to think about. I unroll the hose and begin to give the tomatoes a drink. "He said science is what humans do best. I should have said, what about music, what about poetry, what about acts of kindness?"

"What did you say?"

"Hardly anything. When they put the gene for quickness on the market, I'm buying it. I think he was cruising me. What's so funny?"

"What do you mean, think? Like you don't know? You could have made the *National Enquirer*. Seduced by an alien. Finally somebody famous in the family. Quit spraying me."

I wheel with the hose and send a wall of mist against the angle of sunlight, long enough for a necklace of rainbow to be strung and unstrung by the breeze.

Turning off the faucet, I wrap the hose onto its holder, pausing for a moment to contemplate the sunny garden. Not contemplate, exactly, but observe the electrical connection between me and the green world, the kinship. Does the biotech engineer ever feel this, the thrill of gratitude to whom it may concern? It heartens me that in England biotech experiments had to be cancelled because too few farmers would allow their land to be used but I wonder if this is the last generation that will have such resistance, the last to have hands in dirt.

Yesterday I cut down a redbud tree that had been espaliered against the side of the house. It was a variety called 'Forest Pansy', with luscious, wine-red leaves. With no warning the leaves drooped, turned gray, and the tree was a goner. As tragedies go, minor, but with the drag of mortality. Who wouldn't want to reverse that gravity, the grave-ward drift?

This summer day, passing. The beauty of the garden seems precisely congruent with its transience, and my own. Can bioengineers account for that?

Fall

UPROOTED

"Holy Christopher. You never think it could happen to you and then, out of the blue."

It's mid-afternoon on a Saturday, and I am demolishing a second lunch, a bowl of Gussie's risotto, scraping the last of it onto my fork. Normally she would be seated opposite me, her pleasure watching me eat, but today she is at the kitchen counter. "What am I gonna do with this stuff?" A sweep of the arm encompasses jars and canisters, pots, pans, the photograph-plastered refrigerator. "I'm gonna have a heart attack."

So are the neighbors. Not even Douglas who keeps tab on the cracks in the sidewalks knew Gussie doesn't own her house. It seems— it seemed—unquestionable. Elaine, though she's a relative newcomer, commented that Gussie is an institution, like the Chrysler Building. Rita was more to the point. "If I hear another person say how this or that house sold for two hundred thousand dollars over the asking price I am going to plant my foot in their south forty."

"How can your brother do this to you?" I ask between mouthfuls.

"He has heart troubles so he thinks, better do it now. When he told me how much he can get for this house, I says, you're pulling my leg and he says honest to God."

"He's doing it for the money?"

"He says he'll give me some, help me out."

"You want to do it?"

"You nuts?" She stands and walks to the window. In the reflected light her platinum beehive glistens, the last beacon of fair weather. "I'd rather jump out of an airplane. Thirty years I been here." She looks at me and for once there's no hint of guff. "Hey," she says, "I was going to show you my beans."

The sun lurches amid the tatters of all-day fog. Gussie's vegetable plot is six by twelve feet and half is covered by bush beans sporting golden crescents. So pretty. Some were in the risotto. They tasted just like string beans, which is not a complaint. On the other half of the vegetable bed is a sampler's delight of lettuces, parsley, arugula, thyme, and an albino squash that is, in spirit with the zeitgeist, appropriating real estate. Gussie dips her wrists into the bean greenery, stirs it gently around, extracts a plump snail, and gives it an underhand toss into Bertie's ivy, a snail which in a day or two I'll find in my garden and return the favor.

"Think I'll get any ripe tomatoes?" The little grove on the deck is flush with fruit, every one still green.

"Maybe he'll change his mind."

"That's what my son says but I don't think so. This house is a gold mine."

"He can't throw you out."

"He got me on a waiting list someplace where they look after you. He says he's tired of worrying about me. Like he's ever worried about me." In May Gussie had a spell of dizziness, spent a week in the hospital. Tests showed nothing, and she's been fine since. "'It's just a matter of time', he says. How you gonna argue with that? Sit down. I'll be right back."

"It's freezing out here."

"What's the matter with you? If you put some meat on your bones you wouldn't be cold all the time."

I pull on my sweatshirt and take a seat on the deck in the same chair I always occupy. Habit lodges in "inhabit." Mournfully I envision the Land Cruiser or Dominator bivouacked in Gussie's carport, but of course, the carport will not last nor this worn deck nor the inventive mesh of bamboo and buddleia that Nature Boy wove to keep out the deer where Gussie's fence had collapsed.

I can just make out the roof of Nature Boy's cabin through the leafage. His name is Otis, I learned recently. I think of the note in Carla's mailbox: "If it's okay to kill trees it's okay to kill people." I suddenly picture it, Nature Boy and I banding together, at the barricades.

The nitrous whiff of violence my fantasy secretes is dispersed by high-heeled mules scuffling down the wooden walkway. Gussie is carrying a tray with a tall clear bottle of russet liquid. "My nephew says it's his good stuff." There are two shot glasses on the tray.

"You're having some?" I ask, surprised.

"I want to refresh my memory. *Salute*," she says, and we sip. The grappa is a thin syrup with thick flavors.

"Did you tell Otis?"

"Tell him what?"

"You're getting kicked out."

"What would be the purpose of that? Holy Christopher. Now I remember why I don't drink this stuff. Don't tell me you like it."

"I do."

She takes another sip. "Want my garden stuff?"

"No."

"Why the hell not? They're good tools. You know that."

"This is starting to sound like a damn funeral."

"My nephew will want them. You should see his place. Unbelievable. Like a spaceship, I'm not kidding. Half of the time I'm stuck in the bathroom trying to figure out how to turn the lights on."

"Who needs the money? Your brother?"

"He's got more than what's good for him. He can't think of anything else."

"So why is he kicking you out? Did you tell him you don't want to move?" Silence. "Call him."

"No way."

"Then write him a letter. Dear... what's his name?"

"Bruno."

"Dear Bruno, I don't want to leave this house. You don't need the money. Think about your soul. Love, Gussie."

"Take out that last line."

"You use it on me."

"He says he don't got a soul. Some joke. Maybe he don't. How can I say such a thing? No more for me." She pushes the empty glass further from her.

Soul. An antiquated notion, a fingerbowl with rosewater.

"Okay, forget about soul. In your own words, Dear Bruno..."

To be clever enough to get a great deal of money, one must be stupid enough to want it.
— G.K. Chesterton

I bring back to my garden a half bottle of grappa and a letter that I would not have predicted, cozy in a stamped envelope. I walk it down to the mailbox and clip it there with a clothespin.

I do not bring back garden tools, but here I sit thinking about them. I lied about not wanting them, one tool in particular, her hedge shears. More exactly, my feeling is, no way the nephew is getting them. The shears are Japanese-made, expensive, and worth every yen. Their lightness, the length of their handles, their willingness to hold an edge, changes your life if you have hedges to trim and both Gussie and I do. I gave them to her on her sixty-fifth birthday.

The part of me teetering on broken-heartedness is disgusted by this possessive, not to mention bitter, twin. Hanging in my toolshed the shears would be nothing more than a consolation prize not the least bit consoling. If I take care of my pair, if I clean them, sharpen them, oil and treat them respectfully, they should last my lifetime. But what if they don't? What if I don't? What if, what if, the moist medium of anxiety.

When it is a question of money, everyone is of the same religion.

– Voltaire

For the second time this week, the narrow streets of the neighborhood host a pavane of chromium alloys. Real estate agents descend in their chariots. Human beings, I tell myself, probably blameless in the main but my soul is constricted and fellowfeeling doesn't wedge itself in.

No word from Bruno. I am taking out feelings of powerlessness on my cherry tree that has chosen this moment to become rank with aphids. The outermost leaves are twisted and curled dry, and a black thoroughfare of ants flows up and down the shiny bark.

Even if I were inclined to spray, it is unlikely a pesticide could make its way into the cocoon where the eager suckers suck. My method of control is to cut off the affected leaves and bag them, then put a band of *Tanglefoot* around the base of the trunk as an ant barrier. I've done this in past years, and so far the tree has survived and had more than a few star moments.

I work just down from the street where the comings and goings are equally fervid. A few minutes ago one of the agents begged me for my card, said she had a place that needed fluffing by next Monday, nothing permanent, you understand, just for presentation purposes, I know it's short notice, you do that kind of work, don't you? When I told her that I lived here, this was my garden, she buttoned up her expression and hurried on over to Gussie's but not before she offered me a card in case I was interested in selling.

Four times, twice each direction, a champagne-colored 4X4 trolls by and on the fifth backs into my drive. A head emerges, sees me staring down. "You don't mind if I park here."

I'm not going anywhere, true, but.... "There's a parking place right across the street."

"I don't want to park my car in the sun," he says.

That does it. I run him off. Being mean—that's what Aunt Dot would call it—makes me feel better than I've felt all morning. A bicycle careening down the hillside mirrors the surge of adrenaline. No mistaking the bicyclist, blond dreadlocks a-sail. "Otis," I yell. Perhaps not trusting the brakes, he uses the flats of his feet to come to a stop.

His eyes scan a moment before he sees me in the cherry tree. "Gussie's being run out of her house. We're trying to fight it."

He bows his head, gazing at his handlebars. "Why fight it? It's just a fact of life."

Why is the obvious so not obvious? I don't know this young man. For the first time I notice eyes so deeply set into his face they look bruised. His hair is a nest for glass birds. It's almost the same blond color as Gussie's.

"Grasping onto things," he says after a pause I project as shyness, "is the yuppie mindset. So afraid of losing some precious thing they drive a tank to the grocery store." Another pause, and then he says, "They won't be the first yuppies in the neighborhood." Does he mean me? He wheels off. So much for the Merry Men. From my viewing angle his glide downhill intersects for a brief moment with the flatfooted ascent of Mr. 4X4 who must have found a shaded parking place. He doesn't look my way as he passes. It dawns on me that I don't know him any more than I know Otis, that I might give him the same benefit of the doubt, and then I recall his comment and think, I know more than I want to know.

A secondary thought nags, that we are somehow mirrors of each other; more and more strangers and exiles, adrift in a sea of objects.

What about the soul? A rule of green thumb: to grow a plant successfully you try to replicate the plant's native habitat. So the soul. To flourish, to nourish, the soul has to make or regain a home, establish roots, like Gussie's string beans, arugula, tomatoes. Money can't buy a homeland.

Fine beliefs, I suppose, but of what relevance in this scrimmage of greed and gain?

Fall

BERRIES AND WORMS

My annual penance. I'm on my knees in the raspberry bed, thinning the canes by snipping off suckers. Five sturdy canes per space of a spread hand, that's the goal. I do this every winter and always feel I only half know what I'm doing. I read the helpful guidebooks but when I start in, so does doubt. What if there are 11 spindly canes? Which 5 do I leave? In gardening there is chronic ignorance and up-to-the-minute ignorance and raspberries feature both.

Maybe that's changing. This past summer the bushes were loaded and the berries fat. So were the blueberries. Was it the pruning or was it the compost? Additional watering? All of the above, probably, and the usual faerie stuff. Harvesting them with my fingertips, popping the bundles of flavor on my tongue I felt like a pasha—at least my tongue did. Why would anyone not plant berries? Admittedly, there isn't much difference in taste between raspberries from Safeway and these that surrender to your fingertips with a moist bit of reluctance. The difference is in attention, the singularity of each. You don't gulp them down, or plop them in bran flakes. When I pick them I carry a bowl thinking I'll bring some indoors but all take the kayak to Nayak.

Despite the gratification the berries afford, I bring only a vapor of patience to this job of thinning and pruning. Is it terribly unpleasant? It merely takes time, an hour or two made insufferable by the mind determined to have it so. Yes, I am aware of that but it doesn't change much. I still am in a hurry to get it over with.

Even so, a rhythm sets in, however fitful and my mind elopes with every passing thought, one of which leads my attention to an odd quivering in the branches of Gussie's live oak—-or what used to be Gussie's. She is gone from the neighborhood, deposited in Fairfield. Our letter to Bruno achieved nothing more than a family gathering in which even her daughter came out in favor of the move. Soon the gallows sign dangled curbside and then it was gone and the deed was deeded. Before she moved out I put her tomato plants on rolling platforms and wheeled them over to my place. Though I swore I wouldn't, I took her garden tools. She wanted me to dig up her Japanese maple and so I did that too, and the more I took the worse it felt.

Fairfield. Is it meant to be ironic?

Several nights ago I had a dream in which the live oak was withered, dead. As the saying goes, what makes that a dream? There is a pathogen killing oaks throughout the state. I awoke, grief-singed. Two months

ago the piece of earth that was Gussie's garden was a reliable source of earthly satisfaction. Now it's an abstract of sorrow. When I work in my garden I don't look over the fence much.

Whatever is in the oak is something heftier than an acrobatic squirrel. A boy, crouched in a thicket of thin branches, binoculars aimed at me. The son. I met his parents one evening last week when our simultaneous arrivals curbside made it unavoidable.

He thinks I don't see him. "Hey," I yell. "What are you looking at?"

"Nothing." His soprano carries like an arrow.

Fine. I go back to the suckers, and forget about him. A half-hour more passes. He is still there.

"Something interesting?" I ask as I move close to the tree carrying the canes away. He lowers his binoculars to his chest, says nothing.

I'm not in a mood to pry words out of a seven-year old, especially one about to break his neck. I lug six bags of compost up the steps to the raspberry bed.

"Do you have a wormbox?" the boy asks as I drop the last bag on the ground.

"No."

We both revert to muteness while I spread the compost around the canes. The ending moments of a task, whatever the task, generally ratchet up the seething impatience but this is one finishing job I relish. The frustration and hurry dammed in my system dissolve. Under skirts of clean compost the raspberries look chaste as parochial schoolgirls. I stand, pleased, and look over to see my audience still attentive.

"What do you talk to yourself about?" the boy asks.

A salient question. I scan the route for the latest stops on the mental choo-choo. "I was reminding myself that suffering is optional, that change is inevitable, that the world is an illusion." That should do it.

He nods, digesting this raspberry to his satisfaction. Another kayak to Nayak.

"Want to see my wormbox?"

I don't, but say, "Sure."

He weaves through the branches and steps nimbly onto a limb devoid of handholds. My heart is soon in overdrive but he walks along as if strolling a hallway.

I am waiting for him at the base of the oak tree as he drops from the bottommost limbs and tumbles onto the slope near me. "How did you get here so fast?" he asks.

"Secret gate."

"Yeah, right. This way."

We have seen that worms are timid. It may be doubted they suffer as much pain when injured, as they seem to express by their contortions.

 – Charles Darwin, *The Formation of Vegetable Mould,*
 through the Action of Worms

It may be doubted in worms, but in humans the contortions and the suffering are more or less equal. I watch my sandaled feet move along paths, the scope of my view intentionally not much greater than if I were catching glimpses under a blindfold. Still, I can't help noticing the changes. Gussie's autumn garden was autumnal. Leaves crunched underfoot and it felt right. Now the path is swept and the garden raked clean. Gone is the spicy rankness of rotting apples. There is a new lushness, thanks, I presume, to a recently installed watering system. I hear the hiss of Micro-storms and feel a veil of mist on my cheek. The humidity is obviously good for the new ferns but can't be good for the oak.

Allowing myself a peek around, I see that the area near Gussie's deck has been completely transformed with golden coleonemas, *Sedum spectabile,* and apricot-colored roses underplanted with mounds of thyme. It's nauseatingly beautiful. I feel a catch in my chest that is a mix of grief and amazement at how quickly gardens change personalities, how easily they discard us. Here is a dazzling advertisement for amnesia.

I turn back to watch the bare feet of the boy climbing the cobblestones ahead of me. This boy seems much older than seven. "What's your name," I ask.

"John," he says. At the topmost part of the garden he stops, turns to me, and says, "Actually, it's not a worm box. It's a worm hole." He lifts a yard square plywood board, and a mist of fruit flies swarms his face. He takes no notice as he grabs a spading fork. Gently he lifts of mass of semi-decayed broccoli stalks, cantaloupe rinds, strips of newspaper and carrot shavings, exposing a writhing mass of glossy red worms. "I had them in a box at our old place because we didn't have an outside. I put them here when we moved because the box was starting to rot."

He tells me about the worm box at school, how his Dad helped him build one, how to tear strips of newspaper for bedding, how the worms eat the vegetable scraps, how they make fertilizer, not just the mechanics but the philosophy and ecology of a worm box. Another Berry pops to mind, Wendell Berry, who wrote: "I can think of no better form of personal involvement in the cure of the environment than that of gardening." This boy believes in the cure.

"Do you want some worms?" he asks.

"No. I have a compost pile." He gives me a look of benign forbearance. Who would not want to have a wormbox, this little shrine to healthy digestion?

"I'll bring you some when you're ready," he says. "Will you show me the secret gate?"

We retreat to the fence, and I show him how to lift a board to open a gap wide enough for a body to slip through, and the little tunnel in the thicket of greenery that skirts Bertie's garden and leads back to mine. I can't tell if this excites him or not. He just nods as I slip through and put the board back in place.

"Is it weakness of intellect, birdie?" I cried,
"Or a rather tough worm in your little inside?"

— W.S. Gilbert

In the last few days I've noticed worms everywhere, fat nightcrawlers flailing in the wake of my shovel, red ones like John's in a cluster at the heart of the compost pile, a soggy one under the cat bowl. My visiting sister, to her disgust, found one slithering up the shower stall. I don't want to think how it got there.

Aristotle called worms the "intestines of the soil." Darwin's book on worms, one of his last works, sold more copies in its day than *The Origin of Species*. He wrote, "Worms have played a more important part in the history of the world than most persons would at first suppose." In my garden, before I disturbed them, they were hard at work digesting waste, filtering barren dirt through their gizzards to create loam, the source of life for most plants.

Of course it isn't hard and it isn't work. Worms invite projection. I think of them as friendly while my sister thinks they're creepy, crawling in, crawling out. What difference does it make to them? That they give us life is a benign accident. They are born, they eat, they reproduce, they defecate, they die, and that's as human as it gets.

One of these days I will have to swallow and digest my attachment, not to Gussie or the oak tree, but to the barrenness of "how I'd like things to be" when the fact is, Gussie's garden is now in Fairfield, three pots on a deck.

Spring

TANGLED IN VINES

"For Mamie?"

"For you. Mamie wasn't keen on my bouquets."

Alice takes the flowers, a lavish group of white and apricot roses still dripping rainwater, and stands momentarily rapt, purring. Just the response I'd counted on. Any time spent with Alice is guaranteed to brighten the soul, even this morning, when the occasion is not a happy one. I'm here to dig a grave for Mamie, one of her cats.

"What am I doing?" she laughs, trying to corral the thorny stems in a vase with too wide of a mouth. "You're better at this than I am."

I know where her vases are, and what the choices are, and in a matter a seconds the bouquet is plumped up on the dining table, demanding an encore of appreciative attention. That given, we stand mute, as if awaiting direction.

Alice sighs. "I guess we should get to it. Poor Mamie. We're going to put her under your wisteria. She loved lying in the leaves there."

My wisteria. "Do you hate me for it?" I blurted out a few months ago when she urged me to drop by her house to take a look at it.

"Not at all," she said. "I actually like it. I like plants that do well."

Well, yes, it's doing well. I noticed that immediately as I came down the steps on my way in. It's past the second story and is starting to shimmy across the roof. I've known eager wisterias but nothing like this one. It was so demure when I came across it at the nursery, a few delicate leaves and two lamblike racemes dangling. Such a whiteness. The perfect plant for the trellis screening Alice's deck. Happy Birthday, Alice.

The trellis was snack food, the rainspouts the entrée. One spout is leaking water from its midsection, which I'm sure is the wisteria's intent.

I take my sharpshooter from my pickup and begin to carve a hole in the wet soil. Hacking through the wisteria roots gives me a guilty pleasure. The unfocussed, intermittent dripping all around yields suddenly to a downpour, an impulse from a mostly blue sky. Drops venture down my neck into the channel of my spine. It's the right weather for a funeral. My hands are black from wrestling the clay, but my knees are coddled and comfortable, nestled in last year's leaves. I know why Mamie liked it here.

The hole is dug. Alice hands me the keys to her car and I retrieve the cardboard box from the trunk. I had expected Mamie to be wrapped in something, tissue or cloth, but she's exposed, curled in a ball, black

fur matted. Alice makes a sound that I briefly mistake for a laugh. I want to do something but don't know what. Finally I suggest she get a paper bag. While I hold the bag, she slides Mamie into it. I fold the bag closed and Alice walks quickly back into the house to compose herself.

"I didn't imagine I'd outlive my cats," Alice said during our phone conversation last night. This notion of Alice's mortality continues to come as a shock to me. How could such a flame go out?

I place Mamie at the bottom of the muddy hole and begin backfilling. The rain stops. My hip bumps the trellis and I get an avenging drenching from the wisteria. So you want to cut my roots.

Shovel by shovel the hole fills. Poor Mamie.

"It's so beautiful now." Alice is at my elbow. I look at her face, streaked with tears or rainwater or both, and see that she means the wisteria.

Well, yes it is, the blossoms nesting in the vinous thicket like a flock of snow geese. An hour of airborne acrobatics with loppers and I could have it in shape...bury that thought, my complaining back says.

I wrestle the last chunks of soggy clay into an undignified heap and stand. This might be the time to say something, but neither of us does. Finally I hug Alice, and she says, "Let's go inside. I'm starving."

Her kitchen is in another latitude. The sun blasts through the windows and across the dining table, igniting the apricot of the roses. The brightness seems to be on the verge of splitting a seam, maybe time itself. But not yet...the kitchen smells, tomato, garlic, bind us to the here-and-now. I settle into a chair to attend the singular ballet of Alice preparing a meal.

"Tell me how you've been, but first, let me find the bread."

"I've been dating someone."

"Rita told me."

"Did she tell you I've been a little crazed?" A diplomatic silence. Maybe she's just thinking about the bread. "I may be obsessing. Very unlike me."

We both laugh. After weeks of revved-up feelings, to laugh at myself feels just right. "Everybody obsesses about love," I submit. "What else do I obsess about?"

She laughs again and looks in the oven. Nothing there. "You're having an adventure. Just enjoy it. Cheese. Wait till you taste the cheese I got at the market today. Oh and that good beer."

Enjoy it. Since the adventure began I tirelessly improve scripts of the future wherein all neuroses are quelled and all desires satisfied, or revisions of the past, improving the dialogue so that I would not find myself mired in confusion.

"You cut the bread." Alice hands me a knife, a board, and the anise-seeded baguette. Into a pink bowl she pours olive oil spiced with oregano, basil and garlic. "This is so good I could live on it. I think it's all I had for supper last night."

I'm marinated in desire. I straighten up my house, wash my pickup, tidy up the garden. I shave frequently, dousing my cheeks with lavender aftershave. I perceive omens in Italian vocabulary cards. Every lovesick song, every cliché is pregnant with insight. Get a grip, I tell myself, but when the telephone rings....

"Actually," I say, taking a hiatus from my plunder of the baguette, "it's pathetic. I feel like I'm fifteen."

"It just means you're alive," Alice says, "and your heart is open."

Wine comes in at the mouth
And love comes in at the eye...

W.B. Yeats, *A Drinking Song*

"I'd like to get Mamie a plant," Alice says after the last lick of marble swirl is scraped from our bowls. "Do you have time to help me pick one out?"

"Let's take my pickup."

At the nursery when she puts her arm through mine and we stroll down the aisles of potted greenery, the afternoon is newborn. I feel content in a way I haven't been for days, neither desire nor complaint putting out tendrils. I'm merely curious as to which plants will catch Alice's eye. Nearly everything, of course, and we quickly reach a point where any more information would only cloud the issue.

I intend to steer clear of the vine section but something florid has entranced her, pinkness and lavender in such allure I too am swept toward the greenish thing that, as I suspected, turns out to be a wisteria.

Do aforesaid charms decline as we approach? No dice. A fragrance wafts forth besides. There is nothing to do but submit, led by the nose into the wet blossoms.

Brought to my senses? Why, the opposite, but sanity is easily restored by a casual look around at other vines nearby. On the right, three morning glories in five-gallon containers. Alice's wisteria is cherubic compared to demon morning glory insinuating itself everywhere. Vikki's got one, smooshed and smutty and impossible to eradicate growing between her dining room windows and the fence of the house next door.

89

Here are a half dozen jasmines. Jasmine gives morning glory a run for its money. At a cottage I once lived, having nothing more to smother, it crisscrossed the ground in a dense rattan that only a pipe-wrecking pick could penetrate.

And here a darling passion vine. Prepare a restraining order.

There should be warning signs posted in vine sections of nurseries: *Stranglers, Vandals, Sex Maniacs.*

"I don't think so," I say since Alice lingers beside the wisteria. "You don't want one wisteria on top of another."

"I suppose that would be a bit much."

The vines in my garden are too boring to talk about. I should remove them all. They are relics of a past when ignorance ran rank as their habits. With all, I maintain a watchful truce. A trumpet vine deserves mention, though I'm not responsible for it and its presence in my garden is minimal. By all appearances, it is rooted in Monterey County. This tsunami crests on the backs of the pittosporums in Rita's garden, and rolls under the grapestake fence into my garden. Our agreement is, no further, but I know lawyers are out scouting for loopholes. I keep shears sharpened.

Alice and I amble away from the vines into the shade-plants section where perhaps we should have begun. Gliding through the camellias and rhododendrons is like paging through a fashion magazine, each glossy item saying, *want me, buy me.* I do and I don't, because the perfect plant is in sight. What took so long? I've given five people a daphne in the past few years and have three of my own.

Alice is in full agreement. The variegated one we choose is flush with pink flowers and flagrant with fragrance.

"Be right back," I tell her after wedging the daphne into a secure place amid bags of planting mix on my pickup bed, and dash back into the nursery.

"Yes, yes," Alice says when I return. "You should have it. It's too fine to pass up."

I lay the wisteria on its side, tendrils draping over the tailgate, telling it out loud that I have some behavior requirements. Conditions and expectations. Mainly, it must not to be as rambunctious as its white cousin but it should be as generously floriferous as now. I'm not sure I'm making an impression. There may be ongoing communication issues.

Back at Alice's, one plant and a bag of planting mix transform Mamie's grave from a muddy scar to a resting place. Nestled in, the daphne looks entirely capable of its task of consolation. I kiss Alice

goodbye after trading a promise of some gardening for an encore lunch.

At home, before I escort the object of my latest affection around the garden, I peer through the window of the study to see if the red message light on my answering machine is blinking. *If, if, if.* It's not, but I'm not obsessing.

The wisteria knows immediately where it wants to go, against the wall of the sun porch. I'm soon on my knees again digging, already its slave.

Just enjoy it.

I'll have to build a trellis. A big, thick one.

Spring

READING PALMS

It dawned on me that the noise had been going on for a while, maybe days, just far enough away to be ignored. Trucks in reverse, cheeping like three-ton alarm clocks, finally roused me from obliviousness. I had been taking the silence of the neighborhood for granted, never vacant or oppressive but luxurious, embroidered by the flutter of wings, the sizzle of hail, a cat meowing.

I put down my rake and took an investigative stroll down the street, beyond the ephemeral border that separates the neighbors whose lives intersect mine from those whom I don't know from Adam. I've navigated this little swerve of our street hundreds of times in my pickup, through the stretch of shadow pooled under some redwoods, oaks, and a thicket of ungainly cotoneasters. I never paid much attention to the house up the slope. Though I didn't know the residents, I would have recognized their cars anywhere; the late model gray Volvo with a dent on the right fender and a red Corolla bumperstickered, "EVE WAS FRAMED."

This bite-size message always triggered a chain of thoughts, about a lost garden paradise (was there one to lose?), about how any story depends on the teller, about blame and the juiciness of it, and its ultimate futility. The forbidden fruit, what we gave up paradise for, was knowledge of good and evil. Was making "moral" distinctions the very source of our suffering?

Underscored by chain saws and backhoes, here in the works was a new script for paradise, chapter and verse. The cobblestone retaining wall along the sidewalk, a fixture of my personal geography, was gone, replaced by a muddy passage leading from the street up to the back door of the house. Gone as surely were the redwoods and the cotoneasters, while the oaks tried their best to get out of the way of the backhoes grunting and sighing in the mud. There was nowhere to hide. I grunted, I sighed, and went back home. I prayed it would be over soon.

Now it is a year later, another spring, and they're still at it. The once modest house, introverted in leafy seclusion, has taken on self-importance. It's a stretch to call it the same house, having been jacked up and juked around, amended and appended to. The vast span of Bay, nearly unviewed before, is hereby served up every afternoon on a golden platter.

Give or take the little tower above the garage, the architecture is blameless, even pleasing. Features mesmerize, especially the hammered copper and bronze gates that slide silkily across the driveway, whispering money and taste. Rita told me months ago there was going to be a swimming pool but (disappointment) that turned out to be no more than a damp rumor. Instead of an invitation to swim we passersby get a glimpse through a wrought iron fence of a stream ambling down a hillside into a pond. The rocks lining its descent bristle with bromeliads, tropical ferns and cycads, as if a chunk of the Maui Marriott came to roost on our dry hill.

The temperature always seems to be three degrees warmer when I walk by. Maybe these tropic oases, more and more in vogue, are a conscious or unconscious response to global warming. Why worry? After a chilly winter I'm almost willing to believe a few degrees upswing can't be a bad thing.

I often fantasize about a chance to start from scratch in my garden but details about what I'd do differently remain hazy. When I saw and heard jackhammers breaking chunks of clay and rock, trucks hauling it away, other trucks unloading yard upon yard of fresh soil mix, I had an acute hankering—what paradise it would be to have such ideal soil, never to have to wrestle the clay again. Simultaneously came an insight: it was never going to happen. Get over it.

Now the front garden is finished, or nearly. Golden crushed-granite walkways gracefully define beds framed with swaths of golden coleonema. A rough count tallies thirty different kinds of plants, many new to me. The part of me that wants to dislike it for its perceived pretensions is overruled by a Supreme Court who knows better. Even fairly common plants like ceanothus seem inspired choices, their cerulean blooms an eye-and-nose complement to the honey trumpets of three brugmansias. Lavenders and citrus, a lemon, a lime and two oranges garnish the feast.

But it is the palms that dazzle most and dazzle mightily. Butias, rhapis, and blue fan palms grace their separate beds, while four date palms follow the line of the walk to the front door, italicizing the statement being made. The trunks have been groomed to a fault, as if they've come from a plant spa, all trace of the past buffed away. Every palm is tall, and was hoisted from a truck and lowered into place by a crane. Not being of a mathematical bent, I nonetheless find myself speculating about the costs, but have no points of reference. My idea of splurging is to buy a flat of something.

Impressed I am, but not elated. In fact I feel a tiresome mix of astonishment and envy, a recipe for moralizing. The mind proposes that such extravagance can't be good. Good is simplicity, respect for limits, not mindless consumption. Then the breeze shifts, and the fronds of the palms flutter, winnowing a harvest of sunlight and my objections scatter like chaff.

> *Svelte arbiter between*
> *The shadow and the sun*
> *It takes much sibylline*
> *Somnolent wisdom on.*
> *Unstintingly to suffer*
> *Hails and farewells, forever*
> *Standing where it must stand....*

<div align="right">

James Merrill, *Paul Valery: "Palme"*

</div>

As a child in Kansas the first tree I drew was a palm, a replica of one I saw in an illustration of a Bible story. It was no doubt a date palm, since no other palm was common in Biblical lands. I carefully penciled in the crosshatching on the trunk, diamonds I colored with brown and tan crayons. Outside a blizzard was burying the car.

We're not in Kansas anymore, and I too could have palms. There are at least 25 varieties that are reasonably hardy (to 28 F.), and perhaps 20 more whose expiration point is 32 F. But I don't have a single one. Once I bought two "sago palms" which are not palms but cycads, and they looked so dressy in my bohemian digs that I had to give them away.

Palms, though they signify leisure, are workhorses, providing food, drink, oil, clothing, medicine, wax, thatch, wood, and used as antidote to many diseases. In some Amazonian cultures the palm is so integral to the community's health that it is revered as a deity. The Babylonians had a hymn that celebrated 360 uses for the date palm.

Dates, naturally, would get top billing. They are the "dactyls" referred to in the scientific name, *Phoenix dactylifera*. It was one of the first trees cultivated for its fruit, though where it originated is unclear since it has never been found in the wild. An exceptional cultivar was, and is, a treasure to guard, and there are hundreds, perhaps thousands of cultivars. The date palms in the new garden near my house are there

for one reason, their beauty. The chances of getting fruit in our cool climate are slim. They may well have come from a date farm down south that went bust. Date farming is labor intensive. The flowers need to be pollinated by hand. A single spathe can contain 12,000 flowers, a large tree 600,000. Imagine. If a harvest were possible here, I would certainly plant a twosome.

Linnaeus, who knew at most 15 of the 2,600 or so palm species, called palms *"principes,"* the princes of the plant world. It's easy to see why. They rise above the groundlings, and rouse stronger feelings than most other plants. I was not of the opinion of those who said, "Too L.A." when Canary Island date palms were planted along San Francisco's Embarcadero. Now they stand imposing as Bernini's colonnade at St. Peter's, demanding and earning worship, though I sometimes think of my friend Edith's reaction. To her the Embarcadero is still the "waterfront" where Harry Bridges and comrades struck for economic liberty.

"They just don't belong there," she said.

So much depends on the teller.

> *The palm at the end of the mind*
> *Beyond the last thought, rises*
> *In the bronze décor.*
> <div align="right">Wallace Stevens, Of Mere Being</div>

I stand at the window of my sun porch watching a blizzard. Not snow but cherry blossoms dispersed on the wind. Judging by the number, there must have been a prodigious bloom this year. I barely noticed.

Once it seemed paradise just to have a garden.

Here on the deck I face one of my first big garden projects, the reconstructed path leading from the back door. About ten years ago I changed its route to spotlight the flowering cherry while trying to preserve Uncle Thomas's eccentric touches. It was one of those afternoons when every stone or brick cradled in hand seemed to know where it needed to go and I was just facilitating. I haven't wanted to move a stone since but the luster of the transformation has, like gold plate, worn off. The path is merely the way to the compost pile.

Grasses, fifteen or so, carex, miscanthus, fescues, and stipas, dot the slope. It's the prairie in me coming out. They don't look like much yet, just starting to bulk up after being cut back two months ago, but

come summer, they'll be tall and undulant and every time I pass I will glide my palms (the two I have) over them as over a harp, or a lover. I fancy they enjoy it as much as I. A recent study showed that plants that were touched grew better than untouched ones, the explanation offered that they had to rouse defensive chemicals. We know better.

Linnaeus called grasses "plebeians." Instead of princes, I have a garden of plebeians. Actually, grasses and palms are closely related. Contemplating timber bamboo, a grass, the kinship is instantly readable. My grasses are princely enough. Who has ever caressed a palm?

Summer

HIDING OUT

"I wasn't hiding," I say, but my face blooms red as a peony. My sister's laugh is all gotcha, loud enough to turn heads. We're in a line that's at a standstill. Our destination, should we reach it, is a wedding cake that, when it was rolled onto the patio minutes ago, inspired wafts of genuine reverence. A teeny twosome snorkel amid turquoise and white meringue wavelets. Above a butterscotch beach and plastic palms looms a 3-foot high caramel pyramid. As everyone knows or soon will, the wedded pair met in the Yucatan. Good taste prohibits mentioning it was at a fat farm.

"You wanted to join me," I say.

"I was the matron of honor. I couldn't go hide in the bushes."

These were not bushes. They were astonishing trees, no doubt of venerable age, ribbed and pulsing like three hot air balloons momentarily grounded at the borders of the lawn. I simply had an overwhelming desire to get a closer look.

Such was my line. I probably wouldn't have paid the trees any heed were not the ceremony riddled with longueurs. The minister, Sandy (a lawyer procured through the internet,) kept huddling with Rusty and Ellen, my brother and his bride. They were winging it. Naturally, attention wandered. The inspirational reading, when it finally came, was a parable about a hunter and a beautiful elk, culled from "native, indigenous texts." Most of it was inaudible to those of us in the back but Sandy theatrically got the gist, if not the point, across. Coming hard on the heels of the prancing elk, the recitation of the matrimonial vows provided an outlet for general hilarity.

"The Sufi dance was a unique touch," Sis remarks.

"Different, as Mom would say."

It sent me fleeing. While Rusty and Ellen smooched, Sandy urged all present to spin clockwise with hands upraised to create a "vortex of positive energy." I dove behind the green curtain, unwilling to be caught by a camcorder doing something so humiliating. Before I retreated into the gloom, I glimpsed my poor parents standing dumbfounded in the maelstrom.

By displacing a few branches I could slither my way to a junction where two limbs offered a seat of sorts. What were these trees? Arborvitae? Some kind of thuja? Possibly chamaecyparis. Soon the ribbons and balloons, the orchids numerous enough for Cleopatra, the

elk and the "until death-do-us-part" were forgotten. I was in another world, hidden, intuitive and erotic, oxygenated by the smell of greenery and sap and dust.

Every garden should have a hiding place. The one in my garden is a spot along the upper fence where oaks and wild plums wrestle a lemon verbena for sunlight. It has all the ingredients: seclusion, pungent smells, and a hint of raw nature and decay. Lassitude, not to mention my inability to keep up, had more to do with creating it than intent.

If there's nobody to hide from, the hideaway doubles as a time machine. I am eleven, whisked back to my uncle's farm—into the midst of a lilac bush, a squat, grandmotherly shrub, twice as tall as I and wide as the chicken coop. The lilac was a place to hide behind until the day I hit a tennis ball into its interior and discovered a space in the branches big enough to stand in. Within weeks, disregarding the harm I might be doing to the lilac, I could lie down comfortably in its center. Before that, my hiding places were the tops of trees. I could get snug in those leafy asylums, lulled by the limbs' oceanic swaying, but I knew better than to get too comfortable.

I didn't tell anyone about my hideaway, not even my cousin Jimmy. I was always afraid someone would see me sneaking in and out, feeling then, as today, as if something shameful were going on.

"Why isn't this line moving?" I ask.

"Pictures. The cake must be fully documented."

"Better take them to one-hour development, given Rusty's track record."

"You are too cynical."

"I can count."

I don't doubt Rusty is crazy about Ellen, and I'm pretty sure she is taken with him, but this is marriage number 3. I admire his buoyant toodling port to port. I even wish I were more like him, able to steam ahead with nary a backward look. But I can't get even minutely sentimental about this wedding, despite the lavishness calculated to suggest it's a once-in-a-lifetime event.

I arrived late, the service already begun. I nearly didn't come at all, my resistance centered on getting a passable gift. A plant? For wedding number one I presented him (them) a Korean fir, a 'Horstmann's Silberlocke,' a fir that is to other firs what a panda is to other bears. White highlights on curled needles give it a flocked, cuddly look. The nursery tag said it would reach 15 feet high, ideal for smallish spaces. Precious in every way, I could justify the expense only if I gave it away. For two weeks it sat on my patio begging me to keep it. The day before

the wedding I drove it over to Rusty's house, and planted it in his garden. At that reception much was made over the tree. When the divorce was played out and the house sold, I think I was the only one who gave it a second thought. Curiosity persisted and a few months later I drove by the house, and saw a basketball court where it had been.

This time I called Rusty and asked what kind of gift might be welcome. He and Ellen were registered here and there, he told me. Picking up a lack of spontaneous enthusiasm he said, "Hell, just show up, a gift isn't necessary."

This made me more nervous. Walking out of my house empty-handed this afternoon I succumbed to an impulse and filled a bucket with flowers and foliage, purple smokebush, the linaria called "three birds flying," 'Margaret Merril' roses, variegated clary sage, pink penstemon, you name it. I raided the garden like a Hun.

The flowers are still in the bucket in my pickup. My notion that I would find a vase and a place for the flowers was torpedoed when I saw the acres of orchids. My sister will encourage me to bring in the flowers so I won't tell her about them.

"Hey Dad, how's the cake?" she calls to my father who has snagged a piece and is heading toward the lawn. "What's that turquoise stuff?"

"Haven't had a bite yet. Do you see a place to sit down?"

"Inside," my sister and I both say.

He moves closer to us. "That was no kind of wedding," he says. "What did you think?"

"I thought it was fine," I say.

"A little weird," my sister says.

He shrugs, "Your mother didn't think much of it either."

Once he goes inside, my sister chides. "You thought it was fine. And you go sneaking into the bushes."

Only connect the prose and the passion and both will be exalted, and human love will be seen at its highest.

– E. M. Forster, Howard's End

Amazing what pyramid power can do, or perhaps it was the champagne. I'm not so eager to rush home. A man named Geoffrey, overhearing my sister and me talking about the garden, asked if we'd

seen the "new garden," and offered to show it to us while the gifts were being opened—a good way, he said, "to avoid that nonsense." Suddenly the day looks more promising.

"If you're ready," Geoffrey says as the guests begin to stream toward the living room and adjacent patio. My sister chooses to forego the garden for the gifts.

"Are you kidding?" she says. "This is my favorite part. It's what love's all about."

Geoffrey says, "Through here," and for the second time today I enter the enshadowed world of the evergreens. "Don't you love this smell? These are red cedars, *Thuja plicata*, native to the north coast where I grew up. My mother and aunt would take strips of bark and make baskets. Cedars were the best place to be when it was raining. You could go right to the middle and not get hit by a drop for hours. Good hiding place, too, huh?"

My blush provides an encore. "So much for a clean getaway."

The path dawdles a little in the shadows before it makes a twist toward a sunny opening. He guffaws. "It's all on the wedding video. We watched it while you were waiting in line. Oh, it's a classic."

Now my blush is a floribunda. The Sufi dance would have been less embarrassing. "I couldn't help it. I've seen plenty of goofiness but that was way too California for me."

We pass through a rough wooden gate, beneath a cast-iron arch, and begin a fairly giddy descent. "This garden is all California. Natives. Not too goofy, I hope, though my wife thinks so."

I expect something austere, withered and crackling...it's midsummer, after all, but the flank of this hill is sensuous, subtly pulsing with the movement of grasses and insects. The plants I recognize, like monkeyflower and buckwheat, are uncommonly lush, and then I notice a drip system peeking through here and there. Isn't summer irrigation cheating in a "natives-only" garden? Who's asking?

"The grasses with the golden heads...?" I ask.

"*Calamagrostis foliosa*. They're native to one small area up north. Also called Mendocino reed grass. Pale ale is how I describe their color this time of year. They're hard to find in the trade. I have starts in the greenhouse. I'll give you some." He points to a recently excavated channel. "We're going to put in a trickle of water to mimic a spring. It'll slide down these boulders, spread into a marsh down there, and finally end up in a pool at the bottom. It would be finished by now but the wedding put a serious dent in my budget. When Ellen said she wanted a garden wedding, I thought she meant something small and, well,

intimate. I look at all those white orchids and think of the lace ferns I want to get. You know the lace fern, gets to maybe eight inches, grows in rocky outcroppings?"

I noticed the salt-and-pepper in the goatee, the emerging bald spot, but I thought he was the gardener. "You're Ellen's father?"

"I suppose I should be a better sport but this is her third go-around. As far as I'm concerned, she could have eloped. You look surprised."

Rusty told me she'd been married only once before.

"This is Rusty's third, too, you knew that?"

"We should be in the cake business. That pyramid mess cost over eight hundred bucks."

We weave through the garden, ever descending, and come to a fence beyond which there are live oaks, poison oak, manzanita. The cultivated garden and the uncultivated one stand next to each other like cousins, or brothers in which the resemblances become clearer after a bit of acquaintance.

Geoffrey says, "Jane can't understand why I want to spend all my time and money growing 'nothing but weeds.' Why don't I grow some flowers she could pick?" He bends over and pulls out some bunch grass. "Who knows," he pauses, "maybe three's a charm. Did you read about the couple in North Dakota who got divorced after being married 63 years? Unbelievable. I need to get back. Stay longer if you want."

"Thanks. I will."

He climbs back up the earthen path and through the gate, and I am alone, in a bubble of euphoria under a robust sun, feeling as though I've made a great escape. But from what? A little unease trickles into my mood, and tadpole questions squiggle into being. Why do I so often seek out solitude and seclusion? Am I hiding from something? Shouldn't I be getting back? Why didn't I agree with my father? How can I get my hands on that video?

Fall

LILIES OF THE FIELD

It's a perfect day, the blazing light a call to action. Two thousand and two chores await me, all the usual trimming, raking and weeding. I know the season runs apace, that our boat is drifting hastily toward winter's waterfall, but I lounge semi-nude on the deck, fitfully drowsing. Then I hear a voice....

"Consider the lilies of the field, they neither toil nor sweat..."

I suppose I could take this as a horticultural admonition. I have been ruminating for ages about what to plant in a large elevated bed near the persimmon tree. A bed of lilies? My niece Lily would like that.

"I know what you're thinking," Rita says. "I see the look. You're thinking 'Oh, here she goes again'."

She's right, it's what I'm thinking. For months, Rita has been a political dynamo: writing letters, attending rallies, laboring to keep alive the idea that peace remains a possibility while so much rhetoric is bloodthirsty and defeatist. I feel laggard in comparison, as if immobilized in a giant web. Yesterday, particularly blue, I decided to take a vacation from myself, and good American that I am, went shopping and bought myself a spiffy Japanese CD player. Rita's comment was, "Consumer confidence is up a percentage point."

How could she fault my little gizmo? Just looking at it causes my nerves to thrum. A delicate touch of a fingertip and music! Out with my old CD player and our soured affair, characterized lately by much begging and mild slaps.

I hear her unfolding a chair and sliding it nearby. "Actually," she says, "I'm here to apologize for being a noodge. In sangha last night I asked the Guide about my anxiousness. She quoted the line about lilies, and, if I got this right, the point is not to be the lily—not an option—but to consider it when you are sweating and toiling."

"Meaning what?"

"The lily is acceptance. 'Solomon in all his glory was not so arrayed.' Acceptance...not to be confused with inertia or complacency, *is* an option. I'm working on accepting the one in me who is not accepting, who finds things unacceptable."

"Sounds exhausting, but I'm in favor of it. Tell me this. If your CD player had been stolen, would you have gotten a new one?"

"What I will tell you..."

"...is that you don't miss your TV a bit."

"Not a bit. But I wouldn't have dumped it on my own. Now when I watch TV, and you can't avoid it, I'm revolted, like when I think about eating meat." Rita extends her dance-toned leg and rotates the foot in front of my semi-shuttered eyes.

When her house was broken into a few months ago, and her TV and VCR stolen, she was barely flustered, even though the scene seemed bizarre and perhaps sinister, with trails of blood and two mismatched shoes (both black and right-foot) in the kitchen sink. The police came and did some dusting but didn't bother to pretend much else would be done. I helped Rita put in a new window, and life went on. She was more concerned with the significance of the loss than the loss.

"No," she says uncertainly, "I don't think I would replace it."

"No TV, no meat, no music. Is sex next?"

"Why would I do that?" Rita says and grabs the sunscreen off the rail. "Sex, you probably don't recall, is organic. Birds, bees, even lilies of the field do it. Remember how I used to worry it would sink into Rick that I'm 15 years older and he'd scoot? I don't worry about that anymore, or rarely. Worry was not doing one useful thing."

"Good. You can devote all that worry to Armageddon."

"You don't worry? If all this saber-rattling isn't enough, there's the ozone hole, global warming, plants and animals dying off right and left. God forbid we do anything different, like consider doing without a toy or two, or a 32nd pair of sneakers. All right, all right, I'm stopping. What about rebirth? What are my options, cockroaches and sea spiders and mold?"

"I'm sure lilies worry about their afterlives."

"I was trying to make a joke. Oh well. Worry is not preparation, something else the Guide says. Good God, I'm sounding more like your friend Vikki every day quoting her trainer. Listen, call me later if you want to attend the march. If I were you," she says refolding the chair and leaning it against the house, "I'd worry about being in the sun much longer. Skin cancer is no joke."

Blessed are the peacemakers....

And blessed the silence they leave behind. Once the gate closes behind Rita, I become gradually aware that one voice of the congress in my head is saying something worthy: now, more than ever, tend your garden. If I choose to plant lilies, the bed has to be prepared now,

before the clay gets waterlogged. All right then. I'm off the chaise and into the house to grab a shirt and a hat. I can already see the lilies, white, massive, saturated with fragrance...maybe a whole bed of one variety, like 'Stargazer' or 'Casablanca'. How glorious. And costly. More good news for consumer confidence. I vow, no slipshod preparation. Lilies want a deep bed, good drainage, rich soil—this means getting rid of the clay. Oh sweat, oh toil. I decide to set up the brand-new tiny speakers in the window and put on some music, maybe something energetic to lubricate my labors. But why after 15 years do I suddenly need music in the garden?

Who said anything about need? Not even Solomon could summon Handel with the press of a finger, but I'm suddenly in a mini-quandary about what volume to turn the music, lest Rita hear. Ridiculous, I tell myself, and turn it up full blast, but that seems downright offensive, and take it down from 30 to 22.

Before I get to the removal of the soil, a yet more formidable task looms: the eradication of a trio of asparagus ferns planted in the same era I bought my first stereo. What did I know? The ferns seemed a fairly good idea, something tough and relatively easy to maintain, to drape over the rocks. And so it came to pass, for about five years. Then they acquired imperial pretensions. One day on a whim—no, it was exasperation—I clipped them into mounds. What idiocy. That's what they are now, thwarted but counterattacking with green forays.

War it is. I am not unaware of the irony, also conspicuous in current events, that my enemy is a creature I nurtured not long ago. I line up armaments: shovel, pick and loppers. I search all the likely spots for my gloves, with no success, and decide to do without since I won't drive to the hardware store.

With the loppers I snip randomly. Culling out the prickly stems is next to impossible barehanded, so I take the sharpshooter shovel and skim off the stems where they are attached to the roots. Now the pick comes into play. Each downward thrust procures a satisfying chomp into the wide and gorgonian roots, but the attacks don't loosen their grip. A watering tube is, predictably, hacked to bits. I flail away, physically and verbally abusing this plant. Sweat dribbles sunscreen into my eye and ignites a conflagration. Through tears I make out an exasperating mass of greenery still attached to the roots and I hack and yank, snip and slice, my hands hapless victims. Behold evidence that Nature will survive our worst assaults. I should fetch Rita and share this consoling news.

A soprano not coming from a Handel aria weaves into my awareness—young John from his favorite perch in what used-to-be Gussie's oak.

"Why are you mad at that plant?"

"I'm not mad at it."

"Why are you killing it?"

"It's killing me."

Blatant disbelief registers on his face. "What is it?"

"An asparagus fern."

"Can you eat it?"

"Maybe if you're a deer."

John settles into a watchful silence and I wonder how long he's been spying on me, and what I should feel sheepish about.

"You look like a vampire."

"Vampires sleep in the daytime."

"Maybe you can't sleep."

By now both eyes are involved. I need to stop and rinse them. "Do you want to come over for some blood pudding? My niece Lily and I made it yesterday."

"That's sickening."

"My mistake. It wasn't blood pudding. It was apple pie."

"I'll go ask my Mom."

Cool water streaming over my eyes feels like heaven. When at last I can see again, I put the pie on the table and admire it. I don't know whether our pies have gotten tastier—the apples are always good and you can't go wrong—but I know they have more character. This one is an engineering feat, belying the anarchy that went into its creation—errant peels, clouds of flour, a belching oven. When we began peeling and slicing, I teased Lily saying that since she celebrated her bat mitzvah and now was officially a grown-up, I expected decorum. A reliable recipe for anarchy.

While waiting for John to arrive, I do a graze of the genus *Asparagus* in my horticultural dictionary. One fact emerges from the information: Asparagus is in the lily family.

So, then, what lily are we considering when we consider the lily? The asparagus fern or 'Casablanca'? The garlic I labor to grow or the insidious wild onion I try, year in, year out, to eradicate? The lily family contains over two hundred species; some we coo over and pamper, some we curse and berate.

"The lily is acceptance," Rita's voice echoes in my thoughts, and something else she said yesterday. "All hatred is a form of self-hatred."

"Oh lighten up," I replied, the gloomier of us.

Next summer I may have a stand of lilies that Solomon would envy. I know that when I stop to admire them some part of my mind will be sweating and straining, telling me that if I moved this, got rid of that, added such and such, the garden would be so much better. That's

the gardener's voice and it's welcome enough. When it goes on to say paradise is just around the corner, I doubt it considerably.

Paradise is here, now, or nowhere. That, I'm guessing, is what the Guide would say.

Spring

THIS NURSERY DELIVERS

It's a peaceful Saturday morning, just after 8:00, and I've got a day ahead that's blissfully unencumbered. Then the doorbell rings. Here's Bertie in his rumpled navy bathrobe, a red-white-and-blue umbrella in one hand, though there isn't a cloud in the sky, and a bassinet in the other. The pouches under his eyes are bulging like sandbags, restraining dark pools of fatigue. "Just for an hour or two," he pleads. "We're wiped out."

Just seeing him kicks up a dustdevil of annoyance but I say, "Sure. Go get some sleep."

He hands me the bassinet with the pink bundle inside. "Do you have...?"

"I do."

"Sure?"

"Plenty."

"We owe you big time," he says and shuffles off, looking as if he might walk into a tree.

Butting the door closed behind me I consider the ways that I will cash in. For starters, he'll have to get rid of the ivy that for decades has attacked my garage and is at the moment liquidating the liquidambar. He'll have to stop spraying Orthene. I don't care if his rhododendrons have thrips. No nasty spraying whatsoever. I may be pushing my luck but when a man is over a barrel....

What I won't let him know is how I really feel about babysitting Clara. How the little miss is a big hit, an out-of-the park, over-the-wall grand slam. I part the blanket to get a good look at her dark eyes. She yawns, exhausted after a long night's work of exasperating her parents. I waggle my head at her. What those wide and unfocussed eyes register is surely just another quivering blob but her face lights up with a gummy smile, and I am elevated into the heavenly choir. She likes me! Feelings encrusted in clichés erupt from my heart and I blubber. She smiles again.

Smiles notwithstanding, a mini-fuss is in the works. She flails her gelatinous limbs, as if she'd like to get free of them. To forestall a squall I pick her up and put her over my shoulder. There, fuss over. How skillfully she gets the world to do her bidding. Can this be good for her? We have to be realistic, after all. She can't have everything she wants when she wants it. Wouldn't want to spoil her, would we? These are my

parents' voices percolating through my head, the selfsame whose childrearing methods I rebelled against for decades. Are we confined to the same script generation after generation? I remind myself, I don't need to worry this one out. Someone else can tell Clara about the varieties of disillusion ahead, not to mention pay for college. In this village, and it obviously takes a village, I'll be the fairy godfather.

Who would have thought I'd have any role whatsoever in this baby's life? I didn't even know of her imminent existence until last October when Douglas and Elaine hosted a neighborhood potluck. I was acquainted with most of the people assembled: friends, objects of rumor, subjects of gossip. There was one completely unfamiliar face, and I met her over the food table. "I'm starving all the time," Amy said as she heaped frittata onto her plate. I had heard that Bertie had a girlfriend, but not that she was pregnant, which she visibly was. I marveled that someone so levelheaded, so seemingly mature, not to mention attractive, would be attached to him. Where is the justice? He lurked on the edge of earshot, but I ignored his blatant possessiveness. "I'm moving into his house," she said cheerfully. "We'll be neighbors."

It was mid-December when I next saw her, in the street struggling with a bag of groceries. A week overdue, she was conspicuously miserable. Her skin was sallow and she looked ten years older. That having a baby might be something tougher than, say, doing the laundry, occurred to me but not with much force. I carried the groceries in for her. Just going into Bertie's house I felt I was getting a rash, and I left right away.

Not many days later he rang my bell. Amy was having postpartum bleeding and they had to go to the hospital. Could I watch the baby for a few hours?

I didn't know there was one. I stood aside as he unloaded a caravan of babystuff onto my carpet. All this for a few hours? He hastily returned to fetch the troublemaker. Then there she was, the softest spot in the universe parked next to my desk. By the time Bertie retrieved Clara eight hours later she had a nest in my heart.

Sideways to the mirror I see that she is asleep on my shoulder, her eyes a dime's width from being closed. I ease, bottle at hand, onto the recliner and settle in.

...babbling and strewing flowers....

— Edna St. Vincent Millay, *Spring*

Two hours evaporate, and we're both fully awake. I lift her off my shoulder toward the ceiling and she bestows what might be a yawn or a smile from a seraphic height. "So what are we going to do this morning, my little pearl? The world's our oyster. Shall we stroll the garden? Warm enough for you?"

She bobs, drooling. A yes, I believe.

I carry her carefully across the damp, slippery deck, mindful how last year at this time I went from the dignified vertical to on-my-keister in the blink of an eye. "Treacherous, treacherous," I mutter, meaning the deck but implying the world. She's not worried, not yet.

The sun this morning is a giant incubator. You can feel the shell of winter quivering, cracking. The narcissi are already in their frayed-kleenex phase, but everything else seems right on the verge of technicolor. Budding tulips advertise with a pink swirl, a yellow crescent, a purple swath, the riot to come. Skirting the worst of the mud we ascend the path to get a closer look at them. Every year I plant tulips, every year I swear, never again. Do I even like them?

I certainly don't like planting them. Poking holes in the clay always seems poorly compensated work for two weeks (if rains or wind don't intervene) of display. Moreover, in bloom tulips look as out-of-place in my garden as a corps-de-ballet at the VFW. Too composed, too refined by half. Then the blooms take a dive, and you must watch and wait as the leaves decline, slowly slowly, to a point they can be removed without blowing the chance of another year of bloom. Some springs I yank them right after the blooms are over. Farewell vain hopes and pleasant surprises. Now I buy only Darwin hybrids and species tulips, both types giving a reasonable chance of repeat. A year or two of repeat bloom almost makes the process seem worthwhile.

I plant tulips mainly because Aunt Dot did. She said if she didn't, there might be no spring. Every year there was spring. What she liked most about them was their resilience, the way they could be beaten down by wind and rain yet when the sun came out they could throw off the mud and emerge triumphant, if a bit twisted. If you grew up in Kansas, you could relate. Her sister, Aunt Shirley, had a less heroic view of them. "Tulips remind me it's tax time," she said.

"Remind you of taxes, little darling?" I ask Clara. I buzz her face close to a particularly robust tulip, one that would tower over her if

I could stand her beside it, and see a sudden registering in her eyes, a shiver of baby delight. Maybe I'm just activating the bee genes swimming (flying) in her gene pool. Her pink cheeks blossom with a violet tinge, a reverse mirroring of the tulip's cheeks. Nothing is clearer at the moment, less debatable: all is one, one is all.

My mystical moment lasts less time than a clean diaper. A voice kindly reminds me: Clara's genes, half of them, are Bertie's genes. If you become attached to Clara (become?) you'll have to give up the pretense babysitting is a chore lest he stop bringing her over. That doesn't mean you can't reach some agreements about his gardening practices. It may mean you will find it easier to do so. Would he spray Orthene or blast his leafblower if he considered the baby?

Leafblower? Curious, but that is what I am hearing, and the noise is coming from.... It's more than I can believe, that he would drop off the baby and go home and blow his leaves around when he knows I hate everything about that machine.

Storming over—as much as one can storm with a baby on the shoulder—I discover it's not Bertie but a crew of three working in his yard. The youngest, a boy of maybe twelve, directs the leafblower from one soggy bay leaf to another, coaxing each into the damp, lethargic assembly tumbling down the driveway. I hope, at least, the noise is disturbing Bertie's slumber, but I doubt it, it's too far from his house. When at last the boy idles the machine to hear what I'm saying, I'm babbling, with somewhat less comprehension than when I was blubbering at Clara earlier.

Retreating to my own grounds, I feel subverted and duped, as if Bertie masterminded this. A history of minor irritations hardens like drying plaster over damp ideas of reconciliation, and here I am, encased in a mindset. We can't get along. He's a barbarian. I'd be a wimp to negotiate. Besides, I relish the battles, getting comfort in my alliance with Rita and our ongoing chats in which we dissect his latest idiocy. Peace, truth be told, would not be nearly so engaging.

"What do you think?" I ask the moist squiblet on my shoulder. She rips a healthy fart; a Bronx cheer, I project, for this line of argument. Idiocy, she suggests by her fragility, is to wish for anything but peace.

The leafblower subsides, sputters to a stop, just about the time I've forgotten about it. Two mourning doves reposing in the red-leaf plum tree warble their notes, then flap squeaky wings into Rita's garden. The plum is at a pinnacle of bloom, so it's official: spring is here. A flutter of petals drifts slantwise over the raspberry bed, over our heads, out of the garden, into the world.

It's all yours, Clara.

Summer

HISSING COUSINS

It's raining bowling balls, or so it sounds. Such thumping and roiling on the roof of my study could only be made by...raccoons? At midday? I can get a view of the roof from the upstairs bedroom but my leg is in a cast and I debate the necessity of negotiating stairs. While I ponder, the commotion grows fiercer. What are the bastards doing, ripping off my shingles? I put down my book and grab my crutches.

I'm taking this personally. I feel like they're out to get me, especially now that I'm vulnerable. I've thought so since the morning I found all the plants on my deck pulled out of their pots and strewn about. The night before, swinging a broom I had chased a furry foursome from my porch steps.

Lately the little terrorists have been gouging huge holes in my lawn, hunting grubs or some other midnight snack. Admittedly my lawn is a sad sack, but it is mine. Now it looks like a minefield. I crutch around each morning, replacing the divots gouged out during the night, ruing my decision to put in a pond. Before the pond, raccoons were not a problem.

I thought for years that my garden had a serious deficiency without some kind of water element. I procrastinated, alternately intimidated by doing the work and the cost of hiring it out. One day I put dithering aside and grabbed the pick.

It took two weeks to dig the hole, line it, and set the stone. I kept in mind how water in a garden can be pure poetry, a simple, perpetual refreshment. I was winging it. What was originally imagined as a naturalistic scattering of rocks with a stream became progressively more geometric until I had a circular pool with a copper pipe at its center. It was nothing but hunks of stone with bits of hardware until I filled it with water and turned on the pump. When I heard the contented trickle and saw the quivering light, my spirit took flight. I loved it. I was a genius, again.

In two days the pipes were bent, the pump dislodged, and the water lilies overturned. Little orange fishes flashed by no more. I fortified the pond with cement and wire. The next day the pipes were bent, the pump dislodged, and the water lilies mauled. I exchanged the copper pipe for a flexible rubber one, got rid of all the aquatic plants but reeds and a cyperus, and settled into a reality of diminished expectations and mosquitoes.

Now raccoons come nightly to my pond and picnic. As familiar as they have become, they still spook me a little, their weird hands dipping into the water to wash their grub. Linnaeus mis-named them *Ursus lotor*, the "washing bear." Like bears (and humans,) they are plantigrade, able to stand on the soles of their feet. If I advance toward them they rise up and stare me down, hissing.

Everyone has a raccoon story. Walter was chased by a hungry pack in a state park. Raccoons ravaged a case of Snickers in Rita's garage. Alice battles them for the ripe persimmons. Phil tells of a dog lured into a lake and drowned. For months Matthew endured the cavorting of a lovesick pair on his roof. Neither coyote urine, nor ammonia-soaked rags, nor rubber snakes could quell their passion. He resorted to stringing barbed wire.

The most astonishing story I heard is how someone I know shot seven in his garden in Berkeley.

"Shot! What does he do, stand at the window with a shotgun?" I asked a mutual friend.

"He does it with a handgun," was the answer.

This revelation cast his garden, a dreamland of heliconias and bromeliads, into a very different light. What's under that mound near the stream? From what comes the astonishing fertility?

I could never pull the trigger, if I had a trigger to pull. Or so I tell myself as I reach the upstairs bedroom. I am fully cocked for some operatic screaming but when I stick my head out of the window there's nothing to see but shingles, unscuffed and unruffled. That's a relief, anyway. I turn and head back downstairs toward my easy chair and the book I was reading.

He was becalmed, amongst the strange weeds and hallucinatory beasts of the Sargasso Sea.... The cabin, after eight months of cramped, unmethodical male housekeeping, smelled as if cabbage juice had been poured over old bedding, allowed to ferment, then baked in a hot oven.

– Nicholas Tomalin and Ron Hall, *The Strange Last Voyage of Donald Crowhurst*

I look up from the book to evaluate my own housekeeping: unmethodical and male, but not to the cabbage juice stage. It can wait. My garden, on the other hand, is a nursery of urgencies. I need to pull the rampant self-sowers, the forget-me-nots and montbretia, before they go to seed. Clip the lavenders before they get out of hand. Make adjustments to the watering system. Haul compost for the tomato beds. PLANT THE TOMATOES. My mind races on a treadmill but it is my body that needs the workout, in fact is longing for it. This time of year, the height of summer, work and its payoff are very nearly synchronous. Light brims through the leaves, still plump from the plentiful winter rains. You trim, refine and shape, attuned to the soil as surely as the plants, and occasionally look up and catch the garden unawares, in transcendent newness, as if surprised by its own beauty.

Instead, I am turning into a lump, and there are still three weeks before I get my cast off.

I dive back into the book, to June, 1969. Donald Crowhurst's sailboat, one of seven that set out the previous fall in a race to sail non-stop around the world, is in the mid-Atlantic, heading home to England where a hero's welcome awaits him.

Crowhurst had helped design the boat, a trimaran, and prior to departure had made a few trial sails off the English coast. The trimaran was clearly unsuited for such a voyage, and poorly supplied. Pressed by a starting deadline, he set out anyway. Bad went hell-bent to worse.

Now he's facing his biggest problem: he never sailed farther than the south Atlantic where he drifted for months avoiding discovery, fudging his logs, biding his time. Deep down he knows he will be found out. Bankruptcy and public humiliation await. His logs at this juncture are increasingly dedicated to spoondrift mysticism, peppered with capital letters and exclamation points, evidence of what sailors call "time madness."

Over my head the ruckus restarts. There's no question; they are out to get me.

Wrathful as Ahab I lumber into the upper garden for a different view. Again, nothing to see, so I return to the house, pausing at the doorway to heed the voice questioning whether I, like Donald, could be LOSING MY MARBLES!!! My hallucinatory beasts are not visual but audible.

Then I see a movement over a gap in the wood where the boards of the eaves have warped. Squeezing through the gap it slithers, grotesque, hairy, alive...a striped tail. A raccoon's tail.

Incredulity explodes into outrage when a stream descends. I am nearly, nearly being pissed upon.

I doubt the universe gives personal messages, but perhaps I should start rethinking. Last week I was sitting under a pergola in a Sea Cliff garden, soaking in the view, so to speak. Then I heard a trickling sound coming from the latticework above me. Yes, a raccoon. This is the second time in two weeks this has happened. How many people can claim that?

I could focus on the fact that on both occasions the torrent missed my person but I don't. Action is called for. Homeland security.

"You can't do that here," I yell. I bang my crutch against the eaves. My indignation has no effect. The furball doesn't cork it until there's a puddle at my doorstep. The tail slides out of sight.

A raccoon in the eaves. What can I do, bomb the house? A reconnoiter doesn't enlighten me how the raccoon got in there, unless it somehow curled around the edge of the roof and in defiance of gravity slid through a tiny gap between joists. If anyone could, a raccoon could, but reversing that maneuver would be even more remarkable. A 10-foot drop to the deck is likely. I hear it, or imagine I do, whimpering, panicked, as it hurdles the joists in the attic.

Idiot. I am starting to feel sorry for it.

It seems to me that progress is the coin of most value to humanity.... Progress towards what? Why, towards cosmic integration, of course, where else do you think you are going?

– from Donald Crowhurst's logs

Cosmic integration. That might describe what I feel when the garden is particularly radiant. I bask in a corresponding glow, reading the garden like an appreciative essay on my standing in the scheme of

things, and my progress toward enlightenment. Along come the raccoons—pests of any kind—to bring me down from the clouds and remind me that I practice selective integration (a.k.a. segregation,) keeping some Nature in, most out. It is what all gardeners do as we strive to re-create Paradise, an ideal nebulous at best, and unattainable. Killing is often involved.

How much is justifiable? The junipers? Thumbs down. The redwood tree? Down. Insects? Which insects? There are black widows in the dry agave leaves. Snails? Squash them between my fingers like Bertie does? Gophers? Thank God I don't have them. Deer? The fence works. Possums and skunks? Snakes?

What are my choices with the raccoons? Killing them is out of the question. Judging by hearsay, it will not be a snap to send them packing. I could, but I won't, dismantle the pond. Even in its diminished state, the garden turns around it. I was right, the garden did have a serious deficiency without it. I resolved the deficiency; am I happy yet?

Might I welcome the raccoons to the pond as fellow connoisseurs? I think I already missed that stage. I know some of the heat would go out of our skirmishes if I took them less personally, if I viewed their behavior as merely opportunistic, doing what raccoons do.

I'm willing (is there another choice?) to give it a try, just as soon as the one in the attic scrams.

SNICKERS! I'll lure it down with Snickers.

Summer

THE WAY-BACK MACHINE

"I would get rid of all of them, if I could figure out how," Stuart says, grasping and ripping out stalks of Peruvian lilies. "This garden is a library of My Big Mistakes."

All I read is that Stuart's bent for exaggeration is intact. His San Francisco garden looks better than ever, fecundity and tranquility sandwiched between tall houses in the Haight. I'm glad to be back. Sunday brunches were once a weekly event here, a ritual meeting of a circle of friends. I don't know if we assumed we'd stay friends forever, but nobody would have imagined the circle would be so ephemeral. Stuart and I are the only ones living hereabouts, on opposite sides of the Bay Bridge, a span that seems to lengthen every year. We seldom talk and when we do, rely for conversational sustenance on the past.

A week ago, while shopping at a nursery in Oakland, I overheard a woman on her cell phone raving about a garden, Stuart's garden, it became clear. When she disconnected I told her I knew who created it. Later I phoned Stuart to tell him, and he invited me for brunch.

"Your garden is a landmark and you know it," I say. "I told that woman how you started with a mound of junk surrounded by a rusty chain link fence. I felt reflected glory."

He doesn't seem to hear, attacking the lilies with a vigor that is almost alarming. Part of me wonders if he is truly upset, while another part fears I might be asked to help. Yesterday I spent five hours in my garden. Today I am in a happy relationship with a cushioned patio chair. It is Sunday, after all.

"For instance," Stuart says. "The apple tree. Big mistake. It was my first big purchase. Gravensteins. They do well in Sonoma, ergo.... Wrong. Look at the leaves. Every year it gets aphids—I cut off the infected leaves—then mildew..."

"Does it produce apples?"

"Last year a record seven."

The menora-esque limbs, a polished pewter, repel any idea of a saw but the leaves, indeed, do look scuzzy, brown and crinkled.

"You spray it?"

"I used to, soaps and oils, but I discovered that by August it usually outgrows the nastiness. It looks almost presentable for a month then the leaves start turning. Well, it survives, anyway. It's twenty-five years old. God, I can't believe it."

The outermost three inches of growth is a fresh and healthy green. With spraying eliminated from my own critical evaluation of the tree, I give my verdict: "Not a big mistake. Who notices the cruddy leaves but you? How were the seven apples?"

"So-so. Whereas the cherries from the tree above you, they're something else. Very tasty. Too bad I can't reach them to pick. The birds enjoy them." The cherry tree sways in the breeze, the tips of its branches at the height of the roof of the house next door. "You remember Mimi? It came from her garden. Remember how cranky she could be? She put up with me because I was Ben's friend. I thought she was having a spasm of generosity when she asked if I wanted it. She said how good the cherries were. The tree, it turned out, was a big sucker and needed to be dug out anyway."

"I thought you liked her."

"I put up with her because she was Ben's friend. Actually," Stuart says, "I don't really mind the tree, but it's a mistake."

"What's so terrible about Peruvian lilies?" I ask. "I think they're beautiful."

"If I had the red ones or the white ones or even the pink ones I'd be grateful. But these yellow ones are running dog imperialists. Not to mention stirring up guilt feelings. Remember how Mr. Peabody would say, 'Sherman, set the way-back machine to...'? The lilies take me right back to 1982."

In my brain a volume is pulled from a dusty shelf, its incidents and characters obscure.

"My cousin Sean," Stuart cracks open the volume, "you met him at Lorna's wedding–came with his boyfriend Maurice for a visit. The garden was starting to look like something by then. One day they brought me a gift from the Berkeley Botanical Garden: seeds in a little brown envelope. 'Golden flowers on three-foot stalks,' they said. 'masses of them.' I should have paid attention to that word 'masses.' I suspected the seeds wouldn't germinate well in my shady garden so I sprinkled them all over. Three or four months went by and one day I noticed a shoot, many shoots, which weren't any usual weed, slightly bluish. The lilies. I called Sean in Connecticut. He wasn't too thrilled. Maurice and he had split up. I was surprised, not that I should have been."

"You knew something?"

"Well, yes. Maurice was one of those guys who come across as blissfully uncomplicated. Cute as a button and no problem working it. I can't remember where Sean was but one night Maurice and I were horsing around, and one thing, as they say, led to another, until I said,

Whoa. It was one of the few times in my sexual history discretion reared its ugly head."

"First base?"

"Two-bagger. With an extra base on the overthrow. Nothing to feel mortified about the next day. Maurice thanked me later. The three of us were having a great time and it probably would have ruined the fun."

"So where's the guilt?"

"I went back East the next summer. By then Sean and Maurice weren't speaking. Sean said that Maurice had become impossible, completely paranoid about his health, which, Sean said, was not as bad as Maurice made it out to be. Sean was in total denial. I kept postponing getting in touch with Maurice until the last day of my visit. When I finally called him, I made up some excuse about time getting away from me. He said he didn't have time for bullshit and hung up on me."

Stuart pauses, and a dry smile crosses his face. "He died less than a year later. I felt really ashamed."

"You still do?"

"Not that much anymore. Maybe a tinge. Now I just see the lilies mainly as a nuisance."

His frenetic massacre of the lilies has settled into a rhythm. I enjoy watching the crisp, precise movements of his elongate hands, giraffes compared to my burros. He's not even trying to dig out the roots, merely pinching the stalks to the ground.

"That plant will be happy to be free," I say. "It's turned white."

"It's supposed to be speckled. *Helleborus argutifolius* 'Janet Starnes.' Well, maybe not this pale. I mortgaged the house to buy it, you'd think I'd take better care of it. Hellebores are the rage. At least they were last year."

I think of the hellebores I know, pleasing but demure, and I wonder why the enthusiasm. I stand and move to get a closer look at the leaves of this one, mottled with white spots, lustrous, and I understand. Doubled it would be something to behold.

"How much was it?"

"Too much. The flowers supposedly are white with a tinge of pink. How pink is anybody's guess. Maybe the mugging from the lilies is good for it. In the wild some hellebores get covered by bracken every summer. That's how they get protection from the sun."

A brutal sun will not be a problem here. I move the patio chair away from the encroaching shadows and resume my seat. Stuart and I once timed the transit of sunlight across the floor of the garden at seventy-two minutes. Even in the sunshine the air is chilly, but at least

we're relatively protected from the winds that assemble, or disperse (I can't tell), scraps of fog overhead.

"What would you do?" Stuart asks.

"About?"

"The lilies."

For a micro-instant the thought of herbicide crosses my mind—a squirt here and there, a little bath of a tender stem, but it is squelched. Stuart has been Mr. Organic since Food Conspiracy days. Moreover, I run the risk of starting my own internal pistons pumping guilt. Recently I read of a study confirming that atrazine, the active agent in many weedkillers, in concentrations far below EPA-approved limits, turns male frogs into hermaphrodites. Its use is so widespread that there is no longer any atrazine-free environment.

"I guess I'd do just what you're doing," I say, "keep yanking."

Saying this, I notice he has stopped, leaving a stand of lilies about a yard in diameter. "Are you leaving those?"

"I always do. It's a memorial. It says, I remember you, Maurice. Isn't that what we all want, to be remembered?"

That's fine, I suppose, but it seems like a consolation prize. Wouldn't we rather bask interminably in the sun? Be the living apple of living eyes? But that's not an option open forever.

"Do you still meet a lot of people through the fence?" I ask, suddenly recalling how passersby used to stop and tell Stuart how much they loved the garden, how it meant so much to them on their daily walks. When he replaced the chainlink fence, he built a wooden one spaced so people could peer in. He said it was a great cruising opportunity.

"Hardly ever," he replies. "Last month when these lilies were blooming I cut an armful I just wanted to get rid of. I was too chicken to yell over the fence—'Take some lilies'—so I put them in a bunch of jars and set them along the sidewalk with a 'Free' sign. Nobody took them. Maybe one bunch. I ended up throwing them on the compost pile."

"But people notice the garden. Like the woman at the nursery. Maybe they don't stop and talk because they're all on their cell phones. 'Hi, honey, I'm at the corner. Hi, honey, I'm crossing the street'."

Stuart stops plucking at the lily stalks and looks at me. "By the way, why is it so hard to reach you? Either your line is busy or you don't return my messages. What's with that? I am starting to wonder about our friendship."

Before the flowers of friendship faded friendship faded.

– Gertrude Stein

I nearly say something about time getting away from me. He's right. I am less in touch. Why? Because when we get together sooner or later we must analyze what happened to our friendship. So I say nothing.

As Stuart collects the lily stalks and carries the bundle to the compost pile, I think of my garden across the Bay, and how much of my gardening pleasure I owe to him. I can count at least seven stellar plants he has given me: an astelia, a pink-flowered ceanothus, three kinds of salvias, a variegated weigela, and a 'Royal Sunset' climbing rose. Not one, even remotely, a mistake. A library of delights, actually. Nor can I forget the Fuyu persimmon tree, a birthday gift a half-lifetime ago, which this year, after years of providing abundant visual pleasure and not one persimmon, bears a grand total of five.

The fog, it has become clear, is not going to clear. In fact, fewer flashes of sunlight penetrate it. Freezing, I get up from the chair, and grab a shovel that is leaning against a tree fern.

"Don't even try," Stuart says watching me sink the tip into the soil around the lilies.

"I'm not. I'm taking some home. I have an enclosed flowerbed where they could spread to my heart's content."

"Be my guest. Be careful. They self-sow, too. Probably not in your clay."

It seems a good time for farewells, and I keep them short. My thin jacket is no match for the scouring wind. Ah, summer in the city.

I board the packed and airless streetcar, a sudden contrast to the bluster outdoors. Inside the white plastic bag I carry is a cluster of pallid, fleshy roots releasing bits of humus and sand, looking fetal, blameless, harmless. Or is this the start of a big mistake?

Fall

AFTER THEY'VE SEEN PAREE

"What do you want me to do, exactly?" I ask queasily.

"Oh, I don't know," Philippe says, with a little backhand twist of his wrist, "just put down a few *breeks*."

How did I get into this? Blame it on a warm fall evening, the buzz of champagne, a harvest moon. I was walking arm in arm with Vivian, Philippe's wife, admiring our mutual friend Bosco's new garden when she emitted a sigh that expired as a moan. "I am so jealous. Bosco's garden is much prettier than mine."

I was at a loss for a response since it was all too true, but I figured it was just a joke—Vivian is known to enjoy playing La Princesse—until I felt her manicured thumb and pinkie digging into my biceps. "I'm serious."

Even if she were, I didn't need to be. The sun had set and colors over the Pacific deepened into tourmalines and topazes. Two jets swam lustily toward the buttery light, like spermatozoa hunting the egg. I was experiencing a pleasure that seems, even as others diminish, indefinitely renewable: that of exploring a new garden. I had been here many times before but until recently the garden, if you could call it that, was hardly more than a patch of dry clay with one overgrown pittosporum, sun-scalded ivy, blackberries, and deer-chewed agapanthus.

The transformation was total. Unlike mine, Bosco's garden is small. You can't get away with fudging, and nobody tried. A Zen-like composure radiated from every detail, even though the design was anything but austere. The flagstones, the river-rounded rock and the crushed granite path reflected tones of the same gray, and grew more lustrous as the light faded. Bosco himself seemed changed. Not long ago his relationship with plants was confined to what they did to his view of downtown Oakland, but here he was, giving a tour. "Look at these happy heucheras," he cooed. "Aren't they seductive?"

The muse and flower of his transformation, and the garden's, was Maddie, the mum-to-be at his side, in full bud. We all know it's a breach of taste to exhibit marital bliss in view of loved ones and friends but theirs seemed so generous and inclusive you couldn't help bask in the glow. Maddie caressed the plants almost unconsciously, running the backs of her palms over the leaves of the vine maples, fingering the variegated nasturtiums, conducting, it seemed, a botanical composition.

Under the knee-high lamps the light grew golden, rich. The breeze that had roused some moments earlier settled down and slept, and the

velvet scent of heliotrope blanketed the air. There was the harvest moon in its handsomeness, waltzing over downtown Oakland, and a third glass of champagne in hand when Viv planted herself and demanded, "You've seen our garden. What would you do?" Their garden wasn't that bad. It had some fine plants but as in many gardens in their neighborhood, they were clustered near the fences like cattle in a snowstorm.

"Easy," I said, blithely and falsely, "get rid of that terrible lawn." Vivian responded as I imagined she would, saying how the lawn was good enough. They didn't have time to fuss over it, what with three houses to keep up. They traveled half the year.

Then she paused, and after a few moments of cogitation that set the tips of her blonde curls vibrating, she turned toward me. "And put what in its place? I'll bet you have a brilliant eye," she said, fixing mine with hers. "Could you help us design something?"

What did she know of my eye? She's never seen my garden. What she intuited, correctly, is that I am someone who has never forgotten a compliment. Flattery ripens me and I fall like a mango into another's hands. Not this time. But what she said next made roadkill of resistance. "You know we have the studio in Paris, Notre-Dame right out the window. How about a trade. You help us and you can stay there free anytime you want." She read the interest on my face. "Deal?"

I grew up in Kansas, the anti-Paris. When at 19 I finally beheld Paris, it fit hand in glove into the one I had imagined (except for the Eiffel Tower which was so big.) I am not a cheerful riser, but that summer the sun each morning announced, "Wake up, lucky boy, you're in Paris." To this day in dreams I work out neuroses in Parisian locales, though I haven't been there in years.

Looking around Bosco's garden I could see how something similar could be done fairly simply—moss rock, flagstones, gravel...a couple days' work. I've done similar projects in my garden. I said I'd take a look.

Now we are gathered, three weeks later, Vivian, Philippe, and I. Vivian has just told me that she doesn't think moss rock and flagstones are what would look best. *"Breeks,"* Philippe says, "they are *breeks* in the patios. It must be *breeks.*"

Well, of course. Bricks would look better but the difference between managing a slope using rocks and managing one with bricks is the difference between sailing a sloop and sailing the Pequod.

"I'm not sure what you mean," I say, playing dumb effortlessly.

"You know," Philippe repeats, "just put down a few *breeks.*"

There are certain queer times and occasions in this strange mixed affair we call life when a man takes this whole universe for a vast, practical joke, though the wit thereof he but dimly discerns, and more than suspects that the joke is on nobody's expense but his own.

— Melville, *Moby Dick*

It's not like I owed them anything, or made promises. They're not even close friends. I could have said no, should have, before I sank my spade into the lawn that Philippe had so helpfully soaked earlier. That first rip through the roots was juicy, muddy but unmuddled, to the point. I plunged ahead, making second and third swipes, telling myself I was just sketching with the shovel some general outlines.

Some other part of me was saying, how wimpy to be afraid of a few *breeks*. Wasn't I just the other day looking through a book of photographs of Le Notre gardens? Versailles. Now there was a project.

By lunchtime a quarter of the lawn was in a heap. Someone, possibly me, would have to get the lawn, all four trillion pounds, down a breezeway too narrow for a wheelbarrow, through the garage, out to the street. I or not I, it made no sense to haul it anywhere heavy with moisture. I went home. It rained that night, and two nights later, the first generous downpours of the rainy season. The oozing lawn would be dry by May, if then.

Now it's a sunny Saturday, my day off, and I am back shoveling, mollified by the realization that much of the lawn won't need removing. It can be simply covered over. What is a trifle disturbing is my creeping awareness that the slope, rather than easily finessed, as I thought, inclines about eighteen inches back to front. It will have to be leveled somehow, built up if not dug down.

That's much more than I want to undertake. Quit is the only choice, even if it means leaving a big mess.

"Monsieur, I tell them to put the *breeks* in the driveway," Philippe calls from the second floor window. "It is the only place."

The bricks. Last Wednesday I ordered five hundred to be delivered, along with a yard of sand. They're early! Cancel! I hurry to the driveway in time to see sand cascading from the raised bed of the delivery truck into a mound between pallets of bricks.

It's eleven A.M. Good-bye afternoon movie. Nothing to be done now but suck it up and start toting. At least the bricks' arrival is timely. With each bucket of grassy mud carried out, I can carry back sand and

bricks. Like a tendril weaving through a crack in the walls comes the sound of Vivian torturing her oboe, or vice-versa. I brush past Philippe in the breezeway. He peers over his blue-framed reading glasses. "So many *breeks*." It is what I am thinking, hoping I haven't ordered too many.

When all the bricks and sand have been brought into the garden and all the mud taken out, I sit down on the top of the three steps leading from the studio patio. *Ouf!* Surely the worst is over. Now what? I resurrect a bit of advice about gardening design: if you're having trouble beginning, think about paths as a way of organizing ideas. I'll trust my intuition, go brick by brick.

I level an area and put down a bed of sand, take a first brick and set it in place, then another. That's all there is to it. A path begins to take shape angling from the step, gradually, ever so slowly, leading upward, incorporating three low risers (shouldn't I be using mortar?) until, three hours later, it reaches the perimeter of an apple tree.

I stand, or rather, try to stand, a brick having lodged between my spine and my sacrum—it's noble pain, the suffering of an artist overcoming obstacles, until my brilliant eye judges, in a flash, that the path is thuddingly pedestrian, arbitrary instead of inevitable. The outer edges are imperfectly aligned, and the bricks are uneven.

Oh well. Plants will hide that. It's good enough, just what Vivian said about the late lawn.

I chomp into the bronzed side of a gold-green apple, a pippin of some kind (what apples!) and then another, and another, doing my bit to deal with an overabundant crop. (Overabundance is not going to be a problem with bricks.) Bosco's garden is years away from supplying this kind of taste thrill. Is Vivian aware of this?

Coincidentally a waft of floral perfume reels me in from my reverie. "How lovely. Now what are you going to do?"

When I say I am not sure, she says, "Let's get Philippe and see if he has any ideas."

"Over here," Philippe says without a moment's hesitation standing on the new brick path, "you put a little *peninsule* with maybe bushes so tall and lower bushes over here so tall."

"Then what?" I ask.

"Oh, I don't know. You will figure it out. But maybe you should put the path with a little more angle. *Comme ça.* That way the *peninsule* can be wider. You can do that, no?" Then he notices how few bricks remain. "It takes so many. I am *flaggerblasted*."

He surely knows a "little more angle" means lifting every brick and starting over. Or does he? Vivian, noticing the despair in my face, gives me a piteous look, whispers "*Courage*," and retreats to her oboe.

I sink to my unpadded knees. I try pushing the bricks to shift them all at once like a flock of birds, and only make everything more irregular. Quit, the voice returns, quit now, but that voice is sinking in the polls. Frustration is being alchemized by the awareness that Philippe's little *peninsule* is a burst of goddam genius that begets ideas galore. One *peninsule* is not enough. There will be two; one to define a seating area here, and farther up another mini-patio, fit for a bench or two. The path will make two angled turns, simulating distance, and the plants intruding into the bricked areas will create rooms, adding depth and grace and mystery. Just like Versailles.

It's dark before I know it, and I'm out of bricks. The first path, I see, was practice, and this, so satisfyingly, is the real path, precise, well-built, climbing upward from the apple tree. I'll bring mortar next time, and wood for framing. How many more bricks do I need? At least two thousand.

Merde.

Winter/Spring

MARIGOLDS

An orange glow suffuses the riverbank, as a crescent of fire pierces the haze. Here comes the sun.

"Boat, sir?" a boy of about 11 asks, approaching. It's the tenth time I've been asked this question in the past hour. Gliding by offshore are boats loaded with tourists, risen early to view the ceremonies that take place every sunrise along the Ganges. Indifferent to their cameras and the floating scuzz, a man with a trimmed white beard and a scarlet turban brushes his teeth with a twig, his spindly shins piercing the water like the legs of an ibis. This ghat, a section of the steps that line the river, is the southernmost at Varanasi. By the time the boats reach here the tourists have snapped so many pictures that the flashes are infrequent.

"No boat, no thank you."

"What is your name, sir?"

He sits down beside me, resting his head on his bony knees, watching me sideways. Pankaj is his name. "Maybe later, sir, you will like."

"Maybe."

On a gray, trampled peninsula of silt deposited by last summer's monsoon, a man in a loincloth jumps up and down, exercising. Above and to his right on some steps, amid a thicket of bamboo poles dangling basket lanterns, a boy in a school uniform—white shirt, blue trousers and red tie—reads the newspaper. When he puts a section of it aside, a dusty black goat hops three steps down to nibble the edges. The boy rattles the paper, but the goat is unperturbed. It gives the discarded section a tentative chewing, ingesting all but a corner that floats back to earth.

Halfway to the river a group of women sit in an oval, chanting, rhythmically clapping. I ask Pankaj if they are locals or if they've come here on a pilgrimage.

"From here," he says. "Varanasi women."

The newborn sun irradiates the shawls covering their heads and shoulders—yellows, greens, blues, reds. On my arms I feel a hint of the coming heat of the day.

Pankaj sits upright. "My uncle has beautiful silk shop. He is very famous. His picture in magazine. You want to see?"

"No silk shop," I say. He raises his eyebrows as if to ask, why are you so skeptical? Have I ever lied to you?

126

"I show you," he says and bounds up the stairs and is gone.

The women stop chanting and each takes a marigold and holds it forward, stirring the air clockwise. Then, with gentle prying, they loosen the petals from the flower and toss them into the center of their circle. One of the elders lifts a brass teapot and pours Ganges water over the petals. It reminds me of a scene from yesterday: the sound of urgent chanting, and four men emerging from an alleyway bearing a litter, a corpse swaddled in orange, taken to the river and submerged briefly before being laid out on the cremation pyre.

"I come to India because spirituality is alive here," I heard a tourist say, and I thought, put a cork in it. If spirituality is alive, it ought to be alive everywhere, especially at home. But here I am, watching another sunrise bloom over the gently flowing, polluted holy-of-holies, the Ganges, with an attention that might be reverence, or a prelude to it. How many times this past year have I watched the sunrise at home?

"Here," cries Pankaj, out of breath. "I told you."

He leans against me and deposits a magazine in my lap. On the cover is a photo of Catherine Deneuve. With his index finger he flips to a page that shows Deneuve eyeing a gold sari draped over the arms of a pudgy man in glasses. Pankaj says, "You see? My uncle."

"Your famous uncle. What about her? Is she famous too?"

He shrugs. "Parlez-vous francais?"

"Oui. Et toi?"

"Oui," he says, "et japonais."

A sparsely toothed woman, her red shawl streaming behind her, rushes up the steps. She yells and claps, trying to rout the goats foraging on the ficus leaves from which she molds saucers for the lighted wicks launched at nightfall on the river. The wicks, each in a dollop of wax on top of marigold petals, form into a garland on the downstream current, burn for a few minutes, then go out.

Light in the darkness, fire on water, earth (whether corpse or a marigold) doused with water, set aflame. All the elements weaving, woven together. Maybe that's what gives these ceremonies the feel of sanctity, the consecration of the ordinary.

What's more ordinary than a marigold? They barely registered in my scope before now, unless you count scorn. I've planted, I think, twelve marigolds in my life, two six-packs. I was twenty-two, back from tramping through Greece, and I arrived at Aunt Dot's door (she was putting me up until I figured out what next) with dirty clothes and the marigolds. I planted them in a bed near the kitchen window. The next morning there was no hint of orange. Stolen, I thought. Aunt Dot

had a better explanation. Snails. I could tell she suspected this would happen, and didn't mind terribly.

Where do all these Indian marigolds come from? They are numerous as prayers. They are prayers. Yesterday at the Hanuman temple not far from here I watched as marigolds were strung into 40-foot ropes to decorate the outer walls of the temple. A young disciple of the Monkey God draped a marigold garland over my neck, a heavy, damp weight. I wore it to an internet café where a priest had just blessed the computers, leaving a marigold on each monitor. I was hungry, and while I waited for the server to connect, I considered nibbling at the marigolds, like the high-strung, lovelorn wedding planner in *Monsoon Wedding*.

Watching the women perform their ceremonies, I see what else a marigold is: sunrise on a stalk, a replica and a relic to bless the hours ahead, if in no other way than a scent on your fingertips.

The women stand and begin to disperse. The light is paler, the day is launched.

An ordinary day. But how much ordinariness, even dressed up in ceremony, is tolerable before the urge to escape resurfaces? Besides boats, massages, incense, floating lanterns, silks, and yoga lessons, river vendors also peddle hashish. The urge to weave together is only half the story. It runs head on into the drive for derangement, for fiery crashes, for negation. Kali, Goddess of Destruction, must be reckoned with. In her shrines she is portrayed standing with her foot on Shiva's chest. She would have obliterated creation but Shiva interposed his body and saved it, at least for the time being. So here we are.

Varanasi is also Kashi, City of Light, Shiva's abode. If you die here and your ashes are dispersed in the Ganges, you are liberated from the wheel of karma, the cycles of rebirth. The final escape. There was a woman on the train coming here, gaunt, wheezing, attended by her stalwart grandsons and her grieving husband. I wondered if she would survive the long trip. Yesterday I saw her on a cot in the hospice above the cremation ghat. This morning she was gone.

I need to move. I rise, and stretch my limbs. "Okay," I say. "Which boat?"

Pankaj springs to his feet, astonished. He'd given up on me. "You want boat? You will like. Very nice boat." He runs down the ghat toward a moored flotilla. After a brief discussion with an "uncle" he waves for me to come toward a boat, appropriately orange. I walk down the steps passing the women who are climbing upward. Six goats are already hoovering the place of every marigold petal.

This day, still before breakfast, already seems ancient.

...the very figure and image of a felt interest in life...the supreme case of a taste for life as personal living, of an endlessly active and yet, somehow, a careless, an illusionless, a sublimely forewarned curiosity about it.

– Henry James, *Memoirs*

"No," Alice cries, horrified, "that's terrible. They can't want that. Not to come back."

I have been telling her about the women in the hospice along the Ganges. We sit under an umbrella on her deck in Berkeley, the keen sun coaxing spring along. Below in her garden, the persimmon tree, planted twenty years ago over the ashes of her son, shows pinched green leaves at its tips. Alice has had a rough winter–a tumble, a cracked pelvis, confinement to a wheelchair, but she's not dwelling on it. She's walking again and appears indestructible.

"I can understand," I say, "not to want to be reborn. Not that I necessarily believe in reincarnation. But I can see how a person might think enough is enough."

From the look on her face I judge I have never said anything so shocking. "Oh," she says, "I would accept just about anything. Anything but death, that is. Let me be a bird or better yet a cat, as long as I am living." She fills our glasses with wine, emptying the bottle. "You're not yourself today."

It's my turn to be surprised, pleasantly. I'm glad that she reads me this way, a partisan, like her, of "more life." Numerous times I've prayed, let me be like Alice when I'm her age. Or now, for that matter.

"Or a squirrel. Look," she says. A tiny squirrel digging under the persimmon tree has unearthed a walnut twice the size of its head. It gets the nut in its teeth, staggers, and hops erratically away. We both watch it for a few seconds. Alice laughs, a melodious ripple. "Why does it remind me of our president?" She laughs again. "Tell me more about your trip. You inspire me. I have to go someplace. I'm sure I have one more good trip in me."

I am wondering if the squirrel, like the resident cats and the occasional raccoon, ever climbs onto the deck. I brought Alice some marigold seedlings, the first batch in the nursery, and while she made lunch, I planted them in the pots on her deck–a surprise for her and a reprise, perhaps a successful one, of my experience with marigolds and Aunt Dot. Planting them felt like a ceremony composed in ordinary time. I figured the marigolds would be safe there from slugs and snails, but I didn't factor in squirrels. Oh well.

129

Alice sighs. "Aren't they adorable? Green darlings. *The marigold that goes to bed with the sun, and with him rises weeping.*' Why 'weeping'? Who is that? Shakespeare, no doubt, but what? The way my memory is going, pretty soon the only thing I'll remember is Shakespeare." She laughs. "That wouldn't be so bad. Did I tell you my idea? I'm going to type everything I do into the computer, and that way I won't have to worry about remembering. Isn't that keen? Just listen to me. I've been housebound too long. Maybe if I stopped talking for a minute you could tell me more about your trip. First let me get some coffee. You'll surely want some lemon pie."

I surely do. She goes indoors, and I shift my chair to the shade of the umbrella. Yes, why "weeping?" For joy, no doubt, for sorrow, for the fullness of things and the emptiness of things. Or maybe marigolds literally weep, exuding droplets of moisture during the night. I'll have to ask Alice, if and when these bloom.

Summer

FOUR SQUIRTS

My mind is bristling with swords, honed for attack, because of a helix of spindly green twining up a shrub near my back fence. Bindweed. I have bindweed in my garden. How did it get here? I thought it was one of those pests, like gung-ho patriotism, that doesn't flourish locally. Bindweed and I have a history. As a kid, I often rode on the tractor with my Uncle Bob as he tilled his fields. The tedious back-and-forth plowing would halt whenever we came to a low, suspicious patch of greenery. Idling the engine, he would hop off the platform and withdraw a dusty gunnysack from its place near the clutch. Out of the sack he scooped handfuls of brownish granules and flung them roundabout, as if sowing them. It was livestock salt. Then he would hoist whatever implement we were pulling out of the ground. My job was to scrape the damp, fragrant dirt from the discs or the blades, making sure there were no treacherous stowaways, before we drove on. The least segment of stem or root would readily resprout elsewhere.

Scattering salt over an enemy's land is an old battle tactic. The sterility it causes can last for generations. But if the enemy's land is your land, it is not so smart. In my uncle's fields, it took several years before any green thing would grow in the salted patches, no thistle, no tumbleweed, no devil's claw. Eventually, as the salt leached out, stunted wheat, looking more like implants than plants, grew in the baldness. The wheat's pathetic comeback coincided, naturally, with the resurrection of the bindweed, its leaves yellow and gnarled, but alive.

Escalation, of course, was the inevitable response. Not coincidentally, bigger, smarter weapons came down the pike. My uncle, a typical farmer, tried whatever his neighbors tried, settling on 2,4-D, though even that took multiple applications before victory could be declared, however tentatively.

In Aunt Vera's vegetable garden herbicides weren't an option, so she dug deep as her elbows, eradicating the rascals. Naturally some evaded her. Bindweed found *in flagrante* with cucumber vines got pinched to the ground, again and again and again. The struggle was a standoff, and a regular source of frustration. Now and then she would boil a kettle of water and give the bindweed a lesson it wouldn't forget. That cheered her up.

She insisted that the bindweed arrived in her garden in one of the bales of alfalfa straw my uncle brought for mulch. "She'll never let me forget it," he said, "but she don't know it for a fact. Hell, everybody's got

131

bindweed in their yard." On the bright side, the straw in combination with the barrows of manure from the stable were what made her garden spectacular, a food forest in the plains, as conspicuous in reverse as the sterile patches pockmarking the wheatfields. Cucumbers, tomatoes, squash, radishes, beets, beans, raspberries, asparagus, apricots, melons— she harvested wagonloads, when frost or hail or grasshoppers didn't intervene. Years later my uncle told me regretfully that he could have bought the land he farmed from Mr. O'Malley, the landlord, for 25 dollars an acre but he chose not to because of all the bindweed. "Now," he said, "what with all they spray, bindweed is not that big a deal. I'd be a rich man."

In my garden I discover that the little tendril scurrying up the echium is not solitary. There are others tickling the hellebores, and several scouts telescoping between bricks in the pathway. How did I miss the mischief?

What to do? On the internet I find a wonderfully comprehensive California Department of Agriculture bulletin on *Convolvulus arvensi*, field bindweed. (What a great country!) Other common names are orchard morning glory, creeping Charlie, and lovevine (how twisted!) Distribution is: "Abundant throughout California." Remedies? "Where practical, flooding fields with water to a depth of 15-25 cm for 60 to 90 days can effectively eliminate most field bindweed plant." Before I build my dike, I have a question about "most."

Two sentences reinforce what I've known all along. "When dealing with field bindweed, the farmer, land manager or home owner must recognize that there are no 'quick fix' solutions to eliminate it. It is possible to bring bindweed to a manageable level, but it requires intensive effort and a watchful eye."

Intensive effort, watchful eye. As if I don't have enough in this garden to keep me a drudge: oxalis; ivy; St. Augustine and Bermuda and bunch grass; the madly procreating onion cousins. Weeds usher me toward a grave they'll quickly colonize.

At the back of the tool shed is a white plastic dispenser. Time for a pre-emptive strike.

> *Were Adam and Eve really chased from the garden? Or did they leave?*
>
> – Dorothea Tanning, *Between Lives*

"Did it make you feel manly?" Rita asks. "I've seen the commercials, the hunky suburbanite staring down a dandelion and squirt squirt, zapping it with a pull of the trigger. A little ironic, don't you think, given

the average penis size has shrunk nearly two inches since herbicides and pesticides came into widespread use."

Bindweed crept into our conversation because Rita was extolling a class she recently attended on permaculture. I said I don't see how one of the permaculture principles, "the problem is the solution," applies to bindweed.

"I don't believe it," I respond.

"It's in my notes. There was a recent study, in Denmark, somewhere they have a nationalized health system and keep records."

"Nope. Don't believe it."

"Why am I getting so many penis-enlargement emails? There must be a market to fill. I opened one the other day. 'Wouldn't you just die to be able to add two inches to your penis size?' Wouldn't I just. Heigh-o silver. By the way, where is this wicked plant? I've got to see it."

She is up from her chair and out the patio door before I put up any resistance. Outside it's damp and chilly, the summer fog swirling, thickening into mist. It's not a day that invites an amble. Still, the damp gray light sharpens the resolution of every leaf. Both Rita and I are instantly transfixed by the beads of moisture pearling on the maroon leaves of the smoke bushes, aglow in reverse measure to the overcast. Three variegated euonymous stand attendant to Their Maroon Majesties. The whole slope above the patio seems primed for a pageant. Meteorites of a wine-colored ixia shoot through the air, flung from starbursts of a massive dahlia. Pooling beneath are purple linarias and violet geraniums. Even a cluster of unprepossessing dwarf agapanthus looks dressy.

Masterful. I only wish I could take credit. The sum is a lucky accident. I planted the big plants, but the ixias came from who-knows-where and the linarias and geraniums are self-sown. A sprawling burgundy carpet rose, tying things together, was rescued from Vikki's too-shady garden where it was pasty with mildew and aphids. Here it has regained its sunny disposition, even in today's gloom. The dahlias started as divisions Phil gave me. I thought they'd get three feet tall, not five. They are making the case that they, not the smokebushes should be the center of attention.

Is that bindweed peeking through the dahlia leaves? Bet on it.

"Here it is, and here, and here," I say, pointing to those tendrils.

"That's it?" Rita asks.

"That's the tip of the iceberg. The roots easily go 10 to 15 feet down. They can go as deep as 50 feet. The plant is wicked. It hogs water and light and nutrients. Not everything in nature is nicey-nicey, despite what your permaculture guy says."

"Nicey-nicey? What he did say, and I quote, is that 'we have to get rid of our goddam war mentality.' We have to work with nature, not blast away."

"Four squirts isn't blasting away. *Round-up* breaks down in the soil in a matter of minutes."

"So you say. Who was it, you I believe, who told me that every body of water in this country, every one, has detectable herbicide in it? Ring a bell? Don't you think that maybe the mentality is the problem? You complain about the state of the world but when you can do something different, if it causes the least bit of inconvenience, you choose not to. Right?"

Obviously I felt ambivalent about using the herbicide. I rationalized since it was already on hand, I wasn't putting any more dough into Monsanto's coffers. I've seen the monstrous rolling platforms that agribusiness uses to spray fields, those alien contraptions. This was just four squirts.

"What do you suggest I do, twiddle my thumbs and let the bindweed take over?"

"Why don't you treat it like any other weed? Get on your knees and dig it out. It can't be worse than oxalis and you manage to coexist with that. So what if some of it comes back. Nobody's grading you on perfect control."

"Fine. Don't come complaining to me when you find it popping up in your garden."

"It already is in my garden. I've had it for years. I think it's kind of pretty."

She's goading me, and on cue, I feel a surge of anger. She should have done something before it crossed over to my garden. More infuriatingly, she's right. I could use the Aunt Vera method. I'm not growing acres of soybeans or wheat. The beauty of this slope isn't an outcome of total control but of labor and grace, a combo more alchemical than chemical.

Set yourself limits for what you're happy with: that is another permaculture axiom. With bindweed in my garden and in my psyche, I reach for the spray gun. What am I happy with? It's a good question. I should find out. It will take, no doubt, intensive effort and a watchful eye.

els, each distinct in the molding of the crown and the turn of the
each a picture of the sensible, stable gardener. I don't buy any of
. I couldn't say why.

eter gave himself up for lost, and shed big tears....

— Beatrix Potter

shmael in Moby Dick goes to the sea when he gets the "hypos"
is in danger of "deliberately stepping into the street, and
odically knocking people's hats off." I go back to my garden.
the hat I knocked off earlier lounges on the lawn, unflappable as
Eh, what's up, Doc?
Vascally wabbit.
put it back on and gather the last of the fallen apples and tuck
in the compost, (R.I.P.,) then turn toward rectifying the damage
ccurred to the pond during the latest raccoon orgy; pots tipped,
mangled, sushi. Miraculously, my handmade fortress of chicken
ousing the pump held, though the emitting pipe was broken off,
ng the pond's melodious trickle into a gurgle. I weep with Peter
truth is, beneath my skin, most gardeners' skin, is a Mr. McGregor
g to wring necks.
here isn't much damage to rectify. The raccoons, for some reason,
on holiday after the orgy. I've gotten used to the gurgle, and
ants, on their own, have hitched themselves up and are thriving.
particular, *Colocasia esculenta* 'Fontanesii,' a black taro, is fudge
eyes. It's five, no six feet high. I bought it in April as a ten-inch
ing, not thinking about the pond, learning only later it could be
erged. I wedged it on a shelf at the side of the pond, giving it a
p chorus of golden acorus, also amphibious. Its huge triangular
, with wine-dark veins, are a blast of trombones in my garden of
.
detect something amiss about the taro, a yellowness that might
something mangled. My heart gallops; the raccoons are back.
ng nearer I see, in the middle of the glossy purple stems, a spathe,
of gold eight inches long, tapered like a flame, surrounding a
-colored spadix. I read that taro flowers are seldom seen, but
this one, and there are two more in the wings rehearsing their lines,
d yes.
his is the garden's counter proposal. These are golden days. You
ieve loss without making a big teary soup of it. Maybe even (it

Fall

EARLY GIRLS

"You look like Mr. McGregor in that hat," Amy says.

I stop raking. Mr. McGregor? My hat, wide-brimmed, round-crowned, was made in Ghana, not Glasgow. I retrieved it from the closet because it offers more shade than my canvas hat. It had been banished because it is uncomfortably stiff, though I like its character, or did until I saw a recent photo of me looking like a bowlegged hobbit, a bit sprung. Now this. Maybe Amy thinks of Mr. McGregor as hobbit-like. I remember him as authoritarian and compulsive, murderously vexed by Peter Rabbit. Either way, I'm not flattered.

"I brought you some tomatoes," she says, handing me a basket full of small, spectacularly red fruit.

"That's thoughtful. I didn't quite get around to planting tomatoes this year. Not even cherries. What kind are these?"

"'Early Girls'."

I roll a small one in my hand. It's the size of an egg, and still warm from the sun. "They look good."

"I'm kind of disappointed. Last year they were big and juicy. This year tough little nuggets. Maybe I didn't water them enough, but I thought I was giving them the same as last year. Do you think it's watering?"

I have no idea, or rather, I have several, with no idea making a case for itself. Maybe it was water. Maybe it was weather. Could there be too much sun? Maybe it was fertilizer, too much or not enough. Maybe the unfortunate tomatoes were planted in the same spot as last year. Or in a different spot. Maybe it was a malign planetary alignment.

"They're good in sandwiches," she says. "I hope you enjoy them. I have plenty more."

"I'm sure I will," I say as she pulls the gate shut behind her. I wish I had something to give in return but my garden is in a stupor, nothing to pick, no plums, raspberries, blueberries, persimmons... oh but maybe the pears... but she is gone.

I feel tongue-tied, like stuttering Elmer Fudd. I want to tell her how sorry I am that she and Clara may soon be leaving the neighborhood, but to say so would be to reveal what I know from gossip, heard yesterday, that her marriage to Bertie is a wreck. How she's relieved whenever he takes the au pair dancing because he's out of the house.

Why the shock? Half the neighborhood, myself included, predicted the marriage wouldn't last. It was easy to be glib then, having no stake in its outcome other than slightly malicious curiosity. Then came the morning Bertie stood on my doorstep, a bassinet in hand.

As babysitting became a regular Tuesday and Thursday event during Amy's recovery, I drifted into a fairy tale from which I haven't quite emerged in which I play a role in Clara's life, even though babysitting stints ended months ago. Lately I find excuses to drop over, even if Bertie is home, to get some time with Clara. She's naming things now, and my name is in her vocabulary. Her greeting is a joy that an hour, sometimes a day, orbits around.

I resume raking, rounding up the apples that litter my patio and the adjacent flowerbeds, a windfall without the secondary meaning of unexpected wealth. I'm used to the 'Lodi' apples cascading; it happens every July and August. But not the pippins, not this early. They're thumping on my roof, splitting on the patio, unripe. Like Amy with her 'Early Girls,' I want to know why this is happening.

Ten thousand joys, ten thousand sorrows, the Buddhists say of life. Ten thousand green apples wasting. Why be blue? There are more than enough apples on the tree to make a dozen pies. The windfall may be prodigious simply because there are so many on the tree, unlike last year when I worried, needlessly, that I would have to go to the market so that Lily and I could have our November pie-making day.

I hear the metal backdoor at Bertie's clap shut. Amy has gone inside. I wonder if she has begun packing. I survey the dark foliage of the ivy and the bay laurels of their front garden. Amy had the trees pruned and liberated from the ivy a few months ago, and the autumnal light is pinned to the trunks like gold medallions. With Amy and Clara gone, Bertie's garden will seem like a desert again. The ivy will reclaim every bit of earth and sky it lost to her attentions.

A breeze stirs the topmost leaves of the trees, but not a breath reaches the ground. It is another warm day, one in a string almost spooky in their perfection. How can I gainsay it? Complaining for years that Bay Area weather was ten degrees too cool, I now have my wish and I fret, does it presage less desirable changes? What if the rains fail to come?

I bite into one of the tomatoes Amy brought, expecting toughness, bitterness, desiccation, but it gushes in my mouth, sweet, almost like candy. I'm disappointed not to be disappointed.

...perversities may aggravate
the natural madness of the hatter.

– Elizabeth Bishop

In my pickup on the way to 4th Street in [...]
personae. Mr. McGregor. Didn't he have a bi[...]
beard? Did he even wear a hat? How nasty wa[...]
Of course not. He was a Scot. Elmer Fudd v[...]
always blasting away at Daffy Duck. Or was i[...]
They were never in real danger, Elmer [...]
McGregor, on the other hand, was scary[...]
McGregor's garden, Mother Rabbit warned [...]
ended up in one of Mrs. McGregor's pies. I v[...]
was she telling the truth? Maybe he ran off w[...]
At a store called The Gardener I finger a [...]
hatband. It is the only man's hat in stock and if[...]
lo, there's a jaunty Joe with a fading (faded?)[...]
from the mirror. But attractive, quite. In pro[...]
two stylish clerks, back over his left or is it righ[...]
his orbit. There is...maybe...not admiration...in[...]
look at the fellow in the mirror. Grimy nails. Nc[...]
Holes in trousers. Blotches like dried blood on[...]
certainly, perhaps borderline (a bit sprung)[...]
nothing to do with it.
I stumble over to Peet's for an iced coff[...]
the sun, scrutinizing hats, decrying my lack be[...]
it's blazing. Billed caps abound, some wear[...]
deliciously ducky. I make a dozen assump[...]
woman with the straw halo of a hat is a goo[...]
guy with the cap backward is backward, an[...]
denim hats are capital B Befuddled.
My impulse is caffeinated: I'm raring fo[...]
In my sweltering pickup, feeling like a ret[...]
Berkeley Hort to see what they have in stock[...]
sappy plant made these dark stains on my tro[...]
Euphorbia? Agapanthus? Surely not an al[...]
Maybe it was the falafel. I can tell already, tl[...]
Why do I not change into ratty clothes before I [...]
The hats at the nursery, unbelievably[...]
inexpensive, lined for comfort, generous wi[...]

shouldn't be difficult), you can figure out how to stay in touch with Amy and Clara.

Hold on to your hat, a cool gust, yanking at the brim, suggests. The hat, whose only unassailable virtue was its indifference to gusts, tumbles into the pond. I snatch it, feeling mocked. It's not very wet, but rather than put it back on, I sail it across the deck toward the kitchen door. The fog, bet on it, is coming in.

Fall

FIGS IS FIGS

"Turkish Viagra" reads the little hand-lettered sign above a display of yellow figs. This is the tenth time I've seen figs advertised this way and it still makes me smile. I point and ask the fruitseller for "iki kilo," and he takes a pink plastic bag and fills it. And fills it. The only organ likely to get engorged by this bounty is my stomach.

"What's the Turkish word for 'half?'" is the first thing I ask Omar when I see him in his chair on the cobblestones outside his carpet shop. I remark about the sign and show him my haul of aphrodisiacs.

"I don't need Viagra," he says, yawning, and sinks his head like a tortoise into his black leather jacket, eyes closed. The black and white keffiyah wrapped around his neck slips over his chin. He sniffles, hands stuffed in his pockets. Maybe it's his cold, but he seems glum. He has complained to me several times how bad business is with the war going on but from what I've observed, the carpets are still flying out at a fair clip, and a fair clip is what you get at Omar's.

His eyes open a bit when he hears Vito, one of his "nephews," trying to herd a French couple toward the shop. Vito's patter weaves strands of street French into a woof of Kurdish charm but the couple waver, not quite drawn in. I project that my sitting here outside the shop may act as a lure, since tourists use tourists as guides...but maybe not, since the French twosome float back to the current of the sidewalk, wearing identical, detached smiles.

"I got Viagra for a customer of mine," Omar says.

"Why?"

"He was embarrassed to buy it."

Omar shrugs. He and his nephews can get many things. Yesterday a customer from Cincinnati wanted some old Iraqi currency, something with Saddam's picture. Later in the day Ishmael displayed an absolutely crisp 100-dinar note featuring Saddam himself, looking topnotch. Ishmael dodged telling how he'd gotten it. He had contacts. He said I could hold it if I was careful. Were these bills hard to get? I wondered. I could see suddenly why the man from Cincinnati wanted that bill. It had an aura, a power more potent, I'd bet, than a bushel of figs.

"Some tea?" Omar asks.

"No. I just came by to say hello."

"We waited for you all day yesterday. Why didn't you come?"

"I took the ferry to the Black Sea."

140

Omar lifts one brow. As an excuse, it's not worth lifting both eyebrows. He orders Vito to get some tea. Vito's lower lip droops. If Ishmael were around, Vito would tell him to fetch the tea. Vito has been moping, sick of being "nothing but a carpet boy." Even his name is degrading, attached to him because he "looks Italian." He does look Italian, dark ringlets and pale skin, sulky as a Caravaggio urchin who also knew what it was like to be hemmed in by poverty.

"No tea," I say, but might save my breath. From day one I have told Omar I have no intention of buying a rug, nowhere to put a rug, can't afford a rug. "I don't care about the carpet. Sit down. Have tea. You have time for a glass of tea."

I'm not so dumb that I believe this, but it's his business to sell me one and mine to resist. Besides, I am enjoying our newborn friendship, if that's what it is, sitting here on these cobblestones watching and listening and sipping tea, at a crossroads within the crossroads that is Istanbul. After a few hours here one could almost believe we live in a peaceful world.

Today it's almost too cold to be outside. The summery days of last week have become winter. It rained a cold rain last night and this morning, and the cobblestones hold thumbprints of water. Beneath the eaves the carpets and kilims sway in the gusts of wind. Before I came to Istanbul, I was surprised to learn it is further north than San Francisco. Today it's believable. The tea will be nice.

"You like that one," Omar says. "Your eyes always travel there."

I thought his eyes were closed.

"No, I'm not trying to sell it. I'm only saying, you have good eyes. Look. Very well made." He reaches back and fingers the wool, and shows me the backside of the carpet which is almost as spectacularly sumptuous as the front, a weave of maroon, black, red, orange.

"Beautiful."

"How much do you think it costs?" Not getting an answer, he says, "I could sell it to you for nine hundred dollars. I'd do that even though I would only make fifty dollars. I'm not interested in making a profit. I want you to have it, if you want it."

Vito comes up from the basement, the almond-colored tea in small, clear glasses trailing ribbons of steam. I plop in three sugar cubes, and stir. At home I don't use sugar in tea or coffee but here I'm an addict.

Vito returns to his post along the street. Mere seconds pass before he is ushering another twosome into the magnetic reaches of the shop. "I'm really only interested in looking," the woman says as Omar coaxes her and her mate downstairs toward the showroom.

141

"Come along," Omar says to me, "we have tea together."

I accept readily, eager to watch the majestic unfurlings, how the colors and patterns transform in the shift of perspective, especially when I'm not the object of such charms. There are bound to be plenty I haven't seen yet.

It happens that the young couple, Henry and Mira, are from San Francisco. His grandparents were Chinese, she was born in Vietnam, and they're newlyweds. They promised themselves they would spend no more than three hundred dollars on a carpet. Multiple glasses of tea and/or *rakı* later, that figure is a mirage. With me as cheerleader, they purchase three carpets, giddy with their extravagance, or, seen in another light, enchanted. How could they go wrong? They'll have these beauties their lifetime together.

When I emerge at dusk from the carpet cellar, with my slightly reduced pink plastic bag of figs, I veer the same direction as the scudding clouds, toward my hotel. *Rakı* in my bloodstream glosses all I behold with a tremulous luminosity; the gulls circling the minarets of the Blue Mosque, the polished streetcar tracks, the stately chestnuts sloughing leaves. I am delighted with existence, delighted for Omar and for the lovebirds Henry and Mira, delighted to be in the world where there are such amiable people. But by the time I reach the hotel my gleaming joy is a bit tarnished. The sumptuous red carpet my eyes always traveled to...they bought it. Omar showed it to them with a preamble telling them how much I liked it. Henry deferred to me and I said, no, no you go ahead. I'm not buying a rug.

"You're sure?" asked Mira.

"Positive."

So the deal was done. For eight hundred. I wanted that rug.

> *Is your forehead warm? I know.*
> *Are your lips wet? I know.*
> *The moon is up, white behind pistachio trees.*
> *I know what's happening by your heartbeat.*

> — Orhan Veli Kanik, *Listening to Istanbul*

Four days later I'm in Pergamon, jostling my bones over ruined marble heaps, still toting the pink plastic bag. If Pliny was right, that figs increase the strength of the young and get rid of wrinkles in the

not-so-young, I must be as tight-skinned as Cher by now. I'm just about sick of figs. I'd discard the three remaining, scrunched like tiny turbans at the bottom of the bag, except that it would feel slightly sacrilegious. Figs are Demeter's gift to humankind, and sacred to Dionysos as well. There are, or were, temples to both deities here. Best not get the gods riled, especially on their turf.

My teeth clip off the narrow end of one and I spit out the hard bit, and mash the gummy, grainy meat between my molars. I chew as if adding another morsel of information to my sensual education, something Northerners have always come to the Mediterranean for. My historical education, meanwhile, is on life support. I have given up trying to gain even a cursory grasp on *who*, *what*, and *when*. The names our guide mentions float by unanchored in this stupendous, hilltop *where*. Mithradates... Eumenes... Aesclepius... Hadrian.... Antony raided the library here for presents for Cleopatra. Booty for booty.

With the few stones that remain I try to reconstruct an imaginary edifice where the library was and populate it with men unscrolling texts ablaze with illuminations of gold and lapiz lazuli. "This library rivaled the library of Alexandria," the guide says, "so the Egyptian rulers outlawed the export of papyrus. Knowledge is power. And so, local people began to once again use animal skins. The word 'parchment' comes from 'Pergamon'."

I have an urge to ask him if this library had a secret passageway to the brothel, like the one in Ephesus we visited yesterday. Probably not. Pergamon was a much smaller town than Ephesus, and that kind of secret wouldn't last a minute in a small town.

Maybe the figs are doing something after all. I seem to be thinking about sex a lot.

In rocky outcroppings of the hillside wild figs grow. I'm sure they're figs, the leaves and branches are similar, though dwarfed by these dry and infertile conditions. Do they produce edible figs? The guide says no. How did they get here? Izmir, once Smyrna, is a few hills south. Are these Smyrna figs, or wild cousins? These questions simultaneously tax the guide's English, and his botany. I make a mental note to ask Ishmael when I get back to Istanbul to direct me to a good bookstore.

According to myth he [Dionysos] placed a phallus of fig wood on the grave of Polyhymnos as a substitute for a promised favor, which he kept for himself.

— K& W Farms, Inc. website, *History of the Fig*

Instead of a bookstore, I asked Ishmael to recommend an Internet café, and so I have come to this tiny room five flights up to read about figs and wait out the rain. The air smells of wet wool. At every other computer is a teenage boy. Through the window of the building across an alley I see a group of prostrate men, doing midday prayers.

Minutes ago I said goodbye to Omar and the boys. In the last ten minutes of our final three-hour visit, I capitulated. What color? Omar asked. Red. Vito unfurled three carpets. I didn't bargain. Ishmael rolled the one I chose into a surprisingly small bundle, and wrapped it in plastic. It's on the floor near my chair. I occasionally glance down from the screen at it, and wonder if I've done something dumb.

I turn my attention back to the screen. What would the librarians of Pergamon think of the bounty, the galleons of information a few clicks away? I learn that cuttings of Smyrna figs were brought to California in the late 19th century because Smyrna figs were the best dried. The cuttings took, the trees grew, but the fruit failed to persist and develop on the tree. Since these cuttings-grown trees appeared to be defective, seeds were planted, but the seed-grown trees also failed to produce fruit. Eventually it was discovered that Smyrna figs had to be pollinated by the fig wasp, the blastophaga (bud-eater) which enters the fig through the tiny hole at the base. Pollination is also called caprification. The wasp's habitat is the caprifig—the wild plant (I'm guessing) I saw growing at Pergamon. Cuttings of caprifigs were shipped to California and pollination was achieved, and the "Calimyrna" fig became the basis of the California fig industry.

It's a sexy story with a happy ending, and quite moral, involving matrimony and offspring. But what could our K & W historian mean by the circumlocution, "a favor he kept for himself," considering that in the next sentence s/he writes, "the fig tree is the tree of phallic worshippers?" Three clicks away, thanks to www.sporadestours, comes this tidbit: Dionysos "was shown the way to the underworld by a local guide named Prosymnos [Polyhymnos], who demanded as pay that Dionysos have sex with him. Dionysos promised to do so when he returned, but when he came back he found that Prosymnos was dead. Dionysos thereupon carved a figwood phallus and fulfilled his promise by sitting on it." The mythical woody. Turkish Viagra.

Figs is figs, a friend likes to say. Things are what they are. Taste and see. We're all tourists on the planet.

My favorite figs are the ones they sell in the pastry shop down the street from my hotel, studded with hazelnuts and glazed with honey. I think of the fig tree in my garden, loaded with figs when I left home, dawdling, dawdling, not getting truly ripe, and not going to get ripe. They hardly ever do, unless we have an exceptionally warm summer. I eat them anyway, imagining juiciness and sweetness.

The rain has stopped, at least for now. The room across the alley is empty. I pay for my minutes online, grab my bundle, and trot down the stairs. I still have eighteen hours to explore Istanbul. First stop, the pastry shop.

Spring

LIVE FROM PASADENA

Twenty-two cars, in haphazard file, wind through tree-shrouded hills and canyons of Pasadena. Here come the Hortisexuals, a.k.a. (when decorum requires) the Bay Area Horticultural Society, nearly fifty souls in the grip of plant lust. We have come south to praise and bury, dish and desire, the imperial gardens of L.A. It's the first morning of a scheduled four, and we're on our way to our third garden of forty-eight to see. What could be more fun? More glamorous? The morning is platinum, cool but not too cool. The lustrous haze holds barely a hint of smog.

The gardens we cruise by are dazzling, starlets compared to the disheveled Biology Majors in my neighborhood, and I am starstruck. Each eucalyptus, elm and sycamore is coifed, every hedge buff. Not a dandelion in sight.

"LA must have a hundred thousand skilled gardeners," Randy, driving the car, muses. "We could use some of their tree pruners. You should see the hatchet job done to the grevillea on my street. It's going to die of shame. Did you catch the number of that house?"

"Are they numbered? Here, this is it. Everybody's stopping."

We park along an ivy-covered stucco wall that curves down the hillside, and get out. Even the ivy looks intentional, groomed.

"Deceptively quiet," Randy says.

Sure enough. No mower, no blower, no chipper, no chain saw. What are the chances of that, given these standards of vegetative discipline? A mockingbird can be heard rehearsing on some treetop.

"Be grateful," I say.

"Of course. This is, after all, the cradle of illusion."

I am grateful. I am having a blast, glad I joined the tour. Randy, who is a professional gardener, encouraged me but I was hesitant, not knowing my beschorneria from my elbow. No need to worry. Snobbism has less tenure in this group than enthusiasm, though naturally there is one guy who winces whenever I ask a question.

If Randy is right, and this peacefulness in these bosky dales is a dewy illusion, I say let's have a big helping. Isn't illusion the whole point of gardens? To craft an artificial paradise, fit for a tryst with nubile Nature, some mad smooching under the stars? You say those sweet lips will dry and wither? You tell me a drought all too soon will rough up this well-watered stage set? Later, alligator.

Hortisexuals assembled, we march up the gravel drive. "Gravel," Randy says as we crunch along, "is a cultural indicator of status. Only the uppercrust use gravel. It's expensive and high maintenance. Concrete is for the middleclass." As we near the three-car garage a truck big as a troop transport is pulling out. Chained to its sides and rear are the machines that vex Randy and any other gardener worth his salt.

"We were hoping to be gone before you arrived," the sandy-haired driver says genially as his three Mexican workers clamber aboard. It's satisfying to know that, en masse, we possess the avoirdupois of Louis Quatorze, able to send gardeners scampering before us.

We file under a yew archway, and I overhear a snippet of garden history relayed by the Wife whose Husband complained about the costs of the Daughter-designed renovation. I wouldn't have guessed that this garden only last fall was given a total makeover, not in the Hollywood way to look younger, but older, classical, beyond fashion. Terraces anchored by cypresses, artemesias and Spanish lavender step down toward a reflecting pool surrounded by lawn. The mosses growing on the marble had Martha Stewart as midwife. It's pleasant, and maybe a tad boring, if the reaction of my compatriots is to be believed.

I stroll the lawn to its limit where three steps up lead to a rose parterre. By reading the copper tags, I deduce that the roses are planted in color clusters, yellows, apricots, reds, perhaps even in graduated tones, like a paint chart. Live from Pasadena, a parade of roses.

As a kid in frigid Kansas, I watched the annual New Year's parade, the beauty queens gliding and palominos prancing down an eternally sunny Pasadena street, everything festooned in flowers that, on our black-and-white television, appeared as shades of gray. The flowers were hothouse-born-and-bred, but who knew or cared? Illusion was the ticket. Now, in late March, none of these roses show more than a slip of color.

Three more steps up usher me into the embrace of a citrus grove. A trickling fountain, acoustical perfume, complements the blossom scents. I snatch a kumquat. Yum. And another. I am shuttled off on my first Envy detour of this trip, if you don't factor in the swimming pools at the first two gardens.

Departing the citrus grove, the path climbs immediately into an acre of sunlight surrounding a large patio furnished like a boudoir. To the right of the patio is a bed of succulents that, everyone agrees, sotto voce, could use some rethinking. It's a succulent starter kit, one of everything, in Mutt and Jeff juxtaposition. To the left is a massive

pergola smothered by a white wisteria awash with dangling, creamy blossoms like the one I gave Alice.

"Good Lord," somebody exclaims. "I planted one of those in my garden last month. I must have been mad. Look at that trunk."

"This one plant covers more territory than most of my gardens," Randy says. "I'm glad there are four hundred miles between it and the Bay Area."

The trunk is gray and ridged and tapered like an elephant's trunk. How old is it? I picture what it must look like from the balcony of the second floor, how it might feel like you're floating above a sea of green; and imagine a garden consisting of one plant, one giant white wisteria, braided and sculpted and filigreed, a cozy habitation for exotic creatures.

"I know you," somebody says ending my daydream. A woman, in cerise pedal pushers and pith helmet. "I didn't see you at the other gardens. Where do I know you from?" she asks.

Placing her takes a few moments... a gardener who occasionally worked for Gussie, when Gussie still lived in my neighborhood.

"I live down the street from where Gussie used to live."

"Oh yeah. That jungle with all the fruit trees. How is Gussie? Do you see her? Please give her my love. She was so much fun to work for. She called me up once and barked at me in that smoky voice. 'Flora, I just looked out my window. I saw a purple primrose. I told you, Flora, only orange and yellow.' 'Gussie,' I said, 'I can't always be sure if the nursery is selling me only orange and yellow. How many purple primroses are there?' 'I don't know' she said, 'I haven't looked out since'."

"I spoke to her last week. She told me she almost died twice this month but she didn't 'cause God didn't want her."

"Watch out, God. She'll straighten that slacker out, and not a minute too soon. Well, off for more gawking. Later, alligator." She lifts her pith helmet and flashes dark, amused eyes. "This tour is going to be even more fun than I thought."

Those eye-popping pedal pushers slip through a green portal and are gone. What these horti-folk wear: fuchsias, puces, sulfurous greens. "Earthy" may apply to personalities but earth tones? Never. My mother gave me the pale green shirt I'm wearing. Embarrassing.

Flora. Could that really be her name? What did she mean by "more fun"?

I meander in another direction, past hibiscus hedges toward three languorous naiads emptying urns into a swimming pool sparkling with impossibly blue water. The blue, I see, comes from the inch-wide cobalt tiles lining the sides and bottom. With my fingers I interrupt one of the

dozen jets arcing from the side toward the center. Not heated? That would never do.

The clipped cypress that I thought was the garden's border has a passageway opening onto a steep hillside. To call the planting here "wild" would be a gross exaggeration. It's not even wild by the standards of my "jungle," but the reins are looser here than elsewhere. You might even vaguely imagine a natural landscape. Sycamores and oaks create a canopy, and below are white ceanothus, pink cistus, hellebores. The path leads up curved steps to a copse of pear trees. There, as almost everyone has discovered, is a semi-circle of benches perfect to take in the view over a series of low hills.

"What is this? Nobody can tell me," a carrot-haired woman asks pointing to a small shrub, sounding aggrieved.

"Did you ask Richard or David?"

"They don't know either."

I go to have a closer look at the plant that managed to stump the experts, its finely textured leaves decorated with little orange flowers.

"It's a dodonea," I say as casually as I can. "I have one in my garden."

"It doesn't look like a dodonea. What species?"

Hell. I don't know. "It is," I insist.

"It's a *Dodonea microphylla*," he-whom-it-pains-to-impart-information pipes in over my shoulder.

He's making that up, I want to say, but what if he isn't? It hardly matters, for interest already is dissolving, turning to a new focus: the next garden. We're due in ten minutes.

I find myself walking next to Flora back down the gravel driveway.

"Well, what did you think?" I ask.

"I learned one useful thing this morning," she says.

"What is it?"

"Marry up."

"Here," I say, "try this kumquat."

149

The violet hush of twilight was descending over Los Angeles as my hostess, Violet Hush, and I left its suburbs headed towards Hollywood. In the distance a glow of huge piles of burning motion-picture scripts lit up the sky. The crisp tang of frying writers and directors whetted my appetite. How good it was to be alive, I thought, inhaling deep lungfuls of carbon monoxide.

<div align="right">– S. J. Perelman</div>

My doorbell rings. It's Randy.

"Where did you get that shirt?" he asks. "You look like a pumpkin."

"In L. A. You don't like it?"

"Not on you. It's not your color."

My color? "So your pickup still isn't fixed?"

"I know. I can't believe it either. I feel like I've fallen down the rabbit hole. On Monday it's Wednesday. On Wednesday Monday. I wonder how something like Disney Hall can get built and these guys can't seem to fix a carburetor."

"Why don't they put in a new carburetor?"

"They did. It still doesn't pass the smog test."

At first it was a joke, Randy's trusty old red pickup emerging from the smog check labeled a "Gross Polluter." "I didn't even know it had Republican tendencies," he said. "It's never failed before."

"You don't mind me borrowing your truck again?" he asks. "Today will be the last time, I'm pretty sure. I know, I said that before."

I do mind a little. He panned my new shirt. But I don't say so. Of course he can borrow my pickup. My cousin went to Bali and left his Jetta at my house, if I want to go out.

"You know what I'm thinking?" Randy asks. "I'm thinking about giving up gardening for a living. That place in Bel-Air with the twenty-foot bronze horse hoofing it across the lawn and the six-foot head of the Buddha bleeding water from his topknot did me in."

"You said this before, too."

"This time really. I'm looking for a permaculture farm I can work on for room and board. I can't help thinking all our fancy gardens are frou-frou. Rome is burning. Besides, it seems that the only reason I work gardening is so I can afford my pickup and the only reason I have a pickup is so I can garden."

I've given as much unwanted advice to Randy about his finances as I'm going to; that he might give up his octogenarian clients who hire him by the half hour, curb his tendency to give away plants, say no to

working for friends at cut rates. And I'm not going to wonder if he considers my garden frou-frou.

"I'm sorry you didn't have a good time in L.A." I say.

"I had a great time. Maybe not as good as you, but still."

"What does that mean?"

"As if you don't know. No, no one saw you two making out in the garden in Encino. You were in a spotlight, for Pete's sake, though you probably thought it was the light of her eyes. I was praying her boyfriend wasn't going to take hedge shears to you. Is her name really Flora?"

"He's not her boyfriend. He's gay. They're best friends. You should check him out. Though you probably couldn't get past his clothes."

"I'd give it a shot. On him they look good."

"Thanks. Here are the keys. What time will you be back?"

"Four. Hey, I'm happy for you. What are you doing today?"

"Puttering in my garden. Four is fine."

Puttering.... That's too drifty a word to use for what my garden requires. Not for the first time I ask, where is my battalion of gardeners? A spring unlike any other is ending. Every plant bloomed, perhaps in honor of our governor, as if on steroids. There were so many acacia blossoms that one rainfall left six-inch terraces of them across my lawn. My apricot tree looks ready to collapse from its outrageous load. Even the Fuyu persimmon, which has never produced more than five blossoms in its thirteen-year life, has a dozen at last count. The raspberries are ripening thickly. What do these plants know I don't?

Jungle, I protested.

Don't get me wrong, Flora said. I like jungles.

It's supposed to be a garden. The wisteria is shaggy, the hedges lax. I neglected to prune the plum trees and they're turning into beasts. I see days of work ahead, getting things back in shape and ready. For what? I don't know. I want the garden to shine. I want her to see it shining.

Maybe Randy will help. I wonder what he'd charge.

Summer

DOCTOR, WHAT'S EATING ME?

It has been a foggy summer, which is somewhat reassuring. Isn't it what we're supposed to have? The flannel sky complements my state of mind. When I actually do something to the garden besides stare at it from the window, I feel I'm just going through the motions; fertilize the lemon tree, soak the cherry, deadhead the dahlias; rituals which have lost meaning. Amen, amen. Maybe some dramatic gesture involving noisy machinery would prove a remedy, but other than eliminating the lawn, nothing warrants it. Am I not beautiful just as I am? the garden pleads. I want someone to tell me yes, someone in particular. Actually, she has, but I can't quite believe it. Why on earth not?

"Could be love," Rita said this morning when I brought her two baskets full of plums. "You're moony. Don't fret. It's rarely terminal."

Or is it infatuation? Delusion? Projection? All of the above, no doubt, and it doesn't matter. But the "L" word? We haven't said it. Is that a good thing or a bad thing?

Useless questions uselessly breaking on a useless shore until clunk! an apple falls onto the roof of the porch. Wake up. We miserable and neglected apples are rotting in the ferns, festering on the patio. A waste, a terrible waste.

Guilt. There's something real. In minutes I've filled two five-gallon buckets with the ones that had fallen. Hitting the roof or patio they split and bruise deeply, and there is no backward glance after I dump them into the green bin. By the time I return to the garden two more have fallen.

I start picking the apples still on the tree. What did Aunt Dot do with them all? I wonder if she witnessed a year like this one, when almost every fruit tree in the garden is loaded to what seems a painful degree. I had to rig up crutches for the apricot because branches started breaking in the slightest breezes. The plum trees are equally burdened. The ones I picked for Rita this morning barely made a dent in their numbers. I could have filled a wheelbarrow. No matter how firm they feel in my hands, they quickly turn squishy. For once I welcome the deer that strip the lower branches of the tree hanging over the fence. Eat up, hoovers.

I soon fill three plastic grocery bags with apples to be stored in the vegetable trays of the refrigerator where they will probably rot like their fallen brethren, albeit more slowly. Then I consider the apricot tree, its branches swaying like kelp in a current. I'm not sure my makeshift

crutches are doing much supporting. The blush on each apricot is so lurid the tree looks like it is in screaming heat, but heat is just what has been lacking. Fetching as they look, the fruit is still unripe, a relief on one hand, and a disappointment on the other because I am eager to bite into one. No need to worry about dispersal issues with apricots. The prodigal sun suddenly pops through the fog like an action hero, pumped to rout mooniness. What it brings instead is a wave of dissatisfaction whose story line is that I can't bear another season tending my garden alone, and that I've felt this way for a long time. Not true, a voice counters. Yes, true. Admit it. What? You exaggerate. If there is good news in this yo-yoing, it's that the debate has gone on long enough the charge is run down. But wait, the mind says, one more thing. If you're in love, why aren't you afloat in bliss rather than fretful and uncertain?

Breathe. Here's a body, my body. I notice that it feels calm, even blissful. It wouldn't even mind picking a few more apples, just to help out. Well, okay then. The balls of my feet absorb the pressure from the ladder rungs. My hat chafes mildly against my temples. Sweet, refreshing air complements the spice of sunshine on my arms. Feel and taste how the climate cook has gotten the ingredients perfectly balanced.

Yes. Blissful.

Things base and vile, holding no quantity
Love can transpose to form and dignity.

– Shakespeare, *A Midsummer Night's Dream*

One fruit tree in my garden is the exception. The Newtown pippin is so sparsely fruitful that I could accurately count the fruit if I wanted to. What if we don't have enough for Pie Day? Last year the quantity was somewhat diminished from previous years, and I worried then. Unnecessarily, it turned out. Lily came over and six pies later, there were apples left on the tree, an outdoor pantry I would use for the next month. How many years have we enjoyed Pie Day? Since Lily was eight, and this fall she'll be a junior in high school. Chomp chomp, time takes bigger bites.

I gave the tree more water this spring, thinking that I might have been a little negligent last year and was happy when it bloomed with gusto. Why then are there so few apples? Why are some leaves a bit

wan and puckered? Does it need a particular mineral? More sunshine? It's true the cedar has gotten bigger and casts more shade, but the loquat has been pruned, so that should even things out.

I've known for years about the diagnostic clinic at the Botanical Garden, held the morning of the first Saturday of the month, but never attended. The plants I lost to ineptitude and ignorance were expendable. The pippin is not.

Once I make a decision to take some leaves to the clinic, my view of the garden shifts. I am now a skillful leader in a stately waltz. I tell Flora I'm going and she chimes in, "I want to go with you."

"Hey," a voice exults, "just what you were hoping."

I also call Alice to tell her I'll take in some of the prematurely shriveled and yellowing leaves from her white wisteria, that Moby Dick of wisterias. It has her house in a death grip, but she continues to be attached to it. On the evening before the clinic, I go to her house and collect some leaves and seal them inside a baggie.

"Let's see yours," Flora says when we meet at the entrance to the Botanical Garden. She's wearing a baby blue jersey and jeans. In her plastic bag she carries leaves from a 'Margaret Merril' rose, some with the usual rose rust and black spot, some with vivid blotches of yellow.

"That's mosaic," I say indicating the yellow blotches.

"I know, but does that mean I should get rid of the plant? It puts out great roses."

We turn down the path toward the conference center. The sun is already out, the air holding its breath. The sense of elation I feel is almost palpable, and it seems incongruous to be carrying these funky specimens when the rest of the world seems mint-perfect.

"Do you read the pathology report in *Pacific Horticulture?*" Flora asks. "It's written by one of the guys who run this clinic. He's too cheery about genetic mucking-about, if you ask me."

"I don't want to think about it," I say, and Flora gives me a brief, evaluating look. I hope I don't need to tell her I'm in her camp. Could she think otherwise?

In the conference center we join the short line of people waiting with their afflicted specimens. I notice that the man at the head of the line has also has brought in apple leaves, and so has a woman, her branch currently under microscopic observation. It must be apple panic day. "Manganese," I hear the Doctor say. And then, "magnesium." Lack of one causes one thing, the other that, but I don't catch exactly what. I'm too busy thinking about whether my own apple ailment is worth his attention and whether I should offer my two-cents worth regarding genetic engineering.

"Root rot," the pathologist says immediately after a look at the wisteria leaves. "Wisterias are prone to it." Farewell Moby Dick. Alice will go into mourning.

When I show him my apple leaves, he comments about the mildew, which, I hasten to tell him, I was aware of, and not particularly troubled by, since it is a rare occurrence that the tree grows out of. The puckering of the leaves, he says, might have been caused by mites as the leaves developed, and is not particularly serious. I feel some relief, knowing the tree is basically healthy, but why the scarcity of apples? Might there be a lack of some nutrient? The probable reason, he says, was an absence of pollinators at the opportune time this spring.

"Even though my other apple trees are loaded?" I ask.

"It could happen," he says.

Flora meanwhile peers through the microscope, getting her wish to see rust close-up. Rust, we learn, has a chemical that keeps the leaf tissue around it green so when the rest of the leaf is yellow and dying, it can continue to feed. How talented.

"I didn't know that mosaic shows up only in cooler temperatures," Flora says as we leave the conference room. "Leaves produced in hot weather don't have the markings. Isn't that interesting?" She takes the plastic bags with the ailing leaves from my hand and deposits them in a trash bin. She gives me a radiant smile. "That was fun. I learned three new things but I wish I had asked why and how 'Margaret Merril' got mosaic in the first place. There probably is no answer."

And I realize that I still don't know what to do about the pippins. Nonetheless I make a plan. Next spring I'll fertilize with alfalfa meal. Roses appreciate alfalfa meal, and the apple is in the rose family, so.... Moreover, I like alfalfa meal, its smell and texture reminding me of childhood days in Kansas. As for pollinators, I can only trust that bees will do it and do it some more (educated fleas stay where you are). I have faith the tree will prosper next year. How's that for science? If I have to, I'll supplement the harvest this year with apples from the farmers' market.

Flora and I amble through the bowers of the garden. Occasionally our shoulders bump, and fingers graze fingers as we let our eyes lead us plant to plant. We eventually come to sit on a rock under a paulownia tree, and there's a hiatus in what has been a steady flow of conversation.

Nearby, Strawberry Creek whispers a suggestion, only a suggestion. Say it. Be the first to say it.

Fall

WON BY A NOSE

Today, a warm day between rains, the seasonal tasks of clipping and deadheading usher me from island to island of smell: lavenders, oreganos, thymes and sages and most enticing of all, lemon verbena. As I progress I almost unconsciously wring the cuttings in my hands, squeezing out some essence to rub on my face and neck. Last November I did this same thing, and a cutie at the hardware store said, "Whatever you're wearing, it works." I did not shower for a week.

Recently in the *New York Times* I read about the discoveries of Doctors Richard Axel and Linda B. Buck regarding the olfactory system, for which they won a Nobel Prize. Lawrence K. Altman wrote, "Their work provides a molecular understanding of how people who smell a lilac in childhood can recognize the fragrance later in life and also recall associated memories." Prior to these discoveries, the Nobel Assembly declared, the sense of smell was the "most enigmatic of the senses."

I sense it still is. According to the article, there are an estimated 10,000 smells humans can detect, thanks to some 350 odorant receptors. Ten thousand. I wonder who came up with that number. It can't be right. Every person in the world has a different smell. Ask any dog. I remember a lover once who would sniff my body like an oenophile sniffs a cork. It was thrilling and embarrassing equally. If a person had ten thousand lovers, along the lines of Wilt the Stilt (apparently wilt-proof), and had a good nose and a statistical bent, one could easily....

"Enigmatic" might describe fall itself. In the Bay Area it's a feast of contradictions. We experience some of what the rest of the nation does. Deciduous trees shed with some display. Orange pumpkins dot black fields, and we, like everyone else, go through that downshift into darkness, the end of daylight savings time, and hate it.

But then the rains come, and they came early this year, in mid-October, and a parallel world shimmies into life. The hills put on gray-green cashmere. In the soil earthworms feel the quake of oxalis breaking loose. Away with the smell of crushed leaves and any melancholy idea about the end of things. A cinnamon smell wafts in, and you feel a pure, animal bliss. What is that smell? Every damp flower I stick my nose into says, no, not me. Maybe it's a concoction of smells. I wish my nose were more perceptive. What is it doing with its acreage?

Venerable sages. And lavenders. Oreganos and thymes. I clip each until they are rounded off, in somewhat ungainly mounds. After all these years I'm still not sure how I want them pruned. Next year I'll figure it out.

Now I turn my attention to the tomatoes. Here I might face the fact that the ones that haven't gotten ripe are not going to. Instead I do what I should have done two months ago, removing most of the greenery and all the tomatoes but the few that have a slight chance at ripening. Hope springs eternal. I sniff my fingers, taking in the peppery smell. How intricate, how miraculous, this orchestration of smell and taste.

In a big fragrant bundle I tote the tomato debris to the compost pile. Tucked in the rocks along the walkway leading uphill are paperwhites in bloom, ridiculously ahead of the bulb parade. I don't know how they came to be in my garden; perhaps as a present I couldn't pitch. I should try again. In the November light they're pitifully wistful juxtaposed with a liquidambar in party reds. Their smell, however, is not wan, a hybrid of honey and locker room. It was fetching once.

There are some plant smells I can't imagine growing to dislike, or other people disliking. Mr. Altman mentioned lilac. I bet that he grew up in the East or Midwest, and that no matter the quality of his childhood, lilac has pleasant associations. Local lore has it that lilacs don't do well here, certainly not as well as "back home." I believed it until I came nose to nose with the lilac in Charlene's Oakland garden. I begged for a root cutting, which after a year of guttering vitality, decided to call this garden home. This spring it proffered one spectacular bouquet. Now in autumn it is homely indeed, its leaves bruised and mildewy. I don't care. At the tips of a multitude of branches are dark buttons of near blackness, which I am fairly certain promise even more blossoms next spring.

A small tree, rising between him and the light, stood there saturated with the evening, each gilt-edged leaf perfectly drunk with excellence and delicacy.... And he felt a slow pride in realizing that what he wanted none could bestow, and that what he had none could take away.

— E. B. White, *The Second Tree from the Corner*

"You first," Flora says. We are hiking in Henry Coe State Park and I asked her what were her five favorite plant smells.

"Mine are lemon verbena," I say. "Lavender 'Provence.' 'Margaret Merril' rose. Lilac. And mandevilla. Not necessarily in that order."

"Mandevilla. La-di-da. What does that smell like?"

"I'm not sure. Sweet, delicate, a little spicy. I only said it to impress you. I really haven't decided on a fifth."

157

"I'm not sure I can pick just five. I can make changes, right? First, iris, my all-time favorite. Because it reminds me of my grandmother. I'm also picking lemon verbena. How about basil. And peony. There's my grandmother again. A fifth, hmmm. Frankincense."

"Exotic. I would never have thought of frankincense."

"Did I impress you?"

"Always." I notice the air in the park has a delicious incense of its own, a mix of the wizened and the tender, oak and pine and the dry meadow underfoot. Peppering the straw are spindly, upright, gray-leaved plants with tiny, violet flowers, and we stop simultaneously at different specimens to inspect. Fingering the tiny leaves produces a wallop of smell.

"What is that?" I ask, amazed.

"Don't know. Indian paint remover," Flora suggests. "Square stem, mint family. Maybe a teucrium? Does it make your list? There's room for a fifth."

"Let me think about it."

We keep walking. I sniff my fingertips where the scent lingers, planting a sensual flag that will forever, or for a second or two, mark this place, this now, which I notice, is fairly exquisite. Who knows, this midget might make the list.

At the visitor center a ranger immediately has an answer to its identity. "Vinegar weed," she says. "I don't know the scientific name."

The scientific name is a snap to find in one of the books for sale. *Trichostema lanceolata*. "Tricho" means hairy, fitting for a plant in a park famous for its annual tarantula fest. "Stema" refers to the stamens. "Trichostema" sounds familiar, and after further reading, I remember that I once planted a *Trichostema lanatum* in my garden, another native, commonly called woolly blue curls. Clay and ignorance (I gave it summer water) did it in pretty quickly. *T. lanatum* has a big smell—Indians used to use it to stun fish—but it's not as punchy as vinegar weed.

At nightfall, as we construct a small fire at our campsite, we continue with the smell game, more or less taking turns.

"Alphabetical," Flora suggests.

Asphodel. ("Does asphodel smell?" "The name is so beautiful, it should.") Anise. Apple blossoms. Azara. Boxwood. ("Yuck.") Brugmansia. Cinnamon. Cardamom. Cherry blossoms. Daphne. ("Daphne. Got to be on my list.") Datura. Eucalyptus. Freesia. Gardenia. Heliotrope. ("Oh, yeah.") Honeysuckle. Hyacinth. Incense cedar. ("Incense, again. Must be because you were raised Catholic.") Night-blooming jasmine. Lonicera. Lemon. Lily-of-the-valley. Michelia. ("Good get.") Magnolia. Mint. Nutmeg. Osmanthus. Orange.

Pittosporum undulatum. ("I love saying *Pittosporum undulatum.*")
Plumeria. Pine. Sweet pea. ("Goodbye, mandevilla.") *Rhododendron*
'Fragrantissimum.' Sarcococca. Sage. Thyme, thyme, thyme.
Umbellularia. ("That's California bay." "I know.") Lemon verbena.
Vetiver. Wallflower. Wisteria. ("How could I forget wisteria? How many
do I have now?")

A herd of wild pigs is silhouetted on the westerly hillside. Because
of our voices, or some other alarm, they thunder away. Tonight, unlike
last night when the fog rumbled in, the sky is perfectly clear. The merest
slip of a moon ornaments the marine blue of the east. To the north is a
majestic stand of gray pine, *Pinus sabiniana,* with cones as big as cookie
jars dotting the ground. Their needles are so efficient at sifting moisture
that walking under them last night we found ourselves in a sudden
shower. In the almost pitch dark it was possible to see how moisture
had seeped down the ruts of the roadway yards beyond the extent of
the trees' canopy.

Retrieving some drinks from Flora's van I see a snail pasted to the
ceiling, quiescent. Snail, what have you gotten yourself into? I consider
options about what to do with it, and decide to do nothing. Maybe it
will make a break for it on its own.

Walking back toward the now-blazing fire, I ask myself the same
question. What have you gotten yourself into? Whatever it is, I want it
to continue.

Winter

DILEMMAS IN BLOOM

It seemed so simple; a brunch to celebrate the imminent return of spring. If the rains held off, we would eat on the patio and let the noontime sun dissolve hibernal sluggishness. The guests included several gardeners, each of whom has seen my garden more than once and been either complimentary or discreet, so I didn't feel the need to impress. Although some lavender and white tulips were in full bloom, and the plum trees had already blossomed and were thickening with bronzy new leaves, the garden was still austere. I usually find this restraint appealing, especially since it loosens into the gaudiness of April and May. But austere is one thing, penitential another. I couldn't help but notice certain sections of the garden needed some cheer.

At the nursery I bypassed the eye-candy, the annuals beckoning in gaudy glory, and headed toward the four-inch perennials. Massed annuals don't thrill me, the impatiens, primroses and pansies, the "saliva in the spittoonias." Replacing them seasonally is a costly habit better suited to gardens in Piedmont and Pacific Heights and curb strips near gas stations. That treatment would look ludicrous, in any case, in my horticultural mishmash.

I put four six-packs of ranunculus in my shopping wagon. There arose the inevitable doubt: how were these any less brassy and narcissistic than the annuals? Nearby were some violet anemones, pampered and alluringly plump. No one coming to the party would believe I grew these lovelies, but into the wagon they went. The ranunculus reverted to the shelf.

The lavender nemesias and white bacopas that I collected were no less pumped up than the anemones but I felt no qualms about buying them. Theirs was a sturdy modesty that would suit my garden, and of course, reflect well on my humble self. Also, the bacopa flowers and the froth of nemesia would valiantly echo the lavender and white tulips already in bloom in my garden, and make an artful backdrop for the anemones. Any whiff of insta-garden would be dispatched by the knowledge that these plants might, with any luck, live for years, becoming veterans.

The planting was a snap and the effect pleasing, though as always, I didn't buy enough plants. Clean-up went less swimmingly. Strewn over my patio were sixty pretty-in-pink four-inch plastic pots, sixty-plus plastic identifying tags (some plants had doubles,) and 4 plastic

160

flats. So much plastic! The flats I carted to a far-flung corner of the garden where heaps of one-gallon and five-gallon containers have been collecting, destined someday to be returned to the nursery. I stacked the pink pots, which no nursery recycles, in teetering towers, having filled the uppermost with the tags.

My astonishment at the amount of plastic was disingenuous; this wasn't the first time I've done triage planting, nor the first time I dumped the non-recyclables in the trash, or else slipped them into the recycling bin among the crowd of their acceptably numbered cousins, the Pepsi bottles, Tide containers, and Yoplait tubs. It was my way of making a profound ecological statement: they should be recyclable, now out of my sight.

I decided to see if I could find an alternative way.

I was right. Nurseries, at least the ones I contacted, were not an option. One nurseryman referred me to The Ecology Center where a sympathetic woman told me that she stacks her four-inch pots on her porch and over time the sun degrades them.

"Then what do you do with them?"

"Then I throw them in the trash."

My little ruse of dropping them into the recycling bin only meant that someone somewhere would have to extricate them by hand and trash them. The plastic of the four-inch pots is too low-grade to be worth re-processing. More wasted energy. I learned this from a helpful representative of Nor-Cal Waste Systems. "Let's be honest," he said, "there's already too much plastic in the waste stream." Only a very small percentage of plastic gets recycled, as in used again for the same function. Plastic degrades, and after a few times re-purposing (if it goes that far), it is on to the dump.

I took another look at the new planting. Pleasant, yowzuh. But worth it? Unsurprisingly, a voice argued yes. My sixty pots were nothing in the great flood of waste. Who's talking stream? At the dump in the "green-waste" section bags and pots and flats and identification tags are strewn like confetti from hell. Nobody seems to have scruples about even keeping the compostables free from it. The Jurassic front-loader, huffing and squealing and belching from mound to steaming mound, crushes all before it.

Now another voice chimed in, a victimized innocent who only wanted to do a little gardening and was given no choice but to feed the beast and shoulder the guilt. Why couldn't there be pots made of some biodegradable material like peat pots, but unlike peat, indefinitely renewable? Hemp? Flax? And can't we do without these ridiculously

oversized and redundant identification tags, especially for a plant like bacopa that any idiot can grow?

I picked one up. It was six inches long and two inches at its widest, and wedge-shaped at one end for easy insertion. *Sutera microphylla,* the headline. At center a picture of the nuptial, five-petaled flower. Above it, name and logo of the producer; below, planting information and Web site promotion. On the reverse side, redundant info re specs and general care, logo again, this time with a motto: *A Better Garden Starts With A Better Plant.* Upside down, descending the wedge, in minute letters: "'*Snowstorm®' (Blizzard P.P. #10966) is patented or in the process of patent application. Unauthorized propagation is prohibited. Unauthorized use of all Proven Winners® trademarks is prohibited. Virus Indexed from thermally treated tissue culture.*"

I couldn't help asking, haven't we taken this just a bit too far? Gone a bit too far downstream toward the falls?

Without more dallying, I tucked the pots under my armpits and headed down to the curb where I dropped them in the trash bin, resolving to do it all differently the next time, whatever that meant.

A man should never by ashamed to own he has been in the wrong, which is but saying, in other words, that he is wiser to-day than he was yesterday.

— Alexander Pope

On the day of the brunch it didn't rain, but it was gray. In my dining room the windows steamed over. I doubt if anyone even glanced at the garden. Cozy and warm beats damp and dreary. Over a post-prandial cappuccino, I mentioned my recycling dilemma, and was a little surprised at the stir it raised, especially among the gardeners. I had assumed, I guess, that nobody questioned the waste.

"Chicken feathers," Randy exclaimed, "might save us. I read how in Arkansas they've experimented with using them to make pots which turned out stronger than peat pots and equally bio-degradable."

A balloon of approval burst when Rita, one of only two non-gardeners at the table, said, "Great. Another justification for the chicken death camps."

"I didn't even think of that," Randy said.

"I eat chicken," Phil said. "If the feathers can make some amount of plastic unnecessary, I'm for it."

"You should see the pile of empty pots at the arboretum nursery," Anna, who volunteers there, said. "It must be twelve feet high and wide and it keeps on growing."

I contemplated my cappuccino, a wisp of steam rising from its layer of milky froth. I was wondering if Rita was going to launch into her sermonette about giving up some of our seemingly entitled pleasures. I prayed not.

"I heard something on *NPR* about miscanthus being used in England to make car parts," Flora said. "If it can be used for making car parts, why can't it be used for flower pots?"

I had been wondering what she was thinking. We had a preview of this conversation last night. Her gardening business includes five Piedmont gardens. At more or less the same time I was planting bacopa, she was planting sixteen flats of pansies in one garden alone. Afterward, she said, her van was full of plastic.

"The grass pot. Let's patent it. We'll make gazillions," Anna chirped.

"What could possibly replace all the plastic bags soil amendments come in?" Elizabeth asked. "Do any of you use chicken manure? It's disgusting, especially if it's been sitting around and gotten wet."

"What would happen if you didn't buy stuff that can't be recycled?" Rita asked.

For a few moments, nobody said anything. "What do you mean? There would be nothing to buy," Phil said. "Seeds. But nobody plants seeds. They take too long."

"Well, if you want a different world," Rita said and shrugged, as if she'd made her point. But who among us was going to forego buying plants?

It's a sweet and melancholy feeling closing the door on the last guest after a good party. Flora, more companion than company, stayed to help with the dishes. I collected the cups and plates.

Placing a cup in the drying rack, she said, "I wonder if I might do some re-education with my clients. Rita hit the nail on the head. You've got to start somewhere."

Which of my seemingly indispensable pleasures could I forego? *Snowstorm®* and her overpackaged, thermally indexed kin, perhaps. It may not be so difficult, or even necessary. Just think of the felonious thrill of unauthorized propagating.

Spring

SNAIL POSE

"Kill them," says John, my yoga teacher.

Snails in battalions have invaded the ashram garden. I'm appalled. For the first time in the two years I've been tending it, the garden looks presentable. My ego, naturally, is completely invested, but I can take only partial credit for the infusion of beauty. It is mainly due to the largesse of the winter rains that have come and gone in perfect intervals. Bye-bye blue, we're a green state, at least for now. Even the weeds along the ashram driveway glow like they just came from plant spa. In susceptible moments I even see them as ornamental, and (mistakenly) don't pull them. I suppose I shouldn't begrudge the gastropods their place at the table, but I do. I'm not running a buffet. They've already made lace of the *Aeonium undulatum*. Is *Aeonium* 'Sunburst' next?

I can't tell if John means it, or he's fiddling with my attitude. Let me see you kill them, I feel like saying, but that would make me complicit. If I'm going to kill or be a party to it, I should imbibe the disgust neat, no dilutions. At home I've done the evasions, dropping them into the green bin and shutting the lid, to find them later glued to the top; tossing them into Bertie's ivy; baiting. Actually, I'd give them a toss today if there were somewhere to throw them, but the garden is surrounded on three sides by buildings, with the street on the fourth. Also, the sheer numbers would give Roger Clemens tendonitis.

It has been years, praise be, since I've had to deal with snails in my garden. I stopped planting things they liked and eventually they took a hike. Maybe joined an ashram. When I have tempted fate by slipping a scrumptious dahlia or two into the garden, I've had no problem. Evidently it's not worthwhile to make the trip back.

Mindlessly I squish five or six of the fledglings between thumb and forefinger. I can't quite remain oblivious to the muck on my fingers, and before digit death reaches double digits, revulsion prevails. Now what? On a knuckle of my left hand, hanging on for dear life, is a featherweight, button of a shell, out of which glides an elastic, translucent, four-pointed periscope, swaying, inquiring, whence this upheaval? Where refuge? The wicked giant breathes hot. Squish.

Not only do I feel guilty, there is this matter of karma. The guru, Sri Brahmananda, two decades departed from this realm of illusion, peers down in living, laminated color from one of the walls inside. He, or somebody, keeps watch. I want to believe in karma, to believe that

by doing good, good will come in generous return. If I continue, then, with this massacre, I might expect...what? A reincarnation in which I slide on my belly through the world?

"You're in serious trouble," John told me three years ago when I first limped into the yoga classroom. He put his hand on my lower back. "Can you feel how this side of your sacrum juts out?" I couldn't, but I felt the nearly permanent ache that had settled there. I was shocked. Wasn't my ox-like body born to take endless buffeting? John gave me the name of a body worker who never returned calls. I began to attend John's Iyengar classes twice a week. More shocks ensued. A particularly unfeasible back bend left me splayed on the floor. It took ten minutes to move, twenty to get vertical.

Two hundred and thirty-five classes later (John keeps track), my sacrum is back in line. The soreness I feel these days is simply the result of the exertions of the most recent class. I have more stamina and flexibility than ten years ago. Perhaps in another two hundred classes (or two hundred lifetimes) I'll do that back bend.

When John asked if I'd take over the ashram garden in exchange for classes, I said yes. It was synergy. The dumpiness of the garden made the decision easier still. Expectations were minimal. There was no budget, and aside from John, not much interest. Irrigation was sporadic and superficial. Shade ruled in winter, the byproduct of a three-story Victorian on the south. In summer, sunshine was portioned into dollops by a tall spruce and a metrosideros on one side of the garden, and a cordyline, a fan palm, and a badly pruned, aphid-infested plum tree on the other. Two tree-aloes dominated the understory, along with a rangy penstemon, a golden euonymous, a mock orange, and wispy agapanthus. If the agapanthus were wispy, what were the odds for anything else?

I planted a grab bag of succulents that I hoped would adapt: crassulas, echeverias, graptopetalums, aeoniums, sempervivums, and aloes. Other people's horticultural rejects were incorporated: clivias and a white camellia, a begonia, a dozen out-of-bloom epidendrons. Making a stab at coherence, I added two burgundy loropetalums, three glistening silver astelias, two purple-leafed hebes, and a constellation of reddish bromeliads.

Sounds fabulous. In fact, the lives of the loropetalums were brutish, beset by drought and weevils. To counteract the weevils I watered beneficial nematodes into the soil. A stab in the dark, so to speak. The loropetalums just grew sadder and sadder until I yanked them. But the hebes look grand and the bromeliads continue to be stoic, with mouthfuls of fir duff. The astelias, meanwhile, are undecided whether

life is worth living in such company. Their leaves are also weevil-notched but otherwise look passably ornamental, and the spring growth, though tentative, is intact thus far.

Now snails. Under every leaf a scrum. In the orange throat of the clivia blossoms, couples flaunt AC-DC sex. Whatever it is they do pasted together, oozing goo, I have to admit, looks like fun. The flowers, however, which were lavish as never before, are shot. I thought I knew what snails eat. They don't bother the leaves. Who knew they eat the flowers? Why have they munched the *Aeonium undulatum* and not the other aeoniums?

In gardening, I'm used to not knowing. I don't need to know why, for instance, rain can infuse plants with a radiance that no amount of irrigation can match. The facts would be interesting but I'm happy with the sentiment, or presentiment, that the garden has a mind of its own, that plants feel a variation of joy. Nature is more than a bunch of moving parts. I read how mad Mr. Wizards recently inserted human genes into rice so it can withstand more pesticides and herbicides and I want to somersault naked down the street. What is this insanity? But I see the contradictions, how I'm implicated, too, how I think the garden is my dominion, something I control, or ought to.

Kill them.

I overturn my bucket where I've collected a dozen or so and shake them out, nudging with my finger the ones already fastened to the side. Mentally I direct a petition to Sri Brahmananda, as if he's some pet psychic on heavenly cable: get the word out to these escargots. *Touche pas* 'Sunburst.'

I want to show you the magnolia stellata
crabapples brassy as gypsies on a grassy rise,
to have you smell the rhododendron fragrantissimum
in this moment when to behold
is to be held oneself...

— Alice Gaither, *How Spring Comes*

When I get home I call in succession Henry, Anna, Jeung-Hyeon and Flora.

"You're cracked," Henry says. "Put down snail bait. Or containers of beer. That way they'll die happy." I reply that snail bait is far more disgusting than snails. As for the beer method, I can't quite picture tubs with marinated slugs littering the garden.

Anna reports she has "sacrificial plants" which the snails eat. They leave her other treasures intact. So if I simply anoint *Aeonium undulatum* victim, will they will spare 'Sunburst'? This apparently is what the gardeners at Findhorn in Scotland do, "tell" the snails which plants are theirs and which to bypass. I doubt I'm as persuasive, though I suppose I could try.

Jeong-Hyeon confesses that she also used to tuck them into the green bin. Now peremptory execution is her m.o., but before the shoe drops, she gives each a blessing. "I don't know if it does any good," she laughs, "but it makes me feel better."

"I know what you need," Flora crows, "a raven. Have you seen how they walk along the top of a boxwood hedge after a rain when the snails are up near the top? They pick them out and flick them to the ground and pulverize them with their beaks before eating them. They are smart birds."

I doubt ravenous snails would understand such niceties of conscience but I'd have no qualms about a raven offing the snails. It's just the nevermore I could support. I'd even marinate them in beer if the fowl preferred. I think of Roland, the duck that belonged to my neighbor Alberta when I lived in the Haight in the 70's. Roland took clamorous delight in the escargots I served him from my garden. I was buttering him up, while getting a puerile delight in carnage. He intimidated me. Even the raccoons gave him wide berth. When Alberta decided to move to Mississippi to live with a niece, Roland, for all his mojo, landed on a platter at Easter dinner. "Too tough to chew," Alberta reported.

Sic transit. We're all here only briefly. Is there really such a thing as reincarnation? Does it matter? The *gloria mundi* at the moment is fabulous, if I slow down to notice. My own garden has never looked better. The *Pieris japonicas*, shrubs that have made a lifestyle out of being middling, flounce in carnelian and scarlet. The camellias drape themselves with a shining shawl of leaves, and grow so fast you'd think they had jungle fever. And the roses! I pick a bouquet and am floored by its luminous perfection, how it perfumes the study.

It's not just mine; every garden in the neighborhood is chockablock with fresh greenery. Even Bertie's ivy has a version of majesty, an avalanche in slo-mo. Battles are forgotten, and though it feels almost like real peace, I know it is just a momentary armistice. I see how the Jerusalem sage in my front garden is smothering the preferred geranium 'Bill Wallis,' how the groundcover "snow-in-summer" is really a blizzard in spring, how Bertie's ivy, for the zillionth time, is scaling the tool shed. When I lift up a wing of a hellebore sprawling over the pathway, I find a smear of baby snails.

Minutes after having decided to turn a blind eye to the mischief of the ashram snails (is there a better choice?) I am itching to fling these against a tree trunk. The universe is fiddling with my attitude.

I'm simply going to put this hellebore back down where it was. An armistice, extended long enough, can feel like real peace.

Summer

OUT OF THE BLUE

10 A.M. I bring my pickup around to the passenger zone of the clinic.

"It was amazingly quick," Stuart says as I snap the seat belt around him. He holds his bandaged wrist in front of him, wriggling his fingers. "I hope to God this works."

"Does it hurt?" I ask.

"It's numb."

I want to ask how the surgery affects the distressed nerve, but the topic makes me queasy. We climb over Divisadero Street to the pharmacy to pick up pain pills. It's blustery, one of those fogbound summer days in the city when you wish you had worn a parka. The light is dim, an ongoing twilight. There will probably be no midday breather, no sunny island in the waves of gray.

"I'm so sick of this wind," he says.

"How long before you can go back to work?" I ask as we pull into a parking place near the pharmacy.

"Six to eight weeks."

A long time, I think, in light of his battles with depression. Won't all this extra time make it worse? Then again, maybe the time off will open something up, something to say yes to.

I want to suggest this optimistic possibility as we eat sandwiches at a small table in a nearby bistro, but I don't trust pep talks. "Just cheer up," my neighbor used to say to her forlorn daughter, and I bet whatever I say would sound as patronizing. I vow simply to listen. But Stuart has hardly been talking 30 seconds before I jump in.

"You have to stop beating yourself up," I blurt out. "Depressed is one thing but believing you're a piece of crap for having a feeling is something else. That voice telling you you're worthless and shameful is not your friend. Don't give it one ounce of your attention." I hear my voice rising, in tandem with my queasiness. Here it is: a pep talk.

Stuart nods. "I know, I know."

I want to say, you don't know. If you knew, you wouldn't do it, but that's not fair. "It takes effort. Lots of effort and willingness."

What is this queasiness? My own sour soup of self-criticism. True, I don't know how a person gets undepressed, or at least, starts to feel that it's possible. A pill? Snorkeling in the Andaman Sea? Good sex? Maybe all it takes is a sunny day. I know for certain that the path of self-flagellation is not a happy trail anywhere.

169

We finish lunch, pick up the pills and drive to his house. I make him promise to call if he needs anything before I say goodbye and leave for home.

Crossing the bridge a fanfare of sunlight plays on the gray cables, and for a minute I believe that the sun will come blazing through. Behold the conquering hero. But the fog quickly knits the breach. A cloud swaddles my garden, the proverbial wet blanket. By the time I have unloaded my groceries, I have talked myself out of gardening, though I have a list of chores that lengthens as readily as the blackberry bush coming over the south fence: deadheading the echium, dividing irises, fiddling with the watering system, chores that were not engaging in the first place and are less so now.

What I need is a pep talk. I consider calling Flora but she doesn't like talking on the phone any more than I. Instead, I reprove myself. Given such lax stewardship, judgment opines, it's a wonder the garden survives at all.

The trouble with beating yourself up is that afterward, the chores are still there to do. I change into my beat-up jeans, snatching two peaches on my way outdoors. A half-second from chomping down, I notice they are furred with mold. I take them straight to the compost pile, passing by the stand of echium. Here is as good a place as any to start.

I love echiums, the 'Pride of Madeira,' though they are common as dust. How gladly these specimens inhabit the sometimes viscous, sometimes baked, shank of clay. There must be 100 flower stalks to snip, relics of pale blue and lavender spires towering into the paler blue of the sky. Now they're going to seed, and chances are some will take hold, replacements for the ones declining, a stately cycle of self-perpetuation.

Across the garden something catches my eye. Is that mildew on the dahlia?

I pocket my clippers and descend the slope for a closer look. Indeed, a powdery whiteness covers the leaves and flower stalks. This happens every summer, but always after weeks of floral fireworks. By then, the show is pretty much over and the plant will soon be cut down, so I don't do anything about it. This summer there haven't been any flowers. One is just starting to unfurl.

What do I do? Am I too late? I won't consider *Funginex*, or sulfur. I don't want to handle the chemicals or breathe the fumes. If it means goodbye dahlia, so be it.

What about baking soda? But what about the echium? Don't you finish anything?

The internal tug-of-war is, as usual, of no consequence except for momentary paralysis. Eventually, the little yellow box with its icon of the rolled-up sleeve, the sinewy forearm and bulging bicep, the fist brandishing a blunt hammer, wins the day.

No such box is found on the pantry shelf, but there is an open one in the refrigerator which is what, from the '80s? Does soda lose its fizz?

I mix a concoction: three teaspoons soda per gallon of water, plus three tablespoons of horticultural oil as a sticking agent, and add an extra teaspoon of soda just in case, and transfer the liquid to the sprayer. Waving the mystic wand like a wizard, I generously douse the dahlia. Sizzle, mildew. I have no hopes that the infected leaves will improve, but I hope that new growth will be clean. I'll probably have to spray more than once. Warm days with cool humid nights are mildew heaven.

More than a half-gallon of spray remains after spraying the dahlia, and I do a mental survey of the garden for other sufferers. The 'Gulf Stream' nandina along the walk in the lower garden, that unheavenly "heavenly bamboo," pops into mind. The plant is stranded in a desert. Its leaves are splotchy, its branches half-defoliated. Another item for to-do list: relocate it to where it would be happier; somewhere moister, with richer soil, and not so exposed.

I trek back to the compost pile, ignoring the echium stalks strewn in the path, and procure as appeasement two five-gallon buckets of compost to spread at the base of the nandina. Then I give the leaves a soda spritz. A lick and a prayer, Aunt Dot would say.

Maybe Stuart, if he had had Aunt Dot at a critical juncture in his life instead of a maniac father, might be less canted to the downslope.

Clearly the quality of nurture accounts for much in preventing mildew, but it doesn't explain everything. Spores coat the spring growth of the 'Gravenstein' apple but the apparently equally tender leaves of the 'Golden Delicious' are immune. Roses like 'Tropicana' are mildew factories while others, with similarly unshiny leaves (shiny leaves have more resistance,) survive unscathed.

There used to be a 'Tropicana' rose in the upper garden. Season after season I tried to find some virtue in it because it was one of Aunt Dot's darlings, though even she couldn't keep it mildew-free. The day I chopped it into twigs and trashed it was a banner day. The same day, in a rush of resolve, I made war with 'Peace' and assassinated sweet 'Mr. Lincoln' with whom rust always slept. Or was it blackspot? Three 'Betty Priors' survived the war of the roses because these girls got the vapors for only a few weeks in summer, or perhaps because there were three of them and one of me.

171

To these same 'Betty Priors' I now carry my spray can, eager to use up the mix. A few of the reddish new leaves are indeed powdered with spores. In past years I just snipped off the worst, as I did with the afflicted leaves of the 'Gravenstein,' a control that works well enough. But I have the spray, so I use it until, finally, the nozzle sputters and coughs. By now I am feeling less like a wizard than a nurse in the ICU.

Which could be depressing, were there not a few feet away another rose, a midsize bush covered with flowers ranging in color according to when they opened from reddish purple to frosted magenta. They are deliriously fragrant. On warm days I can smell them when I step out the back door. Last April, when Flora and I took a stroll around the Berkeley Rose Garden, we each chose a favorite. 'Outta the Blue' was mine. A week later she showed up at my door, with a present. The bush was covered in blooms, smaller and redder than the ones I remembered, but no matter. I was smitten even before I got it into the ground.

It might boil down to this: what makes you happy is someone (preferably) or something to love and be loved by.

I rinse out the spray can and return it to the tool shed, and resume the deadheading of the echium, vowing at least to finish that task. As I snip and snip, the afternoon fades into evening, and, as if to give a preview of what we might see tomorrow, the sun slips momentarily beneath the fog, refurbishing with one broad stroke the gold of the Golden Gate. It couldn't be more unsubtle, more pep-talky, a humongous, shameless cliché.

"Look here," it says. "Life is precious."

And I'm chilly. I fill the green bin with the stalks, collect and store my tools, and go indoors to see what gives with all the fruit flies swarming above the sink.

Fall

GOING WILD

Overnight the garden turns mysterious, untamed. Who is the transient here? seems to be the question. The oblique sunlight filtering through the liquidambar is as penetrating as Sister Cyrilla's gaze in eighth grade: will you ever grow up and get serious?

This happens every fall, but this year there is a pointedness, probably in part because the news has been a diet of epic disaster. It's a wonder, and blessing, things are so peaceful here.

Deepening the mystery, something has happened in the garden that I can't explain. Two mornings ago, cup of coffee in hand, idly gazing out the kitchen window, I noticed that the daylilies at the top of the garden were flat upon the ground. Limp from neglect, I assumed, although neglect has never much fazed them. Their blossoms are a drab orange, thoroughly unremarkable, but when it comes to eliminating the colony, I dig up only a qualm or two. What else is going to survive the clay and inattention? Quite a number of things, I suppose, but those things are yet to be planted. Meanwhile, the daylilies strengthen their ties to the land.

I went out to investigate. The flattened area was a well-defined oval. Clearly the cause was not drought, nor the usual fall defoliation. Something had hunkered down there, surrounded and partially hidden by a cluster of echiums. I imagined I could smell the animal presence and felt the heat still rising from the bed.

I was indignant. If the daylilies were going to be abused, I would be the one to do it. The obvious suspect was a deer, but if a deer had gotten in through an open gate, the roses would have been first course. Raccoons having a congress? Maybe it was an addled fraternity boy sleeping one off, or a street person appropriating some real darkness and quiet, or some vagabond poet like ageless Li Po, passing through. Or maybe two humans having congress. Now that's wild.

Something else was odd. Seven or eight branches of an adjacent leptospermum, a tree so juvenile it has only spindly branches, were snapped and hanging perpendicularly. Raccoons break the branches of my persimmon tree for the fruit, but I doubt they mistook the leptospermum for the persimmon. A raccoon could not even get out so far on those thin branches to break them where they were broken. Also, the leptospermum stands by itself, so is not a potential path to, or from, a roof.

My conclusion: a meteor, made of ice that melted like the bullet that left no trace, a deduction one might aptly call farfetched. I touched the soil around the daylilies. Sure enough, damp.

Well, that was close.

I finished my coffee and idled down the steps to the patio. On the bench near the back door, still waiting for me to find it a home, sat the blechnum that Tom gave me weeks ago. He said Sunset Nurseries is calling it 'Miriam,' but whatever her name, this fern is bellissima! Its elegant, ruffled gown of deep green could dress up any motley of plants. When I saw it in Tom's garden, plant lust swelled alarmingly. Fortunately, Tom had this offspring, which he parted with. The best gardeners have generous hearts.

I lifted the pot off the bench to test how the fern would look with the other ferns under the apple tree and saw peripherally that the web I'd been trying not to disturb, the one constructed at head-height just outside the back door, quivered, and a quadrant collapsed. The spider at its center went into a jig of panic and fled into the eaves. I was relieved. Sooner or later I would have draped my face with it. Here was the best of all worlds: the spider unharmed, the web beyond repair, and no eight-eyed hairy-legged fanged mutha cavorting on my nose.

Yesterday morning the web was back, rebuilt in all its intricacy an inch or so higher than before. Was there some intelligent realignment by the spider to take into account human interference, or was the change simply due to the moved pot? It was still too low for comfort.

I had a few free hours to do some garden chores. I don't know when I wrecked the web the second time. Movement in the apple tree had arrested my attention. Not a bird. A rat! The world was going down the toilet. For the first time in several years I wasn't worried about having enough apples for Pie Day. There are so many on the tree. What if rats nibbled and corrupted all the apples? Only a few showed teeth marks, at least what were visible from below. I wondered if it was because they weren't yet ripe.

Here was a new project: to severely prune the adjoining liquidambar, into which the rat hightailed it. If it were going to make its way into the apple tree, it would have to come up from the ground. I was thinking about snot-nosed Cindy, the semi-feral cat who has been on the premises almost as long as I have. She still has some of her mother's fierceness. Kill, pussycat, kill.

I bounced from limb to limb, clipping back the long, supple outer branches both from the liquidambar and the apple. Are rats as aerially adept as squirrels? I wondered if the pruning was all for naught in any

case, since a dense planting of ferns and plectranthus grows at the base of the apple tree, ample cover for a rat trying to avoid a geriatric, somewhat deaf, overweight puss. Well, if nothing else, I was amassing a stunning collection of branches ablaze with hand-sized leaves of burgundy and orange. I could open a shop.

By the time I climbed out of the tree and collected the branches, the only trace of the web was a guying strand floating in the breeze. This time my relief held a higher proportion of dismay. I hoped the spider wasn't taking it personally.

Since the world in no way can answer our craving,
I will loosen my hair tomorrow and take to a fishing-boat.

– Li Po, *A Farewell*

A new day dawns, with a pumpkin-colored light. I open the door at sunrise to put out food for Cindy (should I withhold a little and give the old girl an edge?) and there is the web again, and Charlotte in her striped leotards. I'm delighted, absolved. And, the web is constructed yet another inch higher so I can walk under it without cringing. Clever girl. Dew condensed into droplets lines the strands. I wonder if the moisture is a hindrance to alfresco dining. I feel like I have a new roommate whose preferences I am going to learn willy-nilly. Orb weaver, are you? Does "orb" refer to the web or your plump belly?

Cindy comes lumbering down the steps. Speaking of plump belly...it can't be from the weight watcher grub I dispense for her. She must be double dipping. She approaches to within an arm's length, but no closer. Touch me? Don't even think about it. I nonetheless put forth a hand, covered by the sleeve of my sweatshirt, and she gives me a swipe with her paw that's not as serious as it used to be, but not exactly affectionate.

As she eats, she periodically glances back over her shoulder. What she hears, and sees, seems often phantasmal, but this morning there is a visible object of her attention: Caspar, her brother, vanished from the scene two or so years ago, presumed dead. Where has he been? He's terribly skinny, long, matted brown-black fur, grungy tail flecked with weeds and seed capsules.

Cindy hunches protectively over her pellets and crunches down, if a one-toothed cat can crunch. When she finally ambles away from the

175

bowl, Caspar slinks forward, gulping the leftovers with a furtiveness bordering on panic. It gives me indigestion to watch. When I open the back door to refill the bowl, he scurries away. Once he was on the verge of letting himself be petted, at least when his attention was diverted by food.

A thought tickles me, that it is my good karma that now when I need an extra paw to defend my apples, Caspar shows up. More likely, it's a worm in his guts. The look he directs toward me when I open the door to refill the bowl a second time is of undiluted wildness.

Wildness is everywhere in this domesticated place. Raking leaves I uncover a colony of flailing creatures the size of long-grained rice, that presto, disappear. A raucous squirrel chases a rival in a spiral up the trunk of the pine. Above the wooden steps down near the street winged termites hover and dart. Nearby a jay, tipsy on cotoneaster berries, tries a bit of karaoke.

"In wildness is the preservation of the world," Thoreau famously wrote. It doesn't seem like much here, but it makes all the difference. The clipped, creature-less garden with the perfect lawn and lawn furniture would be as dispiriting as a mortuary. But why worry? There's no danger of that here. I will loosen my hair....

I climb the stairs to the daylily bed to see if there is further evidence of nocturnal romps. My instinct says yes, though there's no evidence. The leptospermum appears unchanged, and I spend a few minutes trimming away the damaged branches. Then I check on apple tree to see if there are more rat nibbles, and find none. Everything in the garden is preternaturally calm, as if waiting for me to notice something obvious, even revelatory, but I don't know what to look for.

Winter/Spring

THE OX IN THE OXALIS

The proposal was, to say the least, romantically challenged. "Two can live cheaper than one," Flora said. We've been "dating" for almost two years, and it did cross my mind, though I didn't mention it, that we might someday want to bump up the status into something less adolescent. As friend Phil pointed out, nobody 'dates' for two years but if fate hadn't pressed the issue—the house Flora was living in was sold— we might have set a dating record.

"We're shacking up," I told Phil the news over holiday eggnog.

"I hope you don't blow it this time. You have issues around commitment."

"I don't either."

"Yes you do, but not what you think. You do the opposite of most men. You always ask for a commitment. It's a straightjacket. It scares people away. Don't do it."

I wouldn't take the bait. I didn't see why I should listen to advice from someone who hasn't been in a relationship in decades, and who now (incredibly) professes not to want one.

"How are you going to split up the garden?" he asked.

That had not crossed my mind. The garden is quintessentially mine, an autobiography with a foreword by Aunt Dot. A sampling of the blurbs reads: "Quirky yet lyrical evocation of an Eden just out of reach." "A pulsating exploration of what it means to be a natural man." "An epic, often chilling, battle with the elements (advisory: contains strong language)." There may be more blurbs than content, bound in tasteful, green covers.

"You think Flora won't want to garden?" Phil continued. "She's a gardener. I always tell people who have an apartment to rent, rent to a gardener. You'll get a garden for nothing."

One hazy January day, two trucks arrived carrying Flora's material estate, the contents of which were toted up the front stairs into the house. What seemed like a simple thing took three days. Overall, I behaved. When her dining room table was placed alongside mine, it was obvious mine got the heave. When she suggested her shelves for the bathroom instead of the slapdashery I was used to, I did the substitution. Her cherry wood credenza was too spectacular not to go into the living room, even if two end tables that Aunt Dot bequeathed me had to go. That the rickety things only went as far as the basement

wasn't Flora's preference, though she didn't say so. She was being flexible, too. I held my ground when it mattered. The funky blue recliner? Stays. Ditto the Grateful Dead tapes. We would discuss the bedroom later.

The garden wasn't mentioned, although one half of one truck was filled with plants, tools, and gardening miscellany. The plants, ailing or not, were parked in the infirmary section of the upper garden near the compost pile. The remainder of her gardening stuff went into the garage. A light rain that began midmorning on the second moving day and then fell steadily the next two days made postponing any long-term decisions sensible.

February eventually crawled out of January's cocoon and once again the derangement called spring was in the air: the daphne blossoming, the bulbs shooting skyward, camellias glistening after the night's shower. As the days grew appreciably longer, I began to spend more time each day in the garden, weeding oxalis, gathering plum blossoms for indoor arrangements, guiding errant sweet peas onto support wires. I did these things as solitarily as ever. Flora was elsewhere, working in her clients' gardens. I didn't expect her to help me weed oxalis, but if she had offered.... Even when I made a point of involving her she seemed unavailable. When one evening I enthusiastically pointed out the budding 'Thalia' narcissi, she just nodded.

Was she just tired? Was it something else? We once laughed over a New Yorker cartoon, a Joe's Gardening truck parked at a mountain vista, and Joe saying, "I would have done things differently." Did she think my gardening skills left much to be desired? Something between us felt cramped and stingy, despite the seasonal exuberance.

"I don't think we're ready to work together in the garden," she said finally. "Our styles are too different."

I hesitantly agreed, confused about what she meant, where this was leading, or what I felt.

"Here's my idea," she said. "I'll take the front garden, you take the back."

In hindsight, I see that sharing the house caused only a few psychic ripples, but sharing the garden was seismic, opening up all sorts of sulfuric cracks.

"But the deer maraud through the front garden," I answered, implying a concern about her expectations.

"Sure I haven't noticed. Yesterday I did a little tango with a buck on my way to my truck. I know what I'm in for. I want to do it. Deal?"

"Give me a second to think."

Something unexpected happened. I suddenly felt like I had taken a snort of nitrous oxide. What a coup! The back garden is fenced in, deer-free. It has the roses, the vegetables, the persimmons and apricot trees, the compost pile and the raised beds. Except for the apple and pear trees, it has all the good stuff. The front garden has clipped boxwood, chewed agapanthus, a seasonal swamp, a privet hedge. It's a truculent slab of clay, an ongoing mockery.

"We can give it a try," I said camouflaging my eagerness. Beneath the elation I felt slightly wicked, as if I were pulling a fast one.

Oxen should have very small foreheads with white hair; their underbellies, the ends of their legs, and the tips of their tails should also be white.

— Sei Shonagon, *The Pillow Book*

I heard, "neuroses." What Flora actually asked is if I had gotten any "new roses."

We are having an evening at home, a table for two, her table, we two in "our" house, a picture of a domesticity that feels anything but settled. Two candles are burning down to nubs.

"No," I could safely say either way. No new roses yet. This is the first spring in many that I haven't had an urge to try a new one. Last year's newbies, the hybrid tea 'Outta the Blue' and 'Belle Story', a pink David Austin, are winners. I guess I don't want to push my luck with any more new things this spring. As for neuroses, why change horses? The old ones still have plenty of pep.

The sound you hear in a lull in conversation is of ruffled feathers getting smoothed. The ruffling happened earlier today. I came home from work to find the boxwoods, formerly lining the front steps, mashed into the green bin. Looking at the front garden was like looking at the face of a man who shaves his beard after decades. Suddenly you see his pink, shameful little chin.

"You didn't tell me you were doing this," I cried.

"Do I have to vet all my decisions?" Flora countered. "I thought you meant it when you said I could take over the front garden."

When we sat down to dinner we were both feeling tentative and cautious with each other, but the tension has dissipated.

179

"I'm taking out the agapanthus, too," Flora says putting down her glass of red wine, "and the nandina. Just so you know. Any objection?" She gives me a lopsided smile that has enough teasing to render it ticklish, but not lacerating.

"You're not taking out the apple and pear?"

"You know I love having fruit trees as much as you. Look. I'm sorry about the boxwood, but you told me at least twice that you've been thinking of getting rid of it for years. I know you'd eventually get around to it but I'm not as patient as you. I'm a monkey. You're an ox."

Does your birth year actually have an effect on your personality? Our styles are so different. Lisa, Flora's friend born twelve years before Flora, also in monkey year, is monkey-like. And truly I'm feeling more ox-like by the second, my belly bulging with risotto, wine and chocolate torte. I'm about to start lowing, or whatever oxen do.

"Let's leave the dishes for now," she says. "It's warm out for once. Want to have your coffee on the deck? I'll grab an old towel to wipe off the chairs."

Some last petals drift down from the plum tree above the deck. It is already almost completely leafed out. It seems that I missed its blossoming. Before I know it I'll be slipping on fallen plums. Why is life accelerating so? Maybe, relatively speaking, if I weren't a lumbering ox, life wouldn't appear to pass by so quickly.

"Before I forget," Flora says, "I'm having Ian come over and take out the cedar. Don't worry about the cost. We're doing an exchange."

That seems fine, too. I'm in a relinquishing mood. Earlier, I was prepared to justify my snit by saying that I wanted to respect Aunt Dot's legacy in the garden. But Aunt Dot would be the last person to make a mausoleum out of a garden. And she never liked the boxwood anyhow, which, I think, predated her. As for the cedar tree, it's gotten far too tall and is shading the fruit trees. Would I have taken it out? Never. But it's not a bad idea.

Woven into the smell of coffee is another smell, unfamiliar, perfumy. I suspect it might be coming from the 'Thalias', which have opened completely, a galaxy of them beaming on the slopes on either side of the steps. I'm too lazy to walk over and get a sniff to know for sure. Maybe tomorrow. Last fall I planted all 100 of them back here. I doubted the deer would eat them but I didn't want to risk it. And I wanted to have them near the house in case they were fragrant. Absorbing a little light from the kitchen window they glow the purest white.

"Quiz. Who is Thalia?" I ask.

"A muse. But I forget of what."

"Comedy and pastoral verse. Perfect for a garden, don't you think?"

"I do," Flora says, and ponders. "Comedy especially, despite Eden and its unhappy-ever-after ending. You know that saying, all tragedies end with a death and all comedies end with a marriage?"

"I think I do. Do you suppose it's a wise crack, or just a general statement?"

"General statement. Think of Shakespeare. The tragedies end in bloody messes, the comedies end with a marriage, or multiple." Marriage. A "marriage of true minds." That's Shakespeare, too, in a sonnet. What's a true mind? My mind is the part of me that's certifiably monkey-like, nattering, swinging from the trees, flitting about. "Love is not love which alters when it alteration finds." Things alter, that's certain. Maybe what Phil was recommending is to let go of the compulsion to chain things down.

One step at a time. Take it, see what happens. That is enough for now.